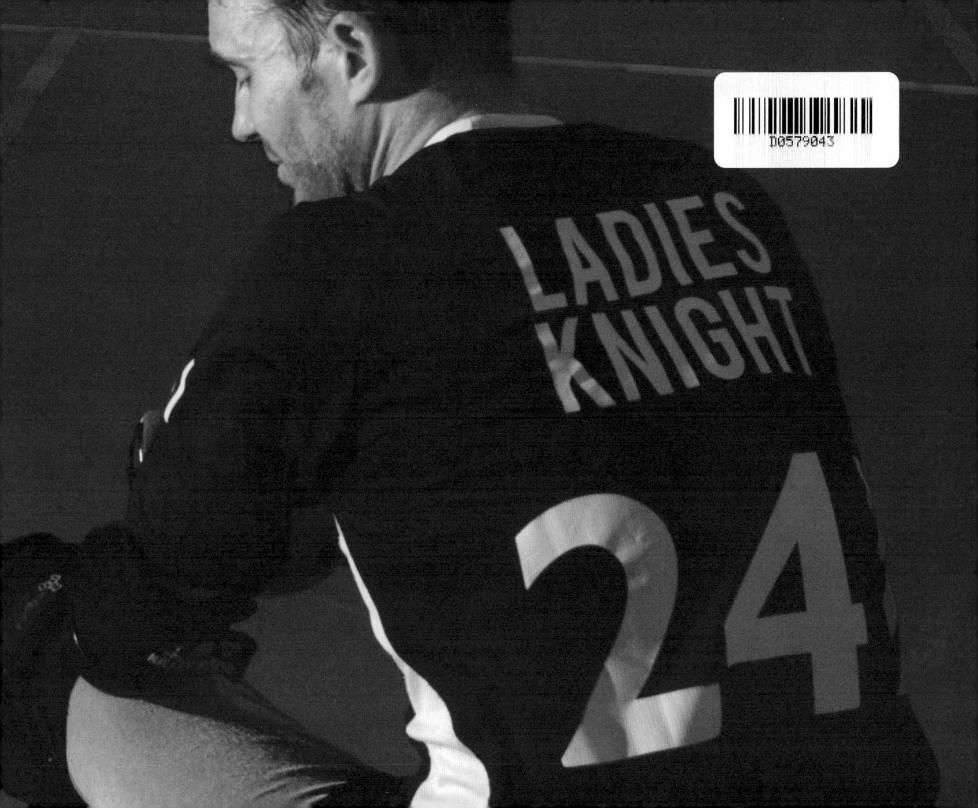

SCARS & STRIPES

ISBN: 978-0-7643-4689-7
Printed in China

Published by Schiffer Publishing, Ltd.
4880 Lower Valley Road
Atglen, PA 19310
Phone: (610) 593-1777; Fax: (610) 593-2002
E-mail: Info@schifferbooks.com

For our complete selection of fine books on this and related subjects, please visit our website at www.schifferbooks.com. You may also write for a free catalog.

This book may be purchased from the publisher. Please try your bookstore first.

We are always looking for people to write books on new and related subjects. If you have an idea for a book, please contact us at proposals@schifferbooks.com.

Schiffer Publishing's titles are available at special discounts for bulk purchases for sales promotions or premiums. Special editions, including personalized covers, corporate imprints, and excerpts can be created in large quantities for special needs. For more information, contact the publisher.

SCARS & STRIPES

The Culture of Modern

ROLLER
DERBY

Andréanna
Seymore

Foreword by Suzy Hotrod

Schiffer Publishing Ltd®

4880 Lower Valley Road • Atglen, PA 19310

INTRODUCTION

O ne day, I almost hit a woman with my car. She was crossing Wythe Avenue in Williamsburg with a case full of roller derby gear. I realized I knew her from the neighborhood, Shannon Brock—I bartended with her boyfriend, John—and I asked her where she was headed. She had just started playing roller derby withe the Gotham Girls, where she skated under the name Papierschnitt—a reference to her papermaking and to her German heritage. I knew immediately that I needed to photograph this.

I thought I would work on the project for about two weeks, add some interesting shots to my portfolio, and be done with it. Little did I know at the time what a rabbit hole I was about to go down.

Roller derby—while famous for being "all-inclusive"—is not an easy world to infiltrate as an outsider, at least not at the level I was hoping. While fans are the lifeblood of any sport, the overtly sexualized aesthetic of the roller derby world, particularly at that time, easily drew creepers, sometimes posing as "photographers," so the leagues and the women involved were—and still are—very strict on what you could and could not shoot. As my fascination with any of my subjects throughout my career has been focused on sociology and culture, I wanted to be—I needed to be—on the inside of these women's lives: in the locker rooms, in their homes, at their practices. I wanted to capture what those lives were like off the track and how that intersected with this mix of counterculture and extreme sport.

My pilgrimage to the East Coast Derby Extravaganza (then called ECE, now called ECDX) in 2008 changed everything for me. The three-day, three-track tournament hosted by the Philly Roller Girls draws a thousand skaters from maybe 150 leagues, and the adjacent swimming pool seems to contain half the attendees at any given moment. It was wild and crazy.

I was struck by two things: The first was how tightly knit this world was. Women from all different parts of the country—from all different backgrounds—got together for this annual pilgrimage to play derby. Relationships and bonds were created instantly over nothing more than their shared passion for this strange combination of counterculture and competition. It felt like a burlesque troop meets a religious revival.

Second was the dichotomy of these people's worlds. "You do what? And then you do this?" It blew me away that, wait, you can be mom, a lawyer, a wife, a girlfriend, an executive, a minister, an Olympic athlete, and then put on fishnets and kick the tar out of people. And you get a paying crowd, and, oh, then you all party with each other. This spoke to the soul of something I've always tried to capture on film. What does identity mean? What defines us, or more specifically, how do we choose what defines us as individuals? I'm particularly fascinated by how people create communities outside of societal norms.

I can't claim that I was interested in photographing the *sport*. While the action on the track was inspiring, I became absorbed by discovering who these people really were. In order to discover that, I needed to become one of them. I would have to skate myself.

Andrea, my assistant that day, thought I was crazy, but to me it was just logical. I was always an athlete, involved in tennis, skiing, and particularly basketball. At the time, I was playing street ball as part of the Urban Basketball League of New York City. But I could not skate at all. On a personal level, I thought it would at least be good for my health. Ultimately, I reasoned, I would gain access to this tight-knit community that would otherwise not let me in.

So I bought myself some skates, and Point N Shoot was born.

I was living part time in upstate New York, so I joined the Hellions of Troy. Upstate is a whole other world from Brooklyn. In Brooklyn, I lived in a lively neighborhood and was friendly with the guys from Street Codes, a local barber shop. They were my basketball buddies who I played with at the community center one night a week. One of the local guys, Red, said to me one day that he had not seen me in a while and he asked where I'd been. I said I spent some time upstate, which made him pull back with an expression of shock and awe. He said, "You spent time upstate?" And I said yes. He said, "For what?" And I said, "Roller derby." He said, "You did time for roller derby? What is roller derby? I never heard anyone doing time for roller derby."

I quickly learned that when one goes "upstate"—in the neighborhood I lived in—it meant you went to jail. No one at that time in that neighborhood had even heard of this thing called roller derby, and I guess he thought it was some sort of crime or athletic incarceration camp. Metaphorically, at least, there might have been some truth to that. Roller derby very quickly took over my life.

It took me six months just to teach myself how to skate. I met the most amazing women upstate, Sonic Euthanizer—my first derby wife—and Mathundra Storm. Both started at the same time I did, and I photographed them as new skaters. There was a lot of unexpected transition happening in my life then, and they were the people who supported me. If my original purpose was to skate so I could get access, the bug that catches everyone else caught me, and I quickly became committed to the world.

Coincidentally, other cirumstances in my life helped this along. When the economy tanked in 2008, the magazine world—and thus my freelance professional career and an independent photography company I had started—took a big hit. This so-called roller derby "project" became everything to me. Some sayings contain too much truth to ever become cliché, and as is often repeated, "roller derby saved my soul." Skating, hitting opponents, and sharing in this vibrant, passionate community helped me through a real rough patch.

In no time at all, I couldn't tell whether my derby career was leading my photography project, or if it was the other way around. There were long periods where I put the camera down and just skated and worked my tail off to support my leagues. After my first year, I returned to the city full time and transferred to the Long Island Roller Rebels. I also made some of the closest friends I will ever have for the rest of my life.

My roller derby career has been an amazing ride in which I was able to get on and off—as well as grow—as a photographer, as a storyteller, artist, and as an athlete. Along the way, I learned that my paternal grandfather had been a competitive artistic roller skater (and had loved the historic banked track Roller Derby). So perhaps this was meant to be.

There were many twists and turns as the project progressed. I never thought of it at the time as history in the making, but many things changed from the beginning of the project until the end, in addition to the fact that now I can skate. The men no longer are the simply the support staff but have leagues of their own. The women held the first international Roller Derby World Cup. Junior derby leagues are proliferating. Young girls who are not the typical high-school athlete are finding empowerment through athletic competition that exists in an environment accepting of all backgrounds, all sexual orientations, all lifestyles, all body types. How amazing is that!? I could travel around the world photographing all these newly inspired athletes.

Roller derby gives people a sense of belonging. It is a family structure of love and discipline. People want to be a part of something that they are passionate about. From the start to finish of my project, the sport has grown like crazy with, on average, a hundred new leagues beginning every nine to twelve months in the United States alone. As of right now there are more than 1,500 roller derby leagues worldwide, all clearly due to the grassroots, community-oriented, DIY spirit of the modern revival born in Austin, Texas.

With growth there is change, and I won't predict whether the sport will earn a spot in the Olympics or whether the grassroots-DIY spirit will fade. I am lucky to have experienced roller derby first-hand in the era that I did and lucky to have been witness to that transition in time of the culture and the sport. I have observed what the roller derby community gives to people and what the community means to people, and I have experienced it myself. I hope that this book gives you a glimpse of the passion, excitement, hard work, dedication, and joy of modern roller derby.

I will always somehow be a part of this community, and I will never stop skating. I think I might start a senior league called the Roller Wrinkles (thanks Meghan Rockey). We will tour the warm states in the winter, and instead of going to the bar after bouts, we will hit the early bird specials and be in bed by 7 p.m. Who's with me?

Andréanna Seymore
Point N Shoot
November 2013

FOREWORD

To the insider, roller derby is much more than a sport: It is a lifestyle. It is a community. It is a religion. It is the framework of our lives. The best description I've heard so far is, "Roller derby is like a gas, any space you give it to expand, it will fill it." It is not just where you get exercise. It is where you collaborate and build a business. It is a powerful network where you find the people you trust most in your life. And it is where you can easily find a used air conditioner.

Roller derby reemerged in Austin, Texas in the early 2000s as a self-taught, self-managed, grassroots revolution of women who for some reason thought that strapping on skates and playing a full contact game that they maybe saw on TV once was a good idea. And good idea it proved to be, as women (and later men) all over the country and then all over the world began to do the same as soon as they had a chance to hear about it or see it. It is a perfect combination of roller skating, full contact hitting (that weeds out the weak!), the camaraderie of a team sport community, and the quantifiable goal of winning the game. When you add in the nontraditional influences drawn from a punk rock-DIY aesthetic (and work ethic) and a strong, independent female voice, it is completely irresistible.

As you wind down from your college years, you realize that health and fitness are an important part of your adult life. But who says you have to rot on a treadmill? Come check out this new sport made for us, by us. You don't have to be able to skate! You can learn here in a safe place where you don't have to be self-conscious if you fall down. We are all learning together. This is a place where you can choose to be strong, athletic, and confident playing a sport made for "grown ups" who want to do our own thing. Where can I sign up?

Roller derby players need to have a touch of "crazy" in order to strap on skates fearlessly and play a contact sport with, in some cases, little to no athletic experience. Luckily this "crazy" is the same spark that visionaries possess to create and innovate; to take a risk on a gut feeling; and to believe in a dream, while having the work ethic to make it a reality. Roller derby players are revolutionaries, and that consistent spark each one possesses is why roller derby can exist and flourish.

Members are from all age brackets, and many leagues are proud to have skaters playing well into their fifties. In addition to playing and running roller derby, the skaters maintain their professional careers in diverse fields ranging from medical professionals, teachers and business owners to accountants, graphic artists and more. About the only thing everyone has in common is the roller derby.

It begins innocently enough when you show up and make it through tryouts (or if you joined in the beginning of your league ...you showed up. Period). But roller derby is much more of a commitment than just learning to roller skate. While we are balancing our day jobs and our families, we are juggling an intensely time-consuming hobby that is completely self-produced. The sport is owned and operated

by the skaters. The majority of the time you donate to roller derby goes into the off-track logistics of running a business, a business where every employee is a dedicated volunteer, and everyone is part owner. A typical roller derby league is made up of sixty to one hundred skaters and support staff. On our home turf, we have to produce and host our events, as well as skate and compete in them. We are networked with leagues and pay out of pocket to travel to play them. The athletic training is at least six hours a week, or, if you are in a highly competitive league, far more than that.

When we were children, our parents coughed up a nominal fee so we could play on the tee ball team. The local supermarket sponsored the uniforms, the coaches were parents, and there was a city park to play in. Our mothers and fathers still come cheer us on—even though we're adults—but we have to figure out how to fill hundreds of other seats with paying fans in order to afford to rent a space to practice in. Roller derby is fending for itself in a gray area: it's less popular than other amateur sports, but more organized than something like a punk rock show. We have found a spot for ourselves, but it is not an easy spot to thrive in.

Roller derby has grown successfully because of people believing in it and sharing it with others. It nutures its own growth. For the majority of leagues, most of the skaters have played for less than three years. Since the sport is still in its infancy, it is common for a veteran skater to travel to another league and lead a training event for the skaters there. Established leagues host training camps where skaters from all over come and learn the same drills that that league practices. There are no secrets in roller derby. Roller derby is always pushing the top level of high-quality play, but almost more important to the longevity and growth of the sport, the top players and teams are committed to educating and training the newer leagues and skaters. Imagine a world where you could go to a basketball camp with Michael Jordan. For those involved in roller derby, we can do just that: a rookie skater has the chance to learn directly from our sport's biggest names. We are a microcosm with our own heroes.

Once you *believe* in roller derby, you give all of yourself to ensure its success. The result is an organization that is built not with money as its backbone, but with blood, sweat, and tears. This key distinction defines what has built the sport thus far. Getting paid is not a factor. As a matter of fact, we pay to play; we pay to be a part of a league, we pay for our gear. Every one of those trips is funded out of pocket, or with money that we work hard to raise. Most importantly, anyone involved in roller derby is paying in personal time and love. Our lives become so intertwined because we give all of ourselves to this.

I have much stronger friendships with teammates with whom I share little in common except roller derby than with anyone else because we have built a level of trust in one another, a responsibility for one another, from pushing each other to accomplish incredible goals. We learned to be democratic and respectful of one another in a group of alphas. I have seen far more orderly, productive meetings in roller derby than in the corporate world.

It is not just the skaters themselves who believe in roller derby. A skater's biological family helps build the roller derby family. Our partners are either with us, or they disappear for good. Especially in the sport's early days, they become our bench managers, our referees, or simply our biggest fans. Being able to play roller derby requires full support from your family. Our children become our cheerleaders. Our parents are our number-one fans. There is the dedicated husband who attends every game to watch his wife, even if she is the least played on her team. Many of us have found our life partners here. Roller derby might seem nontraditional to outsiders but our internal community embodies traditional family values: commitment, support, hard work, and respect. Behind the scenes, our personal families share the burden of our roller derby lifestyle by sacrificing personal time together to practices, commitee work, off-track events, travel, and of course bouts.

The big payoff in roller derby is the culmination of all the hard work—the bout. All the countless hours of volunteer work are forgotten. You are now in an alternate world where there is nothing

else to think about but this single hour on the track, and the ultimate reward—winning it. We are extremely invested in the few bouts we get to play in. We become professional athletes: driven, focused, and hungry for victory. There is no money at stake: No salaries, no contracts, no bonuses. We do it for the thrill of competition and the rush of aggressive physical gameplay. Well...and for the bragging rights. We live for this all-too-brief escape from the rest of our lives. We can choose to put on warriors' face paint, crazy colored stockings, or wild makeup—or we can choose to look the same as we do at work on a Tuesday afternoon. It is different for everyone. You choose. There are no rules.

Why do we do it? Why do we hemorrhage countless sums of money, sacrifice our bodies to risk of injury, and put everything else second in our lives? We do it because everyone takes the plunge together. This is a team sport. Those involved are immediately team players, and success on and off the track comes from working in concert. It is possible to believe in it, because we all believe in it together. We have confidence in this because we are are equally invested through the sacrifices we have all made. In order to be successful in something you truly believe in, you must put everything else in your life second. It is the love that others around us gave us that built roller derby; it is our love for one another; it is the comfort in knowing that we all gave up all our free time, all our money, all our healthy knees, together!

Love built roller derby. We wear our hearts on our uniform sleeves. You see it in the tears of the victory celebration, the tears of failure, and the tears of physical pain. Those tears are not about just that one moment in time. They are the landslide of emotions born of everything that took place behind the scenes, everything that that made that moment happen, that brought the game into being. That moment, each moment, is the culmination of each participant's investment in this thing we love, whether that person is a skater or official, support staff or fan. Imagine celebrating a game-winning victory on the same track that you yourself had mopped a week before. Roller derby is a labor of love, but the love is what makes the labor worthwhile.

Modern roller derby is a precious, untouched world right now where *We* are still in control. I do not know if that will remain, or if it will drastically change. Larger sponsors could enter our world. The sport has received mainstream attention in movies, television, magazines, and social media. What does that mean for the future? All I can say is the snapshot of what it is right now is how I always want to remember it: a sport built out of love and sacrifice. When you experience these captured moments—a team's celebratory scream, an injured skater bravely holding back tears, the focused look before a game begins, a playful laugh in the locker room—know that all these emotions and moments are rooted in the sacrifices we have made to build a sport we love together.

Suzy Hotrod
December 2013

I never had many *girl*friends, or such a diverse group of friends, until roller derby. I had grown so close to these ladies in a *very* short period of time. We had pushed ourselves and each other beyond what we thought we were capable of, and it had paid off. I not only see roller derby teammates, but I see a lawyer, a park ranger, a papermaker, a book editor, a private investigator, etc. The sport is made up of every shape, size, education, background.
— *Papierschnitt, Gotham Girls Roller Derby*

Derbytaunt Ball, 2008

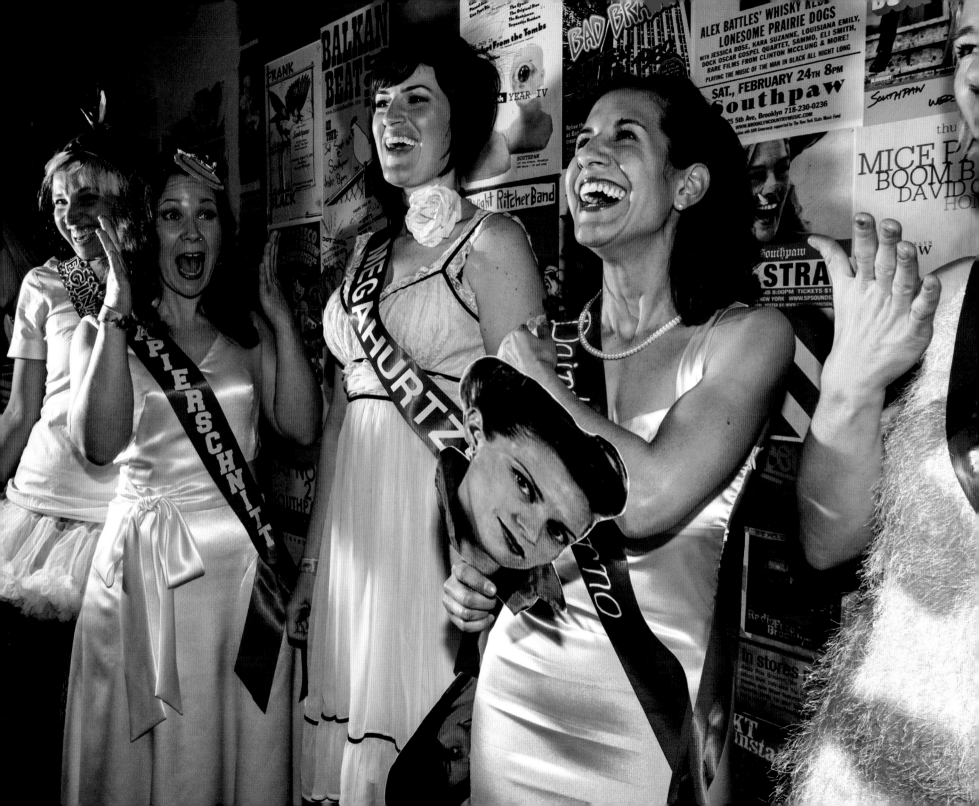

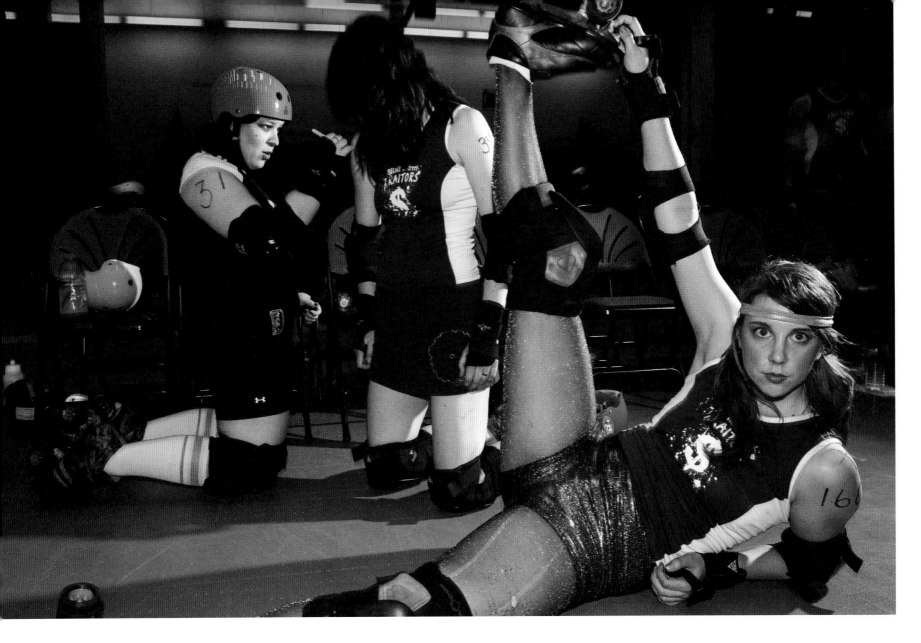

Barbara Ambush,
Wall Street Traitors, 2008

"I grew up loving all things that were shiny and gold and glittery—that there was a space to bring those elements into sport was initially very enticing to me. I have a particular memory of enjoying the Wall St. Traitors because it was such a tongue-in-cheek team name/theme and many of us enjoyed working it with tons of gold spandex and makeup. Our coach was 'David Lee Roth IRA'—how genius is that?!

"My current experience in derby is very much grounded in discipline, work, athleticism, and competition. I wear whatever allows me to stay cool and move, and tights and plastic hotpants are no longer a part of the equation—not that they can't be, but that's no longer how I roll."

—Barbara Ambush

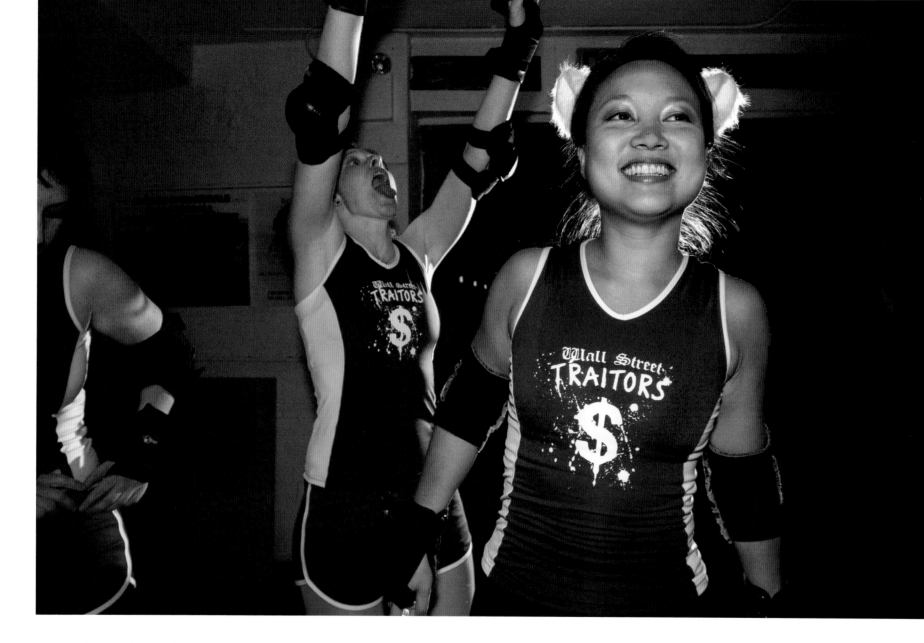

"It was always a huge adrenaline rush right before the game when you would hear the crowd scream for your team. I always fed off that noise, it pushed me to work even harder. I'm guessing from my ridiculous facial expression that I was bursting with nerves and excitement. Getting ready in the locker room is usually a time for everyone to individually prepare themselves mentally. For some people that is being quiet and thinking about their goals for the game or reviewing strategy. For me, I would usually chat with my teammates and listen to music to dance some of the jitters out. It always made me feel more calm before the game."

—*Lil Red Terror,*
Wall Street Traitors

Untitled, 2008

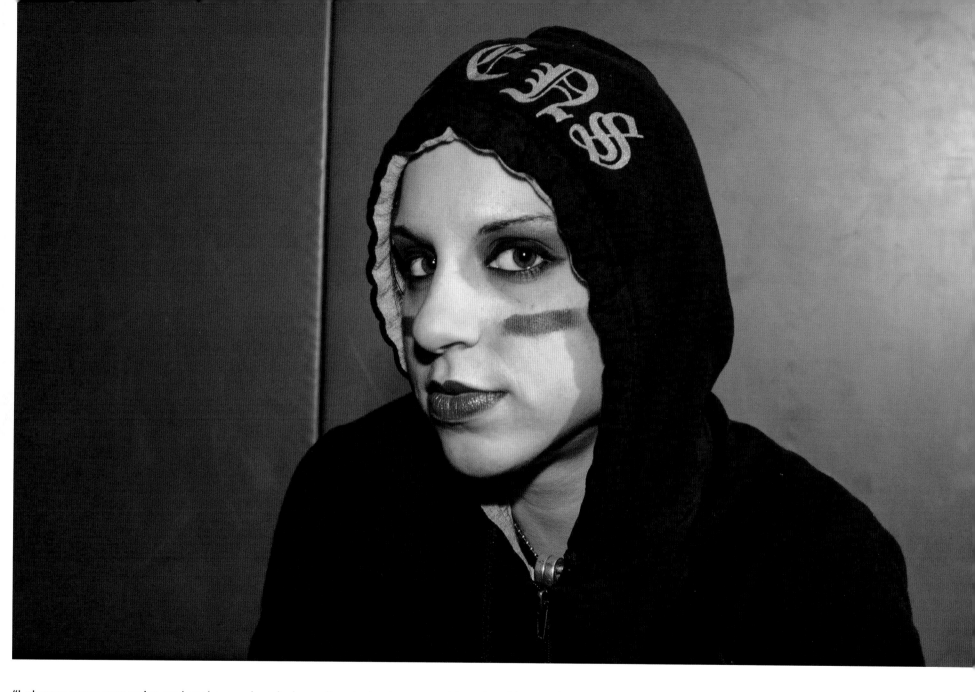

"I always wear war paint and makeup when I play roller derby. I am an athlete, but I just so happen to like to wear makeup when I am playing in the game. Roller derby has become increasingly athletic and serious, but there are still skaters who choose to be playful with makeups or uniform accents, and I think it's great that we have both elements of athleticism and style in our sport."

—Suzy Hotrod

Suzy Hotrod,
Gotham Girls Roller Derby,
2008

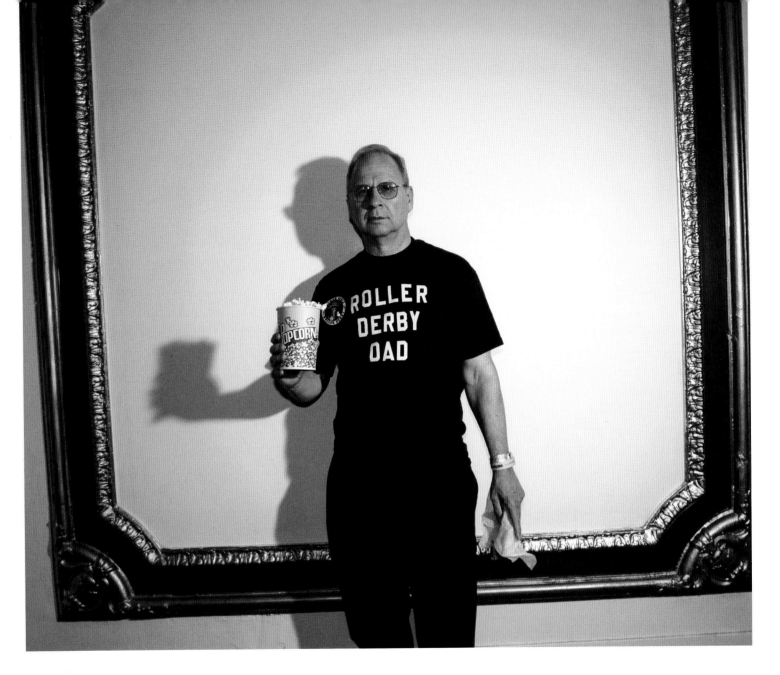

Roller Derby Dad, 2008

"My dad and mom are both devout roller derby fans and come to every one of my games, even the far-away, out of state ones. They are crazy and won't fly, so they have driven A LOT for roller derby. My dad doesn't have a derby name but I made him this shirt my first season skating, and I love how it is anonymous. He's just Roller Derby Dad. We're so lucky to have a lot of dads come watch us play. I know almost all of my teammates' parents."
—Suzy Hotrod, Gotham Girls Roller Derby

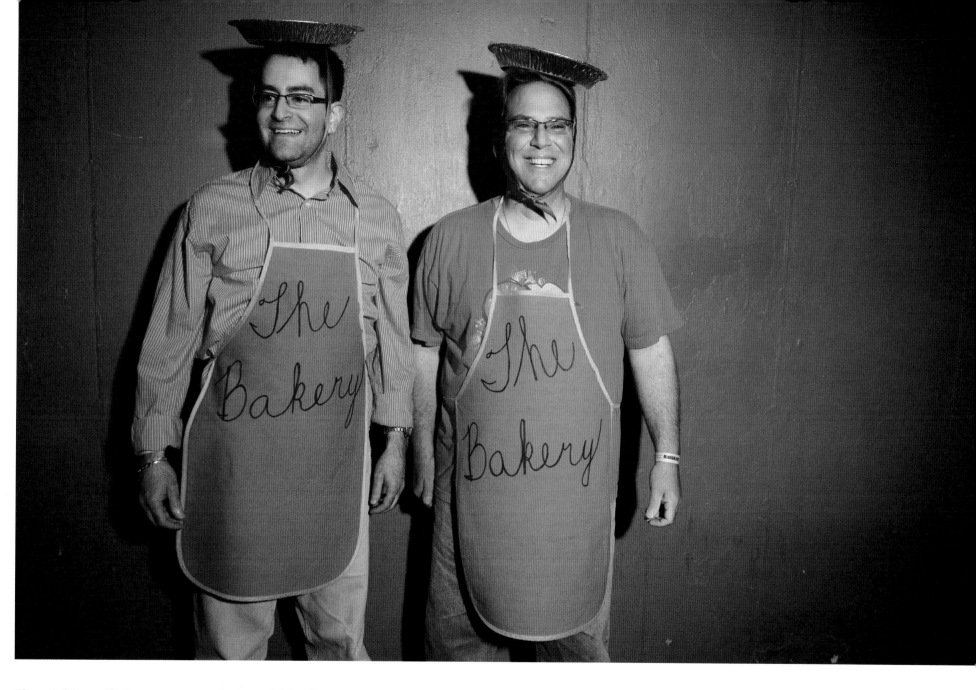

"Sweet Sherry Pie's parents, our very good friends, came dressed as Pie Makers and we were part of the support team. It was our first roller derby match, and we were asked to come down at half time and help cheer for the Manhattan Mayhem. I was embarrassed. Bill kind of liked the attention. I think both of us figured after it was over, no one would know who we were and no one would remember these two middle-aged men dressed up for roller derby."

—*Dr. Kevin Slavin & William Koumas*

Sweet Sherry Pie superfans, 2008

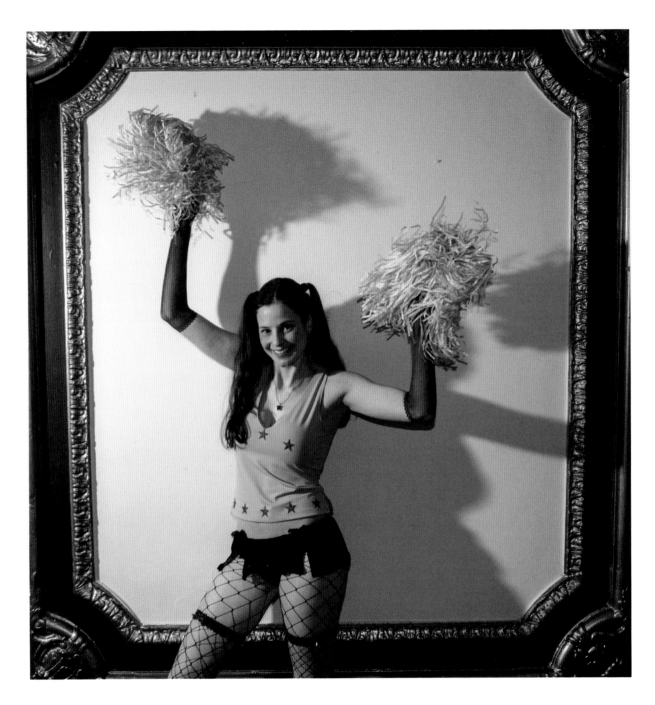

Crazy Cara,
Philly Roller Girls
cheerleader, 2008

"It's really amazing what gold tassels and a can of spray paint can do."
—*Crazy Cara*

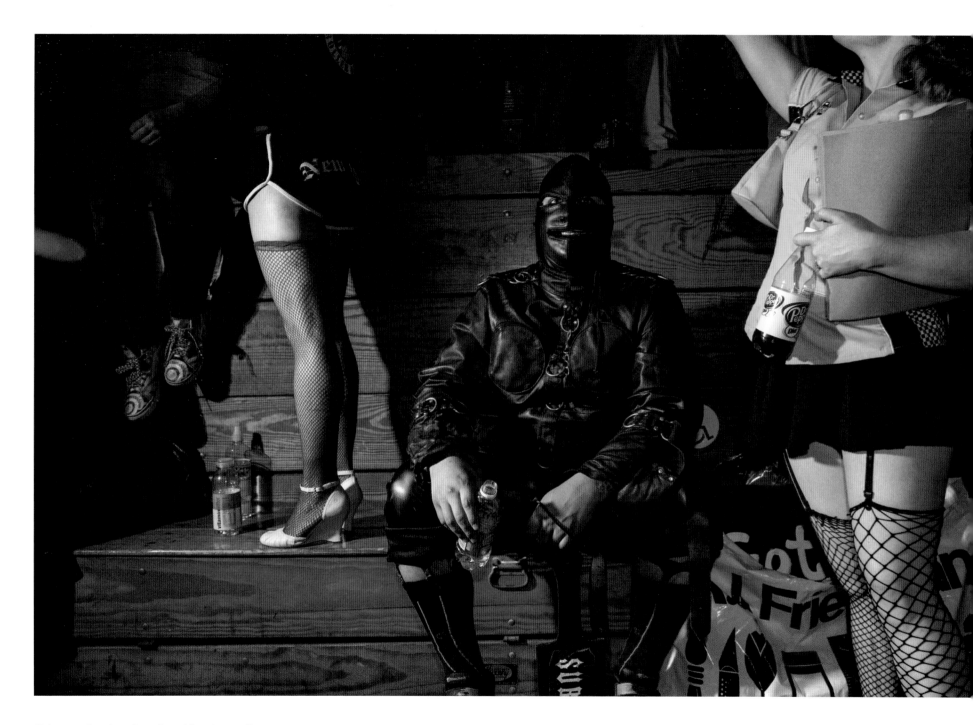

"Mascotting is a hot, hard business." —*The Persuader*

The Persuader,
Queens of Pain mascot, 2008

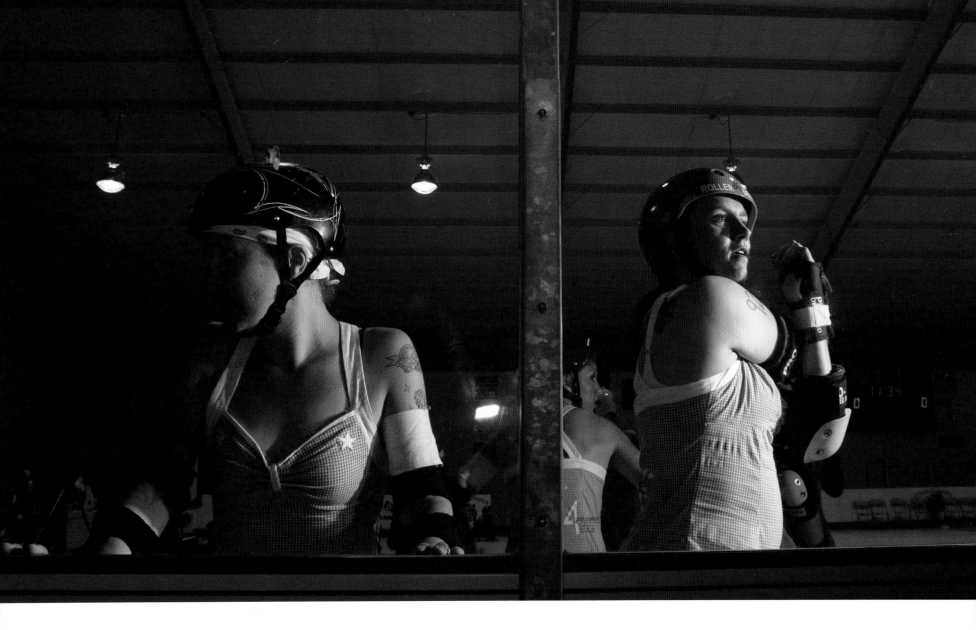

Crackerjack and
Dolly Pardon Me,
Mad Rollin Dolls, 2008

"Stretch, stretch, stretch. Moo, moo, moo. It's hittin' bitches time!" —*Crackerjack*

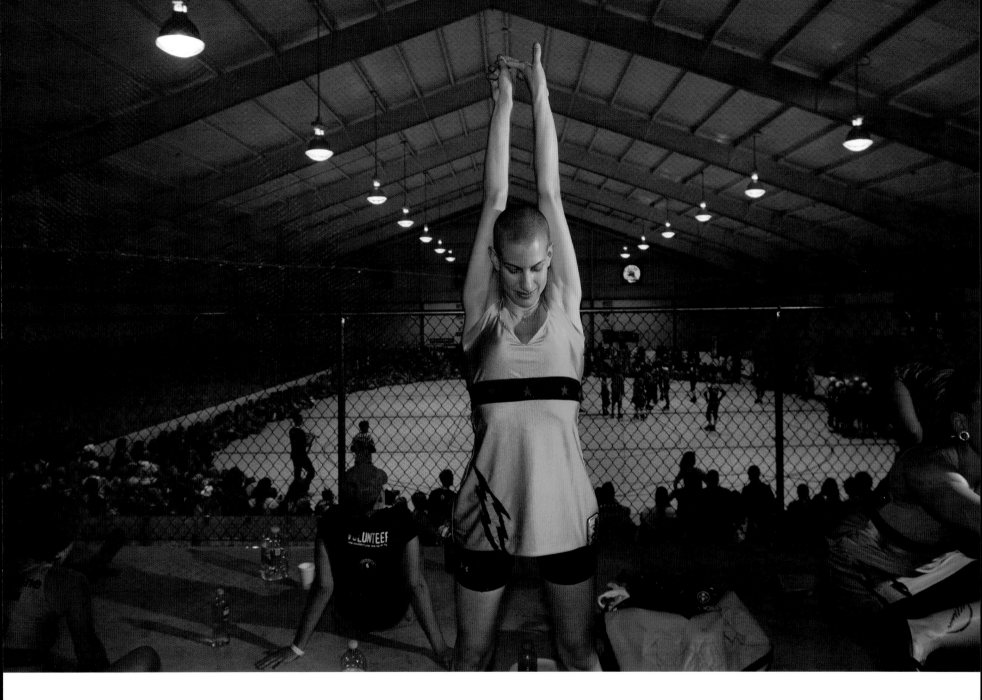

Mo Pain,
Philly Roller Girls, 2008

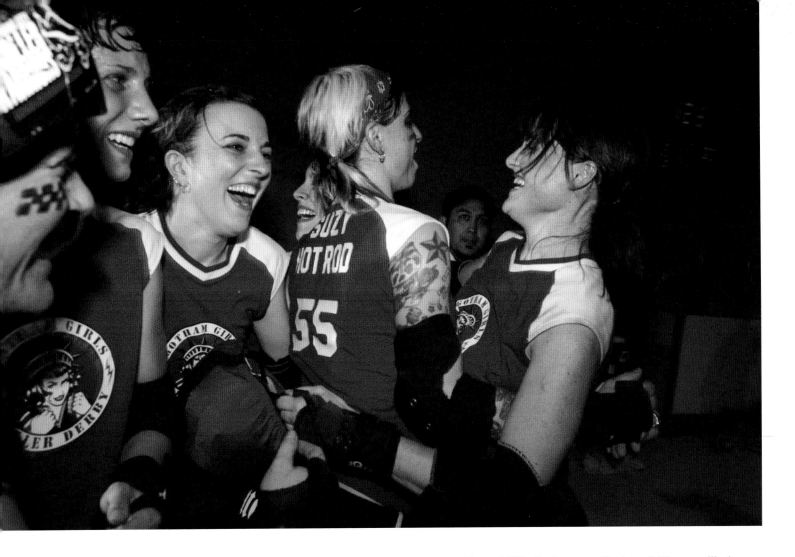

The Upset, 2008

"Everyone is beat-able. Who's the next Texas? Who's the next Gotham? There will always be a next 'someone.' This sport isn't going anywhere."

—Ginger Snap, Gotham Girls Roller Derby

"We were the underdogs in that bout for the last time that season... and for a long time since."

—Beatrix Slaughter (aka Bunny), Gotham Girls Roller Derby

"For a few years we were really superstitious about wearing red, so whenever we had to wear red after this game Buster Cheatin would remind us, 'We beat Texas in red!' to unjinx ourselves."

—Brigette Barhot, Gotham Girls Roller Derby

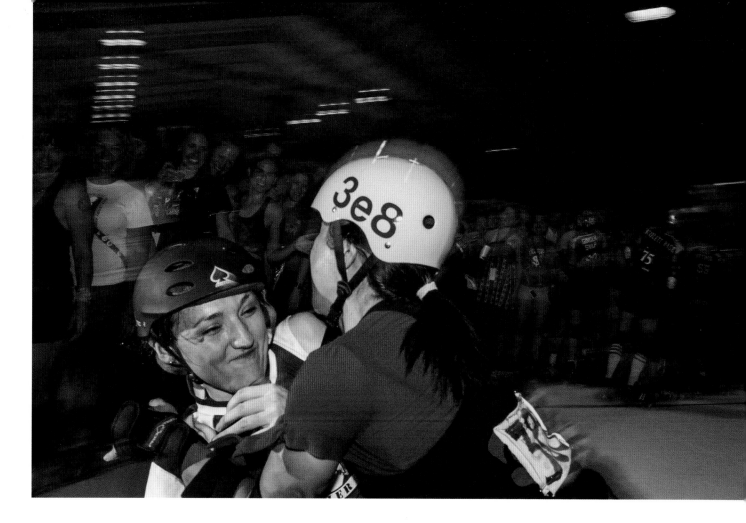

"A major turning point in modern roller derby. Wrestling used to absolutely be part of the game and a legitimate 'strategy' a team would use to stop the opposing jammer from scoring points. We used to practice 'safe' takedowns, and dogpiles were common at bouts, which were played at roller rinks in the dark. Penalty wheels were spun at halftime; pillow fights, bowling, match races—they were all fun things to do on roller skates, so why not incorporate them into bouts?

"Of course things changed, and changed for the better. A lot of that naturally disappeared as we learned how to roller skate and actually play roller derby. We started turning the lights up, jammer takedowns were frowned upon before they became outright illegal (though more for insurance reasons than through the democratic rules process).

"This game was the first time I played Texas as a member of Gotham. There was still a lot of ties to, and a bit of nostalgia for, where we had come from, so Rice Rocket and I had a good old-fashioned wrestling match on the floor. I think some of my new Gotham teammates at the time might have been a bit scandalized. I think at any later date that wouldn't have been tolerated. But it was fun to goof off. A last nod to the old days."

—*Fisti Cuffs, Gotham Girls Roller Derby*

Old School, 2008

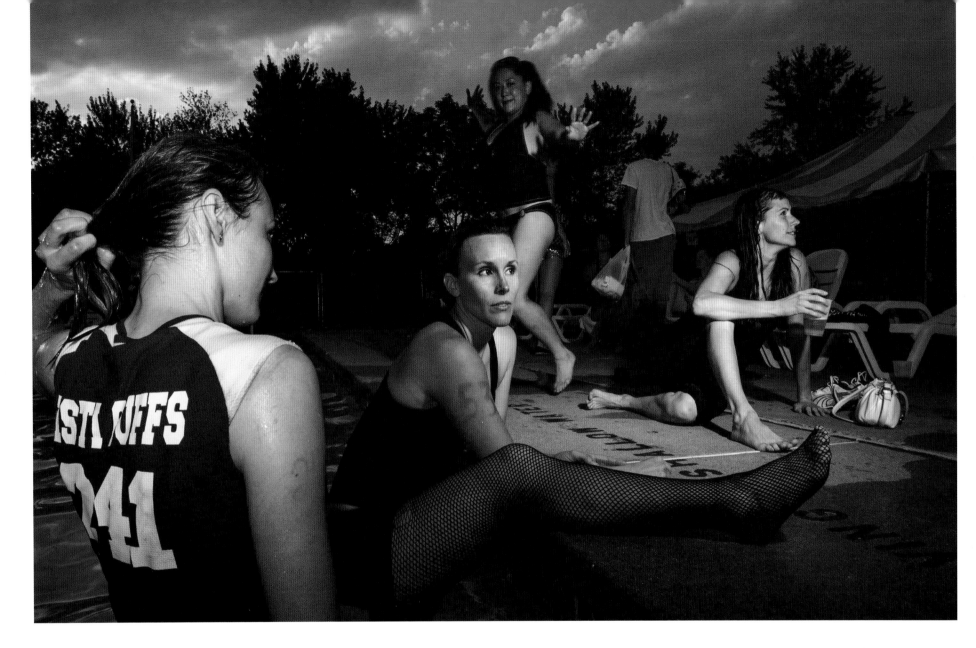

East Coast Derby
Extravaganza,
2008

"We had just lost and I know I was disappointed about that loss—it was the first Texas loss by that margin, but I also remember soaking in this new adventure of roller derby and meeting new people. No matter what happens on the track, once the game is over we can all meet at the pool or after-party and bond over a common love of our sport.

"Teammates retire or change—I never thought my teammates would retire or that I would later be teammates with Fisti. The sport continues to evolve into a more competitive game; each year after that roller derby became smarter and more athletic. But the culture at its core is still the same. That culture is camaraderie; ultimately, we are all on the same team."

—*Vicious van GoGo, Texas Rollergirls*

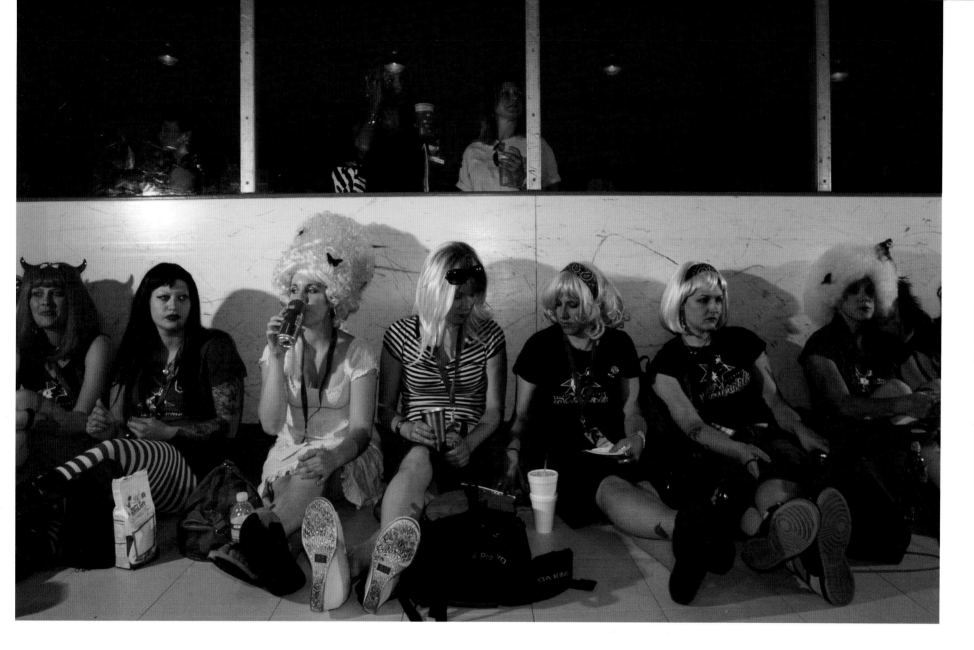

"Teamwork makes the dream work!" —*Anne Shank, Rocky Mountain Rollergirls*

Rocky Mountain Rollergirls,
East Coast Derby
Extravaganza,
2008

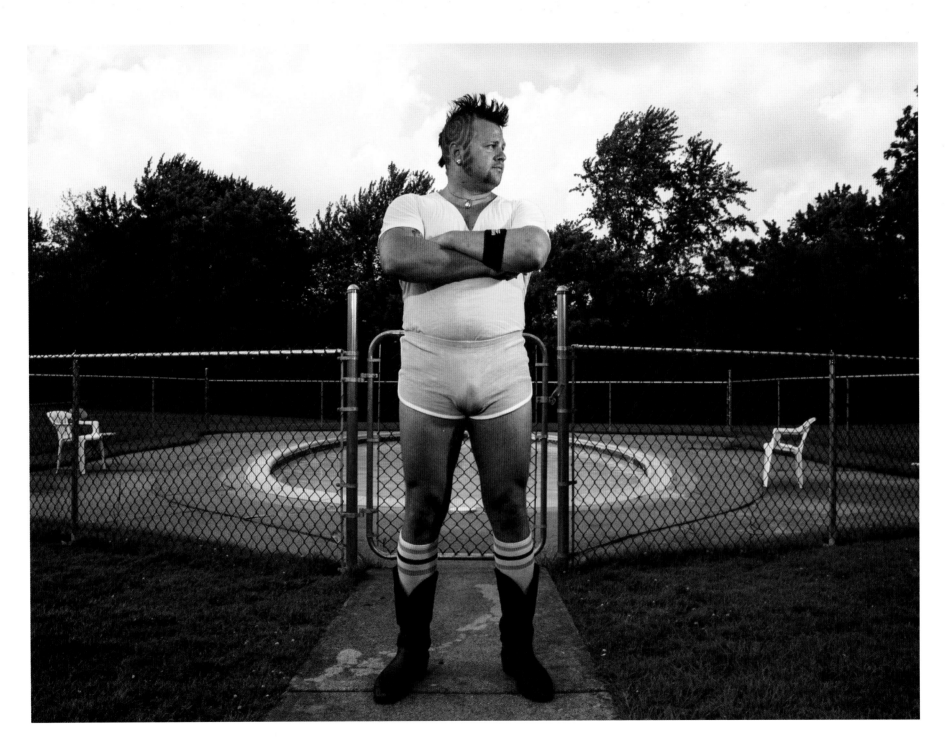

Dumptruck, announcer, 2008

"Pants are for people with something to hide." —*Dumptruck*

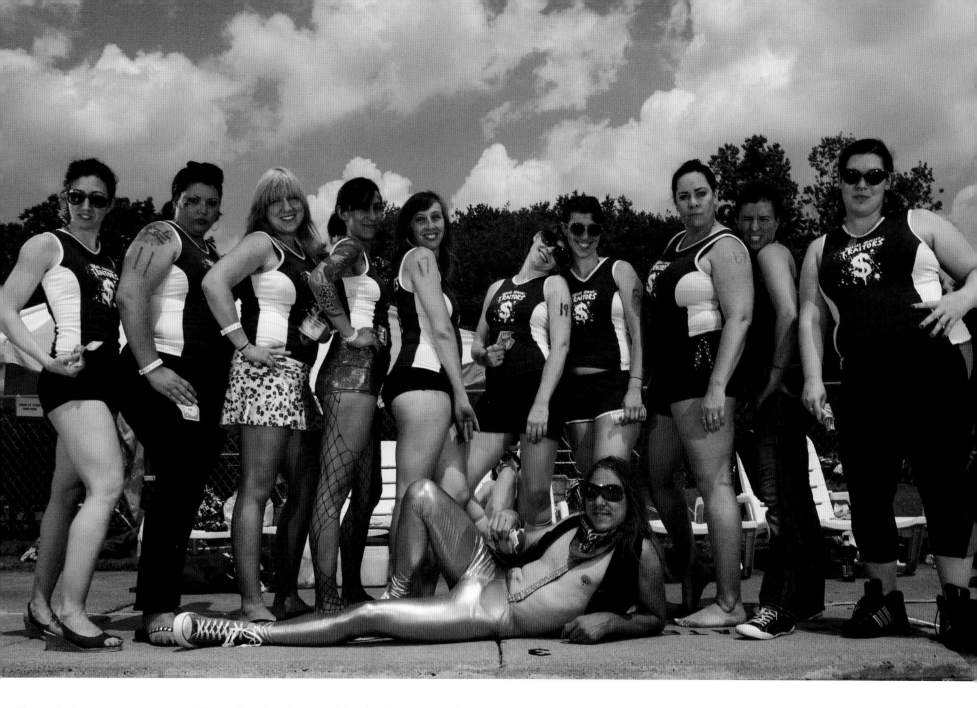

"I am glad there are so many different levels of competition in the sport, and teams like the Wall Street Traitors have not fallen by the wayside in favor of a league strictly supporting only their all-star team. I am also very pleased that the sport has not totally given up its love of a good pun."

—*Chassis Crass, founder, Gotham Girls Roller Derby*

The Wall Street Traitors,
East Coast Derby
Extravaganza, 2008

"The change between then and now is that now I have a plate and a few screws in my left ankle, but the bruises—especially bruises in those locations—are still the same.

—*Papierschnitt, Gotham Girls Roller Derby*

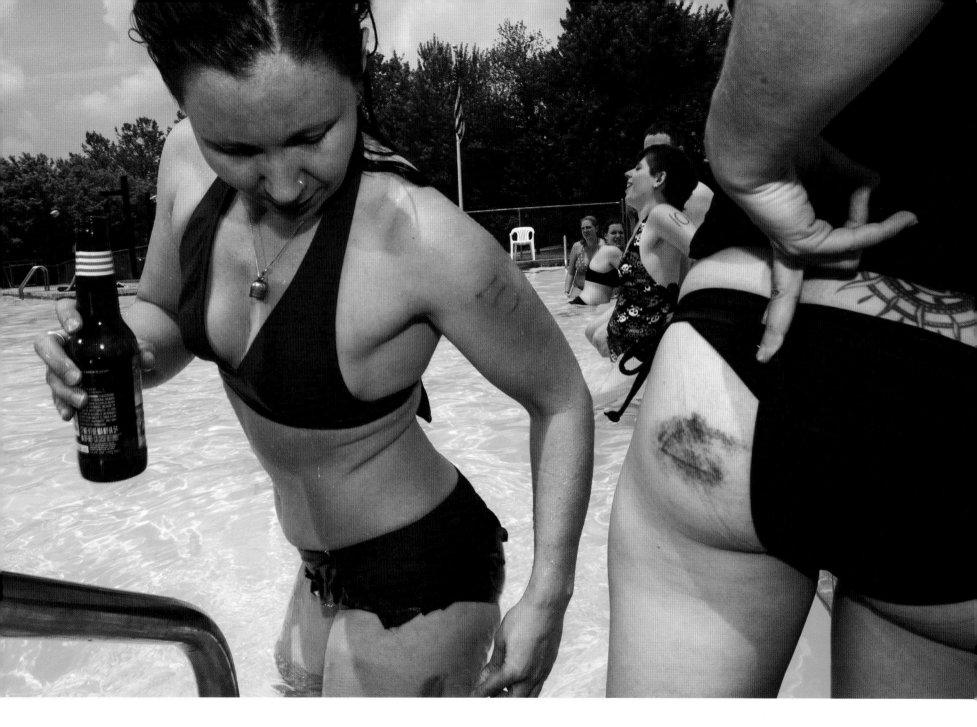

Scars and Stripes, 2008

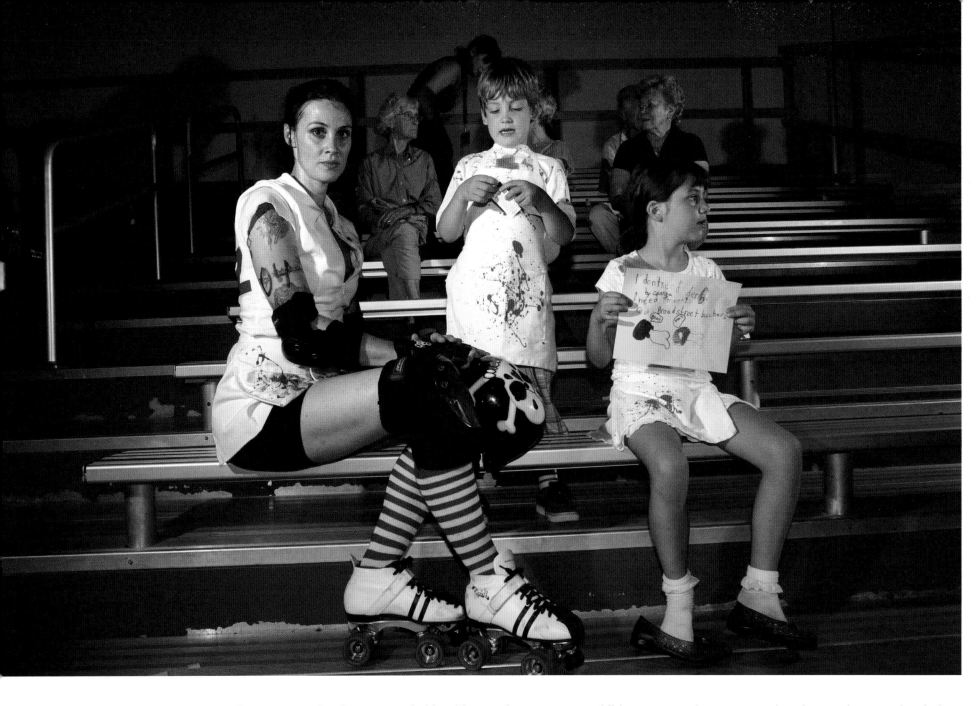

Leggs Benedict,
Broad Street Butchers, 2008

"I am so proud to be surrounded by this amazing group: my children, my mother, my grandmother, and my mother-in-law. My father-in-law and husband are there as well. I am so grateful for their support and the support of my husband when, at the tender age of late thirties, I decided to try something new."

—*Leggs Benedict*

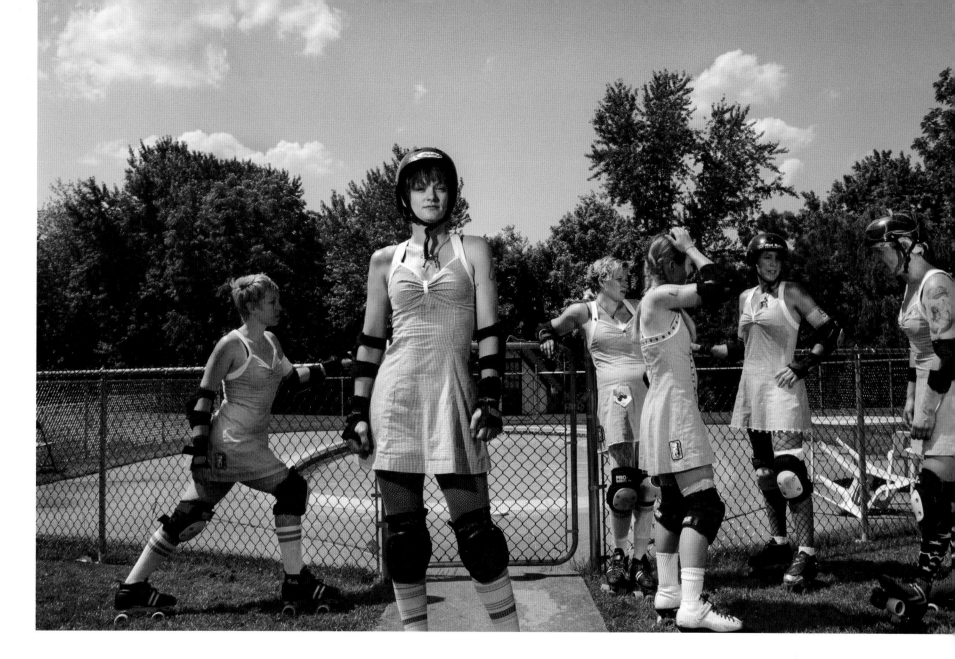

"I have often mused that while there are new and amazing opportunities for derby skaters, I woulnd't trade being around in the beginning for anything."

—Chop Suzzy, Mad Rollin Dolls

"People still talk about the dresses in the pool. Legen-dairy. I still skate for Dairyland Dolls, telling boring stories about the good ol' days to whomever is stuck in the penalty box with me."

—Mouse, Mad Rollin Dolls

Mad Rollin Dolls,
East Coast Derby
Extravaganza, 2008

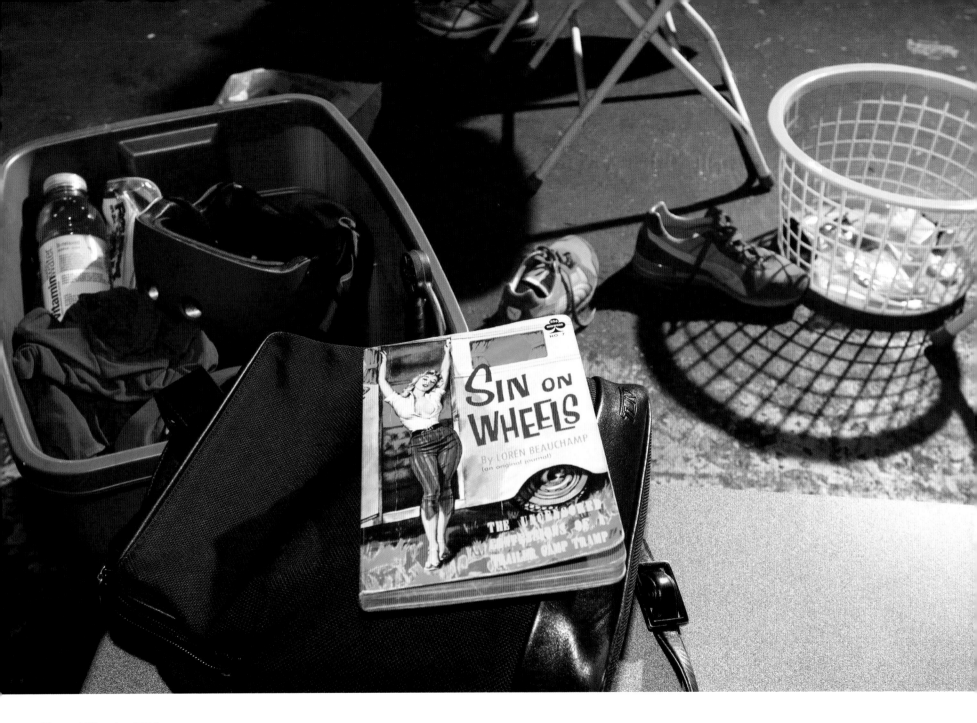

Sin on Wheels, 2008

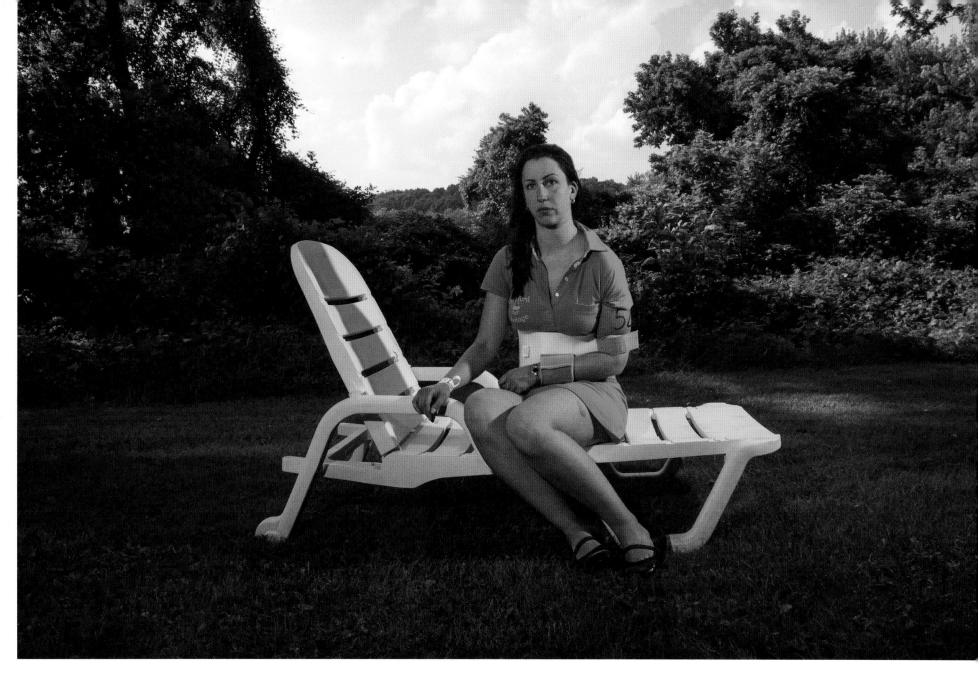

"Everyone always said it's not *if* you get injured but *when*. I had experienced the injuries of so many girls, but I naively never thought it would happen to me!!

"I never skated competitively again after breaking my collarbone in Philly. I knew girls who broke theirs, had surgery and got right back to skating. I knew then that this was it for me."

—Tina Colada

Tina Colada,
Connecticut Roller Girls,
2008

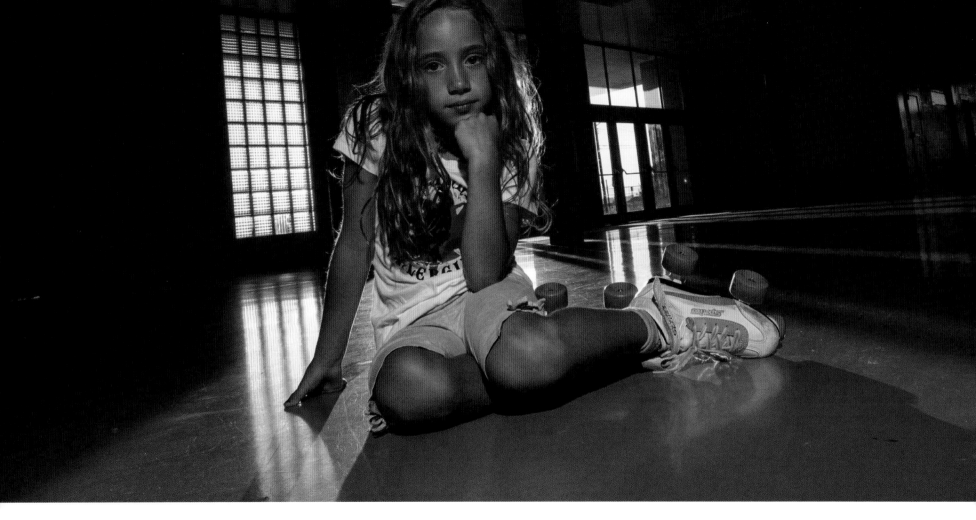

Sugar, Cincinnati Gardens
(Cincinnati, Ohio), 2008

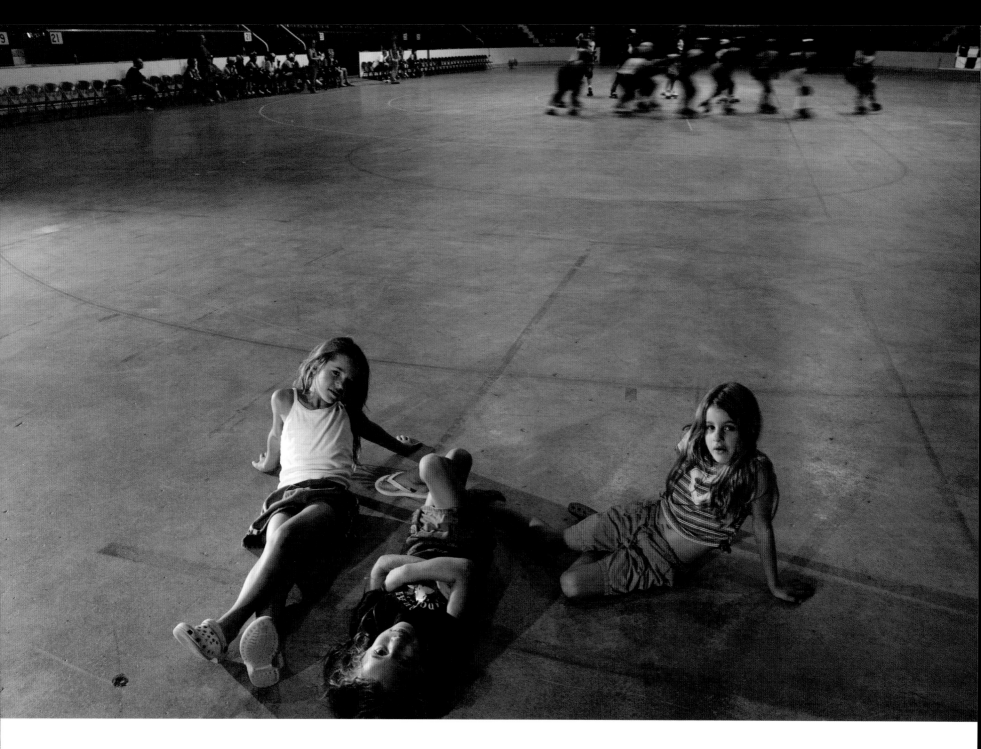

Practice, 2008

Leigh Steck,
Delta flight attendant, 2008

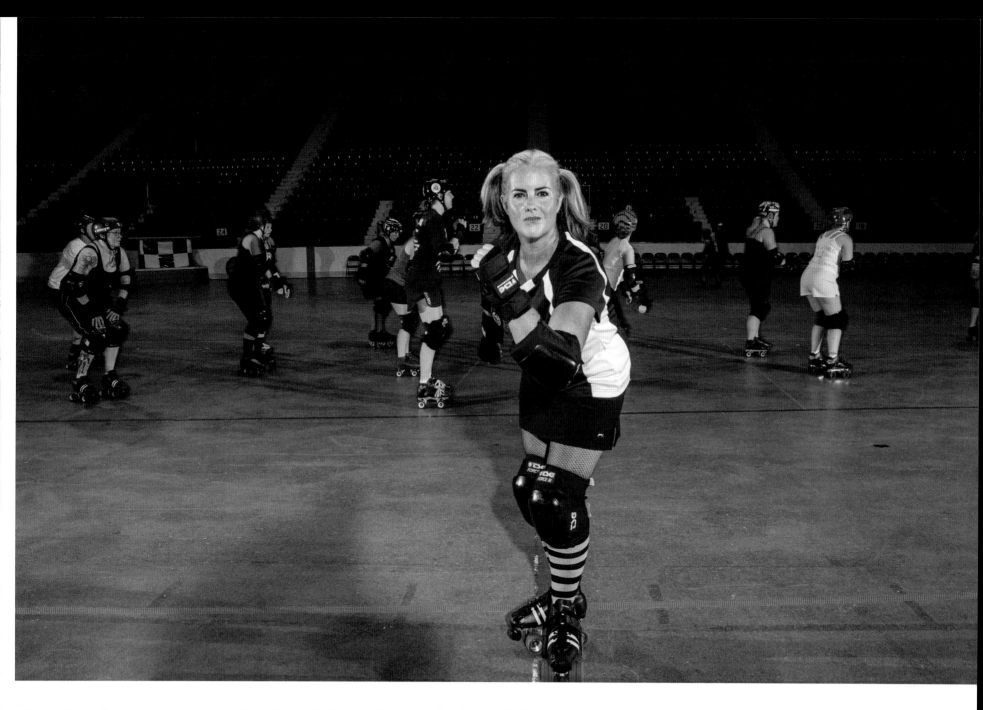

"Many players lead two very separate lives. In the derby world you need to be tough, fearless and strong on the track. In my life as a flight attendant I am assumed to be welcoming, friendly, and helpful. It is sometimes hard to separate the two. I will never forget my first year when my coach pulled me aside and said 'Fight, I need you to get hold of your inner aggression!' My reply, 'It's hard, I've been thanking people for their trash for eighteen years. Wait a minute, that should piss me off!'"

—*Fight Attendant*

Fight Attendant,
Cincinnati Rollergirls, 2008

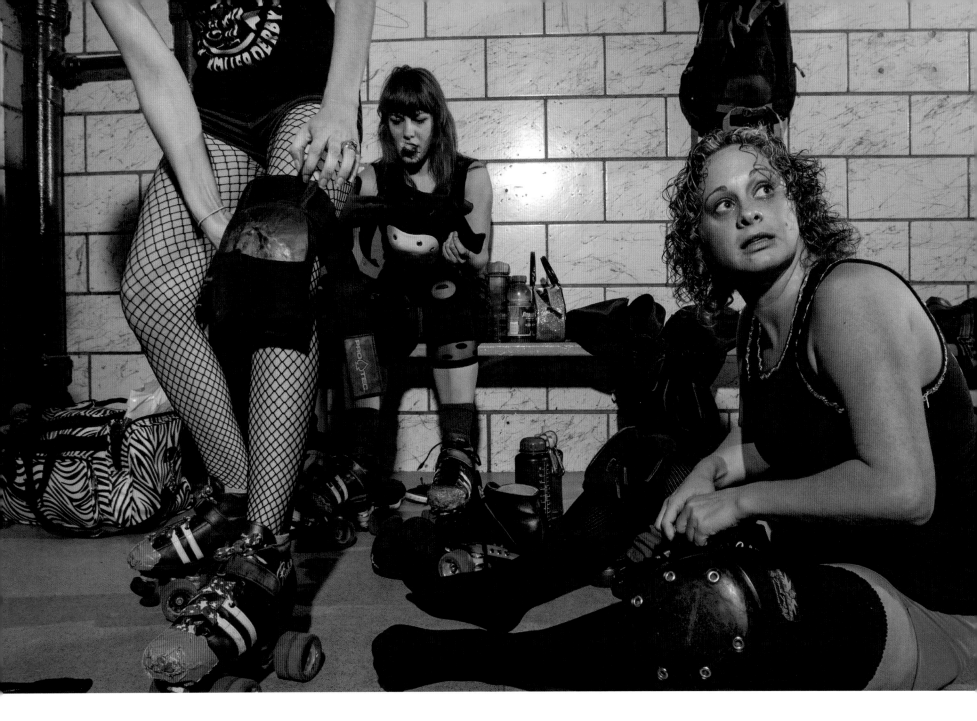

Locker room,
Roller Consolation
New England, 2008

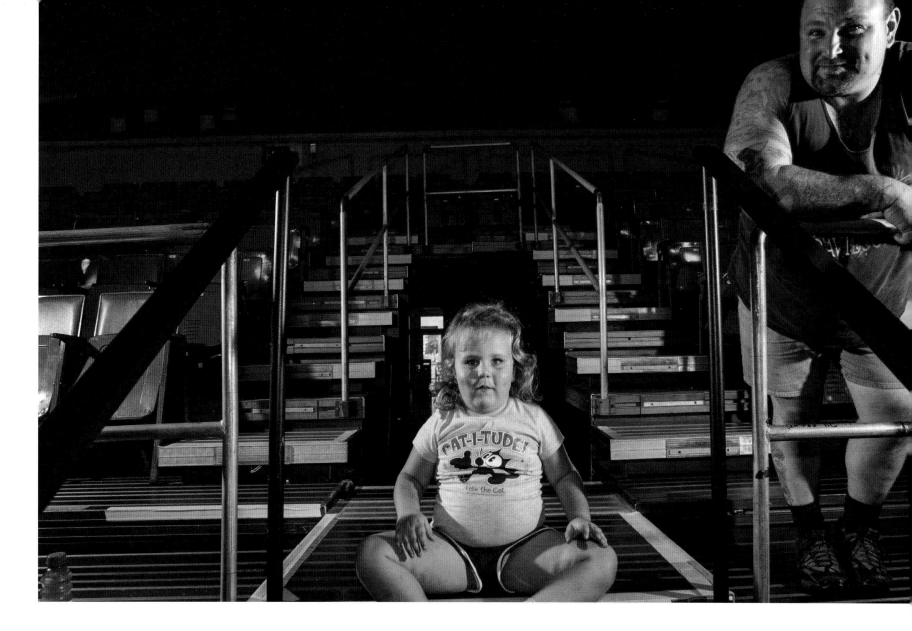

"Skating began for me at age seven. My cousin Jerry was taking lessons. I distinctly remember leaning against the half-wall watching and thinking, 'I can do anything a boy can do, and I can do it better!' But I was signed up to learn the waltz and tango and fitted with artistic skates, denied the chance to speed-skate. Guess I showed them, thirty-some years later.

"I guess if my daughter were a bit older, and this were current, she might be skating with a junior team, but that doesn't seem to be her thing. I'm totally okay with that. *But*, she's not sporting a dance tutu either. She's at home in the dojo, sparring with boys and girls of all shapes, ages and sizes. I hope that my playing derby has something to do with her feeling free, not feeling compelled to conform to society's concept of gender."
—*Blaze, Assault City Roller Derby*

Peanut Butter Punch,
age 4, 2008

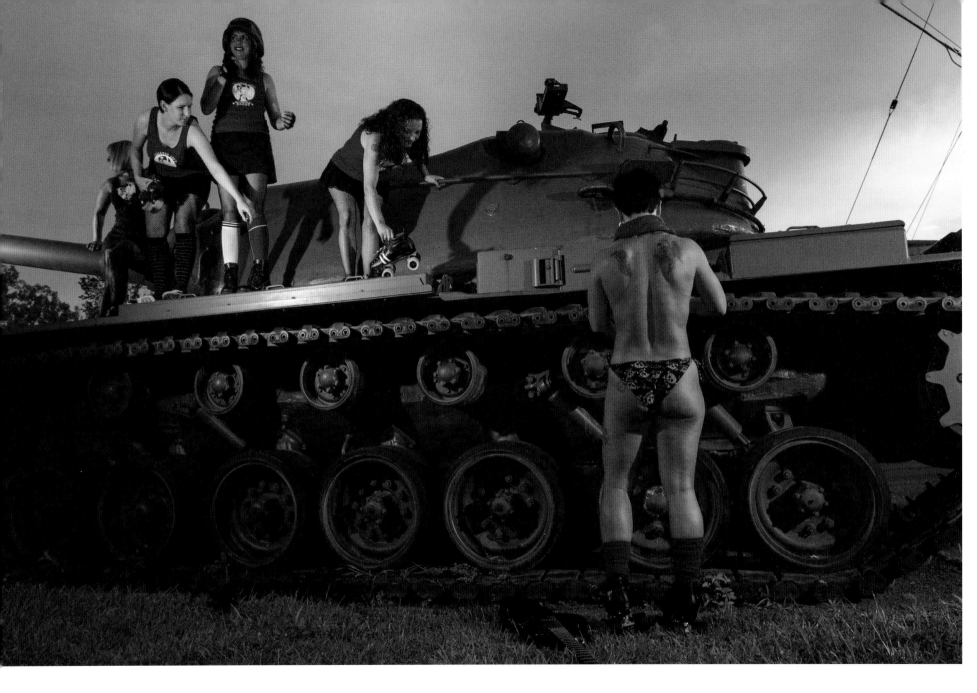

Assault City Roller Derby
(East Syracuse, NY), 2008

"My first photo shoot with my team. I was a bit worried about my teammates' reaction to my exhibition. Later, as I deepened my relationships, I realized that the women who had the type of character I appreciate didn't mind, and the others didn't matter.

"A part of derby is dying: the show. We came to recognize that if we wanted to be respected as athletes we had to play that part. We learned to save the zany, bizarre stuff for after-parties."

—*Blaze, Assault City Roller Derby*

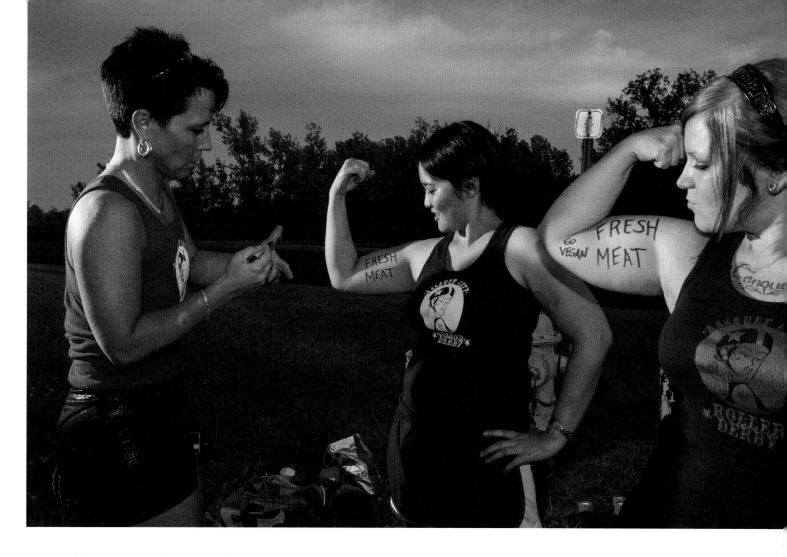

Fresh Meat, 2008

"It was great to be among all these strong, beautiful, and hilarious women. Roller derby helped me to make new friends, and I got more involved with the community through service opportunities, appearances, and social gatherings. The women on my first team became my adopted family. It also jump-started my fitness routine and helped me to maintain a healthier lifestyle.

"My family was proud but always nervous of the potential injuries. New relationships outside of the roller derby community were difficult because of the time commitment. But I work in a college setting so students and employees loved that I was on the team. They would come out and support me at the bouts.

"Roller derby has taught me about self discipline and working hard to get results. It provides confidence, a sense of belonging, and a desire to constantly improve. I believe roller derby provides inspiration for young girls and women. I think it also helps to dispel myths about the women in roller derby... there were lawyers, counselors, scientists, nurses, educators, and doctoral students on my team."

—Dino Cakes, Assault City Roller Derby

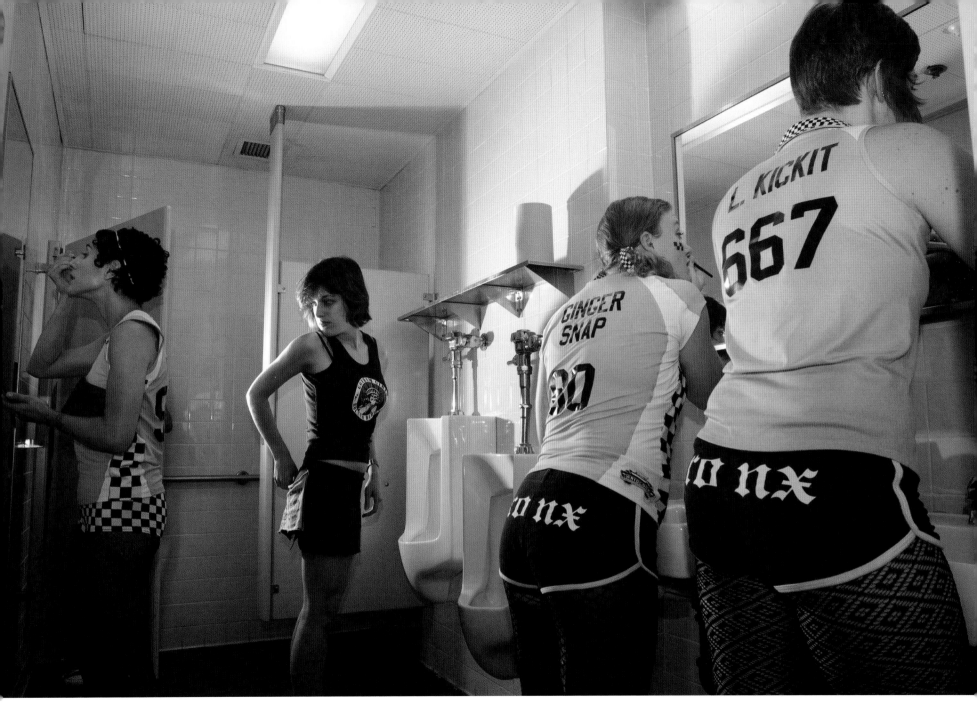

Bronx Gridlock, 2008

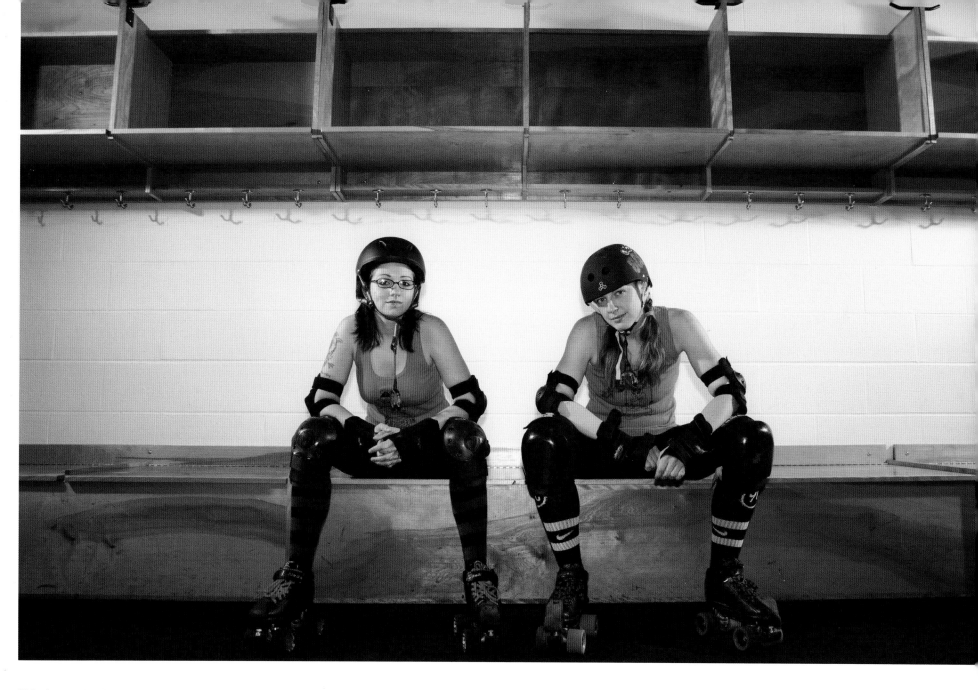

"It's funny. I tell people I used to play roller derby, and they think I'm a badass. I'm really not, and people are always surprised that I used to play. Roller derby really gets you out of your shell. I was always shy and awkward. Roller derby really gets that right out of you."

—Nikki Sixx Shooter, Assault City Roller Derby

Nikki Sixx Shooter and
Pussycat Proulx,
Prison City Pinups, 2008

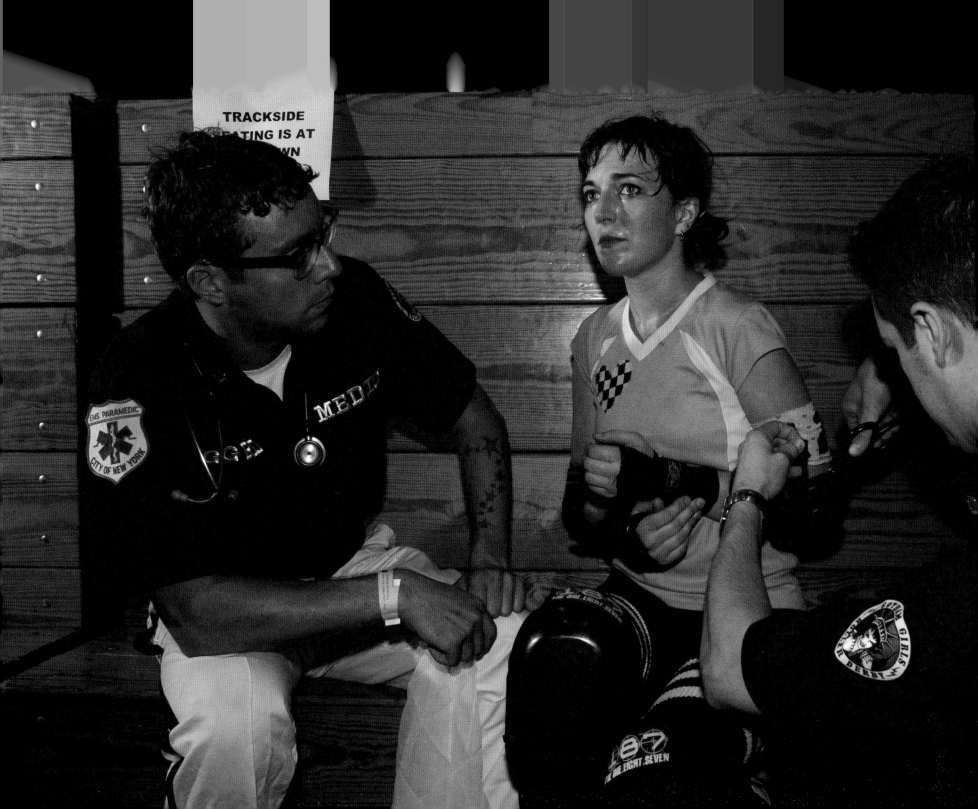

> "I rarely, if ever, saw a skater cry. Although B looks as if she is about to, I'm sure she stifled it. These ladies are tough. I saw a lot of spills and bruises and bumps and scrapes and a lot of *big* crashes, but very rarely did one of the skaters want to take a shift off. Beatrix is clearly in some pain, but I'm sure she'd have been on for the next jam if she could have been."
>
> —Andy Biotic, Gotham Girls Roller Derby medic

> "It was the best game of my career. I was less than ten points at that moment from breaking the Gotham record for most points scored and our team was in the lead against our arch-rivals the Queens of Pain.
>
> The hit was legal. And it fractured my collarbone. I was worried about when I was going to get back on the track more than anything else, that night and for the rest of the season. We had Regionals and Nationals to win that season, which sadly I had to sit out.
>
> I've often felt (as many have) that I've been martyred by derby: It's such a life-changing phase with so much pain and ecstasy, and you sacrifice yourself happily for the cause. I still don't know if it was hell or heaven, but it was worth every moment."
>
> —Beatrix Slaughter aka "Bunny"

Beatrix Slaughter, Bronx Gridlock, 2008

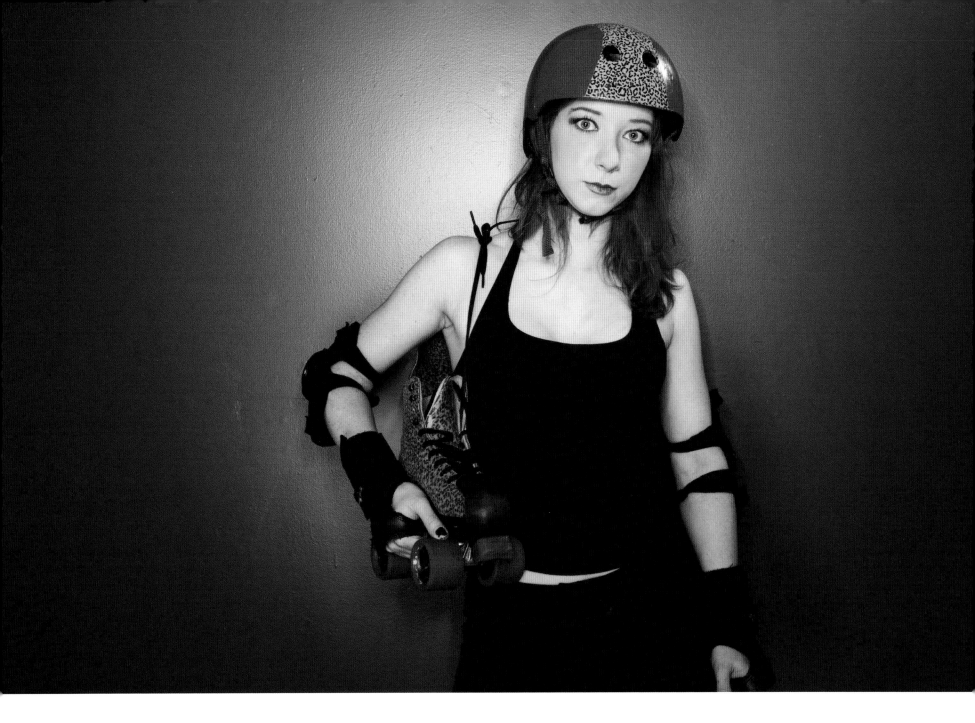

Kitty Porn,
Albany All Stars, 2008

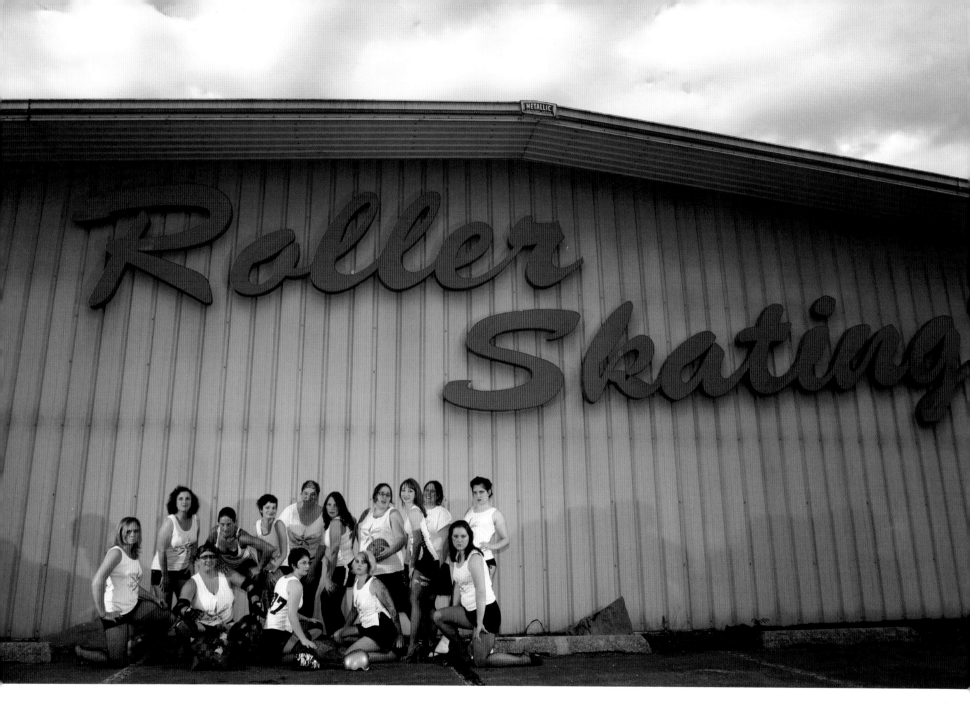

"It's universal: the team putting a smile on and standing unified, while managing a gear bag full of internal drama."

—*Bitches Bruze, Albany All Stars*

Albany All Stars, Skateway (Wilkes-Barre, Pennsylvania), 2008

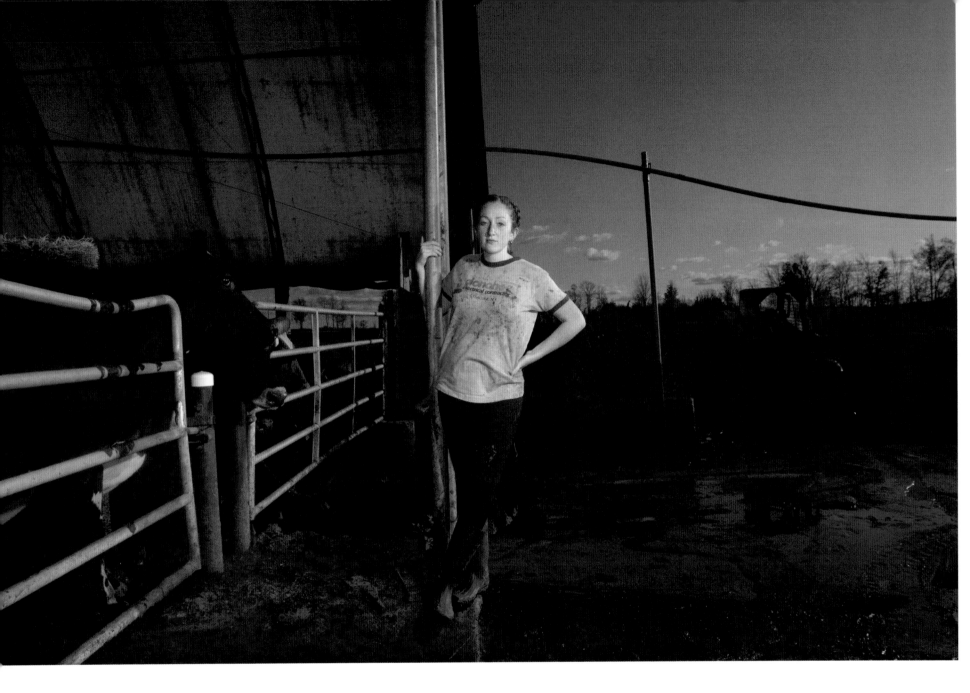

Anne Meyerhoff,
farmer's daughter, 2008

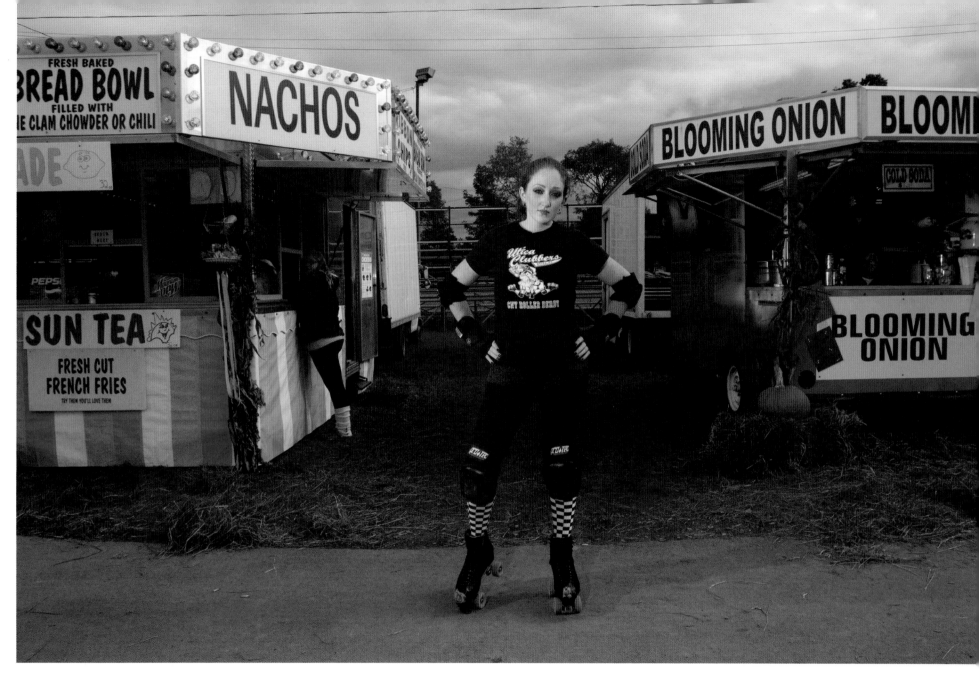

"I chose Farmer's Slaughter as my derby name because of my dad—I'm a farmer's daughter. He was the one to convince me to strap on skates, after hearing about roller derby through an interview on K-Rock while he was doing chores one day. He taught me that 'work is a verb' and that 'giving up is guaranteed losing—anything else is trying to win.' Those lessons have served me well in derby over the past five years."

—*Farmer's Slaughter*

Farmer's Slaughter,
Central New York
Roller Derby, 2008

I was 'refereeing' for a recruitment event for Central New York Roller Derby. We called it mud wrestling, but it was vanilla pudding out of five gallon cans with hot cocoa mix to make it brown. We were having random people from the crowd sign up to wrestle the girls. Looking back, it was a terrible idea for both public image and liability, but it was fun! Murder Antoinette is the female wrestler. The guy who just got his ass kicked by a girl was really surprised how strong she was. I was trying really hard not to laugh at the guy. He was kind of full of himself and was actually trying to really wrestle—took it a bit too seriously—and Lauren crushed him as soon as she sensed he was thinking that way.

It's a great moment in time from the beginnings of our league before we had any sense of where the sport was going. It was still about costumes and mock fights and portraying a badass punk image, and so we were rolling with that to gain some public interest.

To put a bit of perspective on it, this was part of a larger event that was organized as a women-focused weekend by a female promoter at a local fairgrounds near us. There were a bunch of all-girl bands, and a demolition derby of all-girl drivers, and the plan was to do a roller derby demo in this building with a flat floor. None of us knew how to set up a track properly at the time, so we threw down some cones and did our best to stay upright for about an hour showing people mock jams and how the rules worked. Since there were bands still playing, the majority of the crowd was watching the music. We made a sort of on-the-spot decision with the promoter to stick around, fill a pool with pudding, and have at it. The entire place went wild. There were probably 100 to 150 people in the building watching this. Surprisingly, no one got inappropriate, and it stayed all in pretty good taste despite the premise.

After this pic was taken, the girls grabbed me and crowd surfed me into the pudding. I smelled like hot cocoa mix for weeks. I literally found pudding in my ear almost a full week after this, despite showering every day and trying to get rid of it. We had this pool in my attic three years later and the whole attic smelled like hot cocoa mix. I still can't drink the stuff.
—*Grambo, referee, Central New York Roller Derby*

I'm somewhat allergic to cocoa, so I was fighting throwing up the entire time. I'm also not a fan of pudding.
—*Murder Antoinette, Central New York Roller Derby*

"Mud" Wrestling, 2008

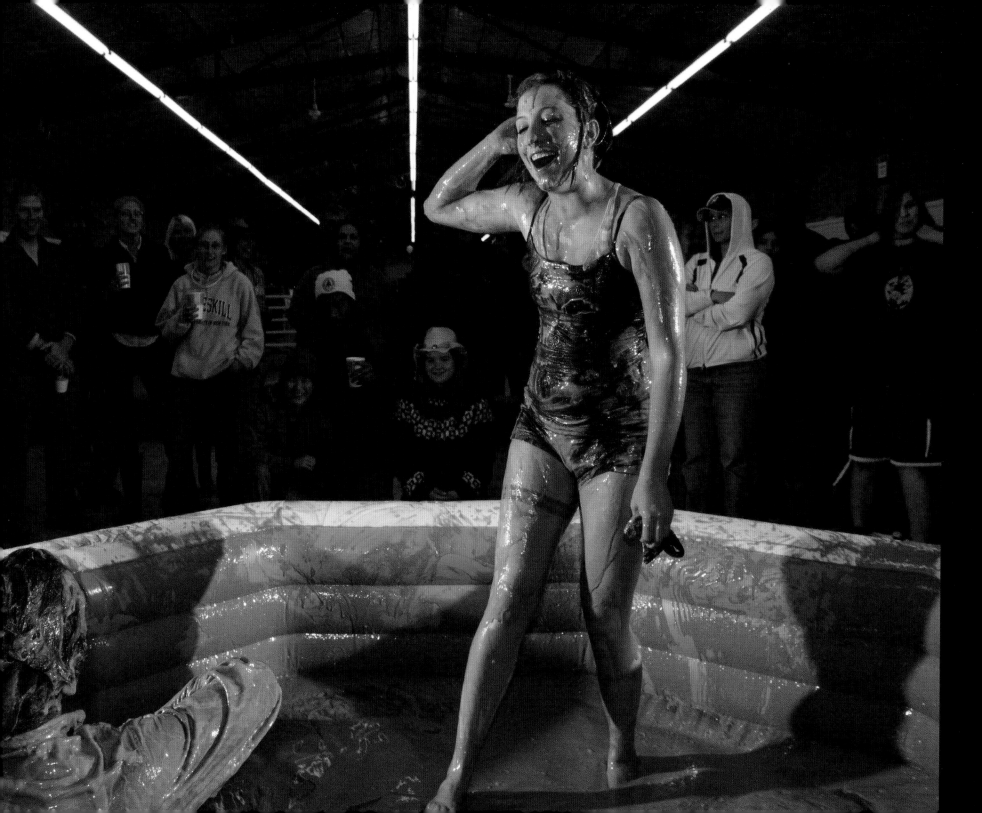

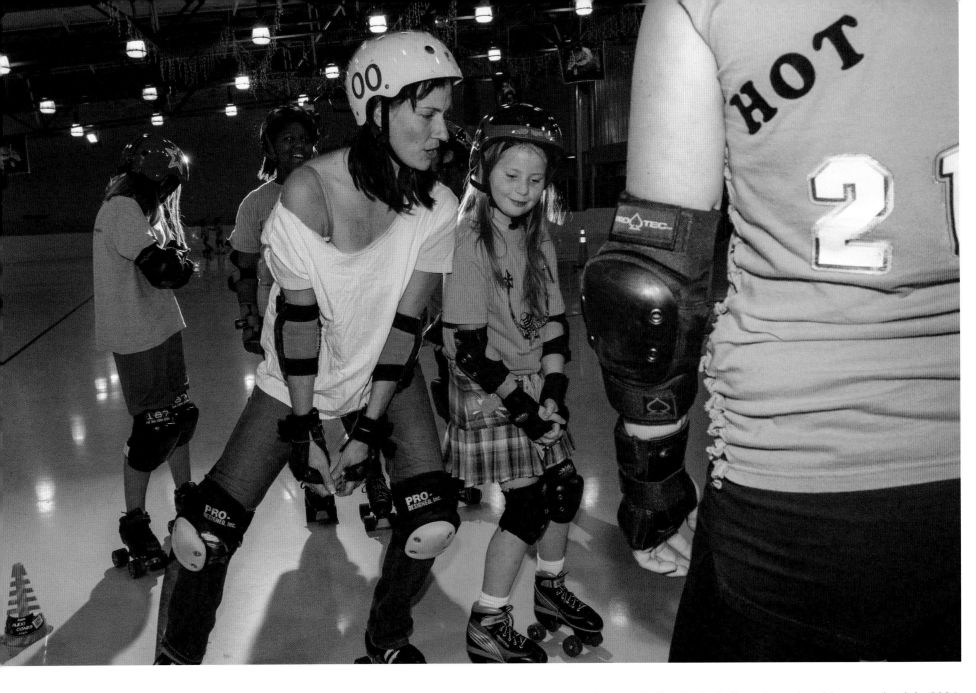

The Future of Roller Derby, 2008

"I've cried two times over my derby career. First, when I saw Tucson Roller Derby's first championship game back in 2004. Seeing others play what we had started proved that, yes, derby is bigger than just Austin and will succeed everywhere. Second time was upon seeing my first junior game. Coaching others, especially young girls, rewards me more than any trophy of championship has."

—*Sparkle Plenty, Texas Rollergirls*

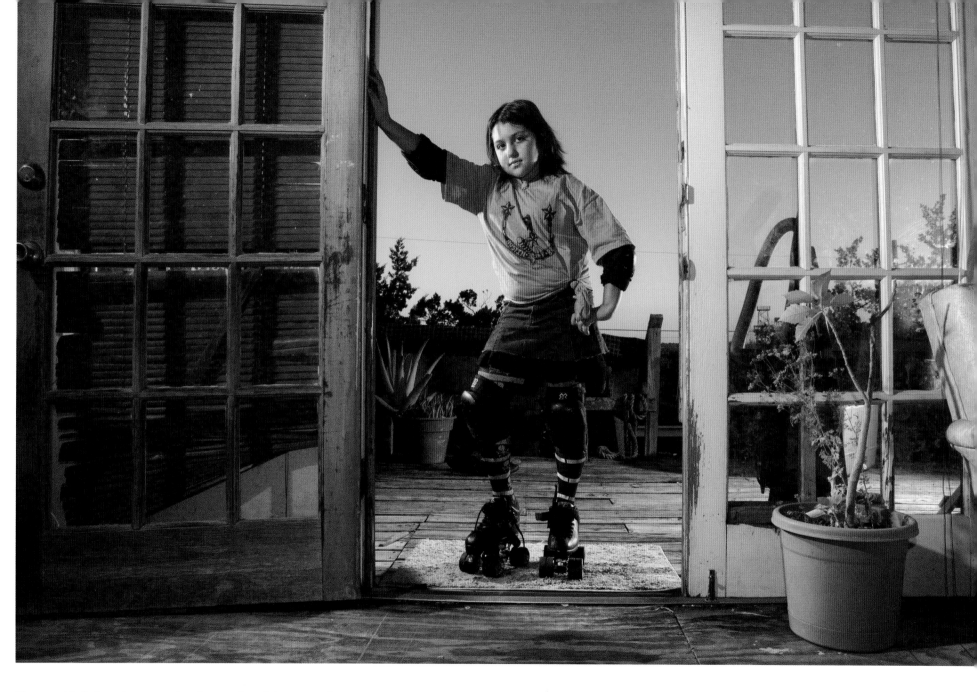

"At age 11, I already wanted to be on the older team. I wanted to be a part of the *real* roller derby, not just junior roller derby. I knew I had what it takes. Sadly, roller derby is not currently part of my life. Nobody but the veterans remember me and how good of a player I was. I'm still not 18 yet. But when I am, Fuego Azul is coming back."

—*Fuego Azul*

Fuego Azul,
Austin Derby Brats,
2008

Roller Derby (this way), 2008

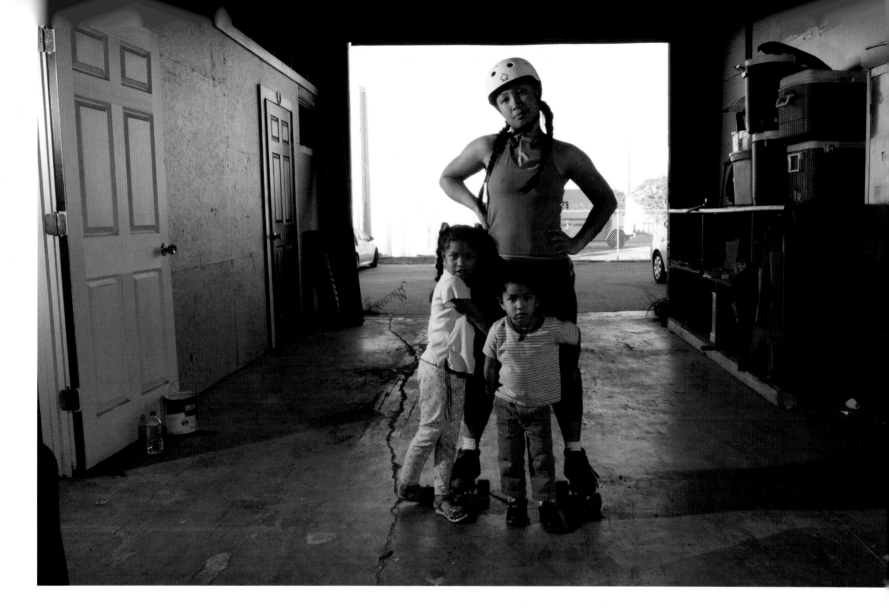

"I first caught a glimpse of modern roller derby flipping through channels while breastfeeding and becoming glued to *Rollergirls* on A&E. Little did I know that two years from then, I would actually be skating with some of those girls in that very same league!

"I was TXRD fresh meat and just beginning my roller derby adventures. I was at practice and had to bring my kids with me. My daughter, Irie, was 4 and my son, Ajani, was 2.

"Roller derby culture captivates women from all walks of life—from the young and single to the married with children. There is a universal feeling of empowerment that many women feel being a rollergirl; everything revolves around my family, but when I'm out on that track with my gear strapped on, this is just for me."

—*Rice Rice Baby*

Rice Rice Baby,
TXRD Lonestar Rollergirls,
2008

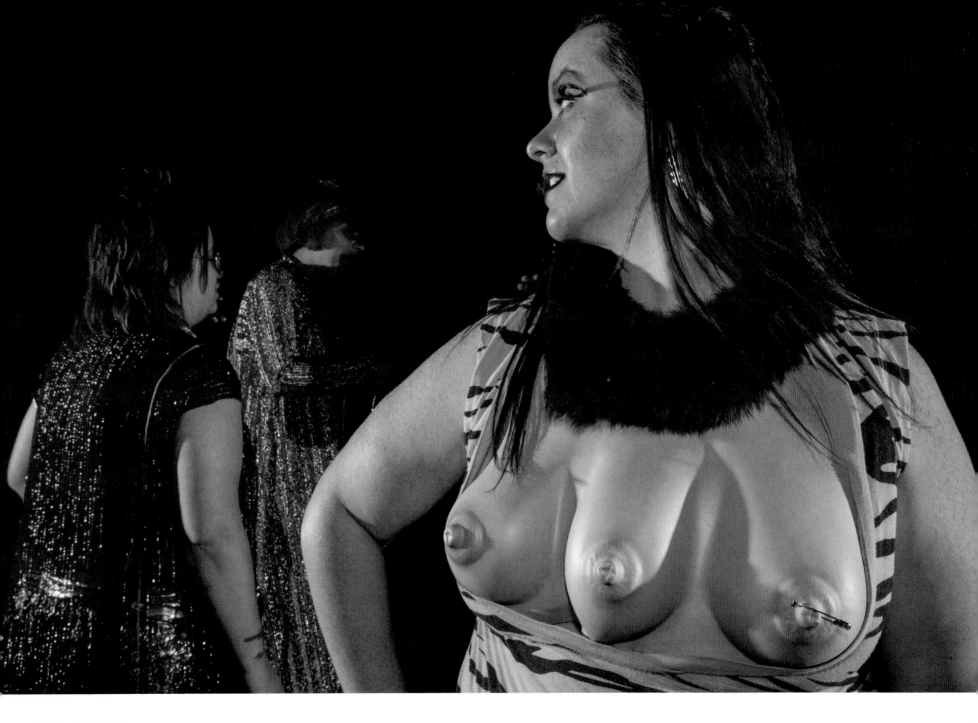

Rollerball, 2008

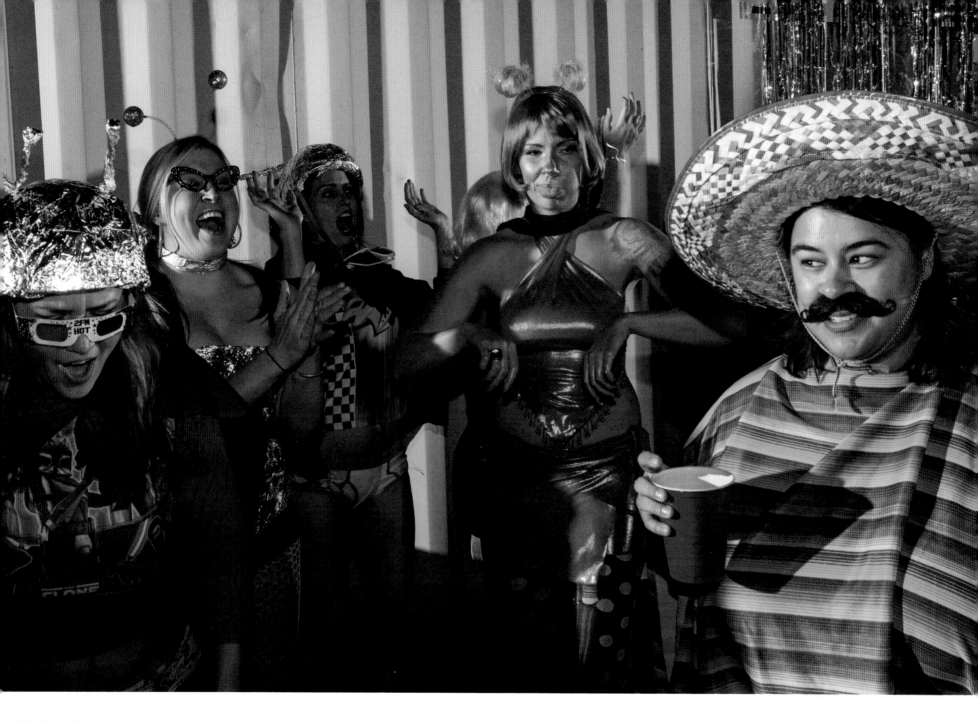

"Rollerball is our end-of-the year awards ceremony. I won Best Tickets (breasts) that year. Yep, that was an award. I was nominated for most feared that year, too, but lost to Knottie Knoxville. She was one tough bitch. Love that girl!"
—Mz. Behavin', TXRD Lonestar Rollergirls

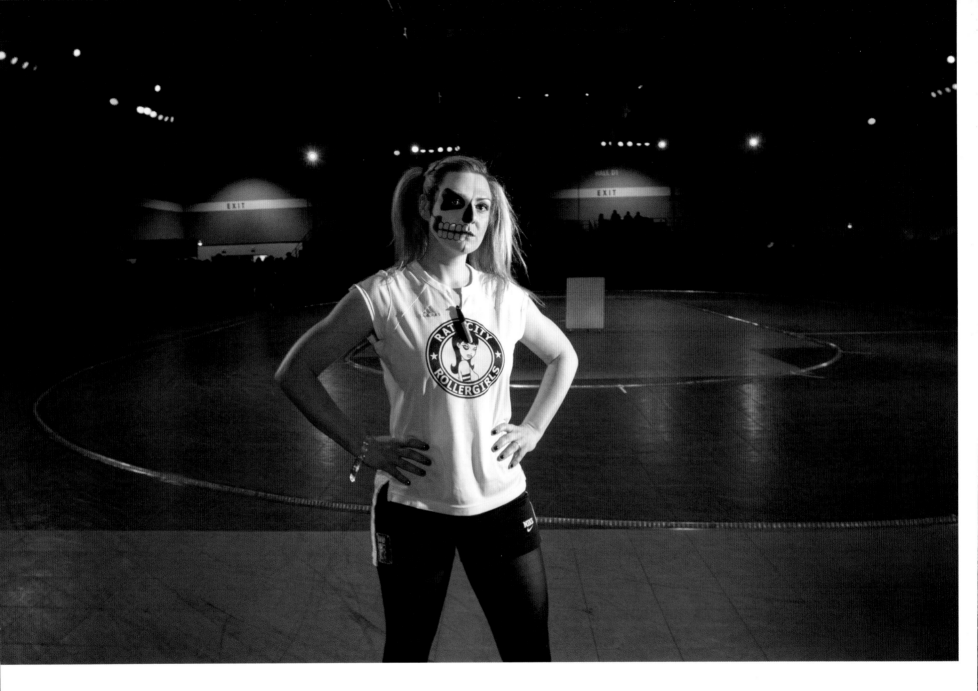

Rettig to Rumble,
Rat City Rollergirls, 2008

"In this sport, women do not need to apologize or be embarrassed to be strong, aggressive, and deadly competitive. They can stand confidently in front of a crowd of people, wear their hearts on their sleeves and their aggression on their faces, and not worry that their physical competitiveness will detract from or discount their femininity."

—*Rettig to Rumble*

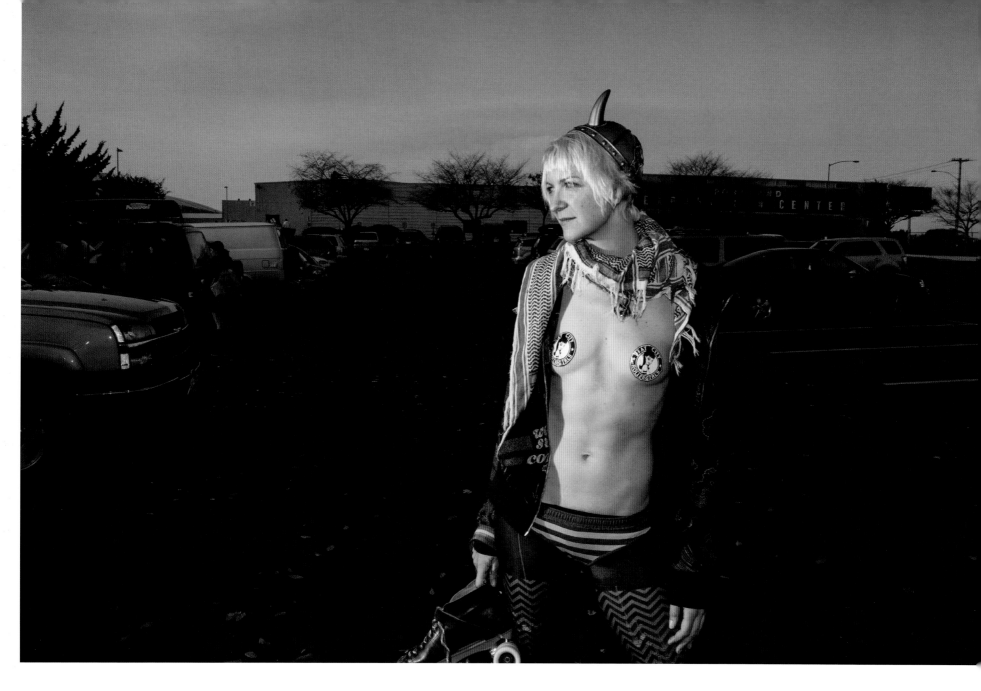

"I was on my way to volunteer at NorthWest Knockdown, and I thought this was the most appropriate way to dress. Stickered nipples, that was sort of my thing back then. My way of showing team spirit. We all have become more decently dressed, but we are still wild at heart. I think that is the soul of derby, to be wild at heart."

—Swede Hurt

Swede Hurt,
Jet City Rollergirls,
2008

"I captained my home team for the Minnesota Rollergirls in 2007. For one bout, my boyfriend, without my knowledge, arranged to be a "guest announcer." He also arranged for my entire family to come to the bout, his family from South Dakota, and one friend from Denver and another from Madison.

"After the game, the opposing team's captains and I went out to the middle of the rink with him for a post-bout interview. I didn't notice that our friend from Denver was filming when he walked out to do interviews, or that our friend from Madison was standing by the rink holding something.

"He started by interviewing the other team's captain, then asked me a generic question about how I felt about the team's performance in the game. He then started to say something else, paused, got onto one knee, and asked me to marry him. The fans at the Roy Wilkins Auditorium made a gigantic roar! I nodded for several seconds before I realized there was a mic in my face, and I should say yes.

"I still say it was coercion because there was no way to say no in that situation without being chased out of the hall by three thousand fans."
—*Desi Cration, Minnesota Rollergirls 2005–2007,*
Texas Rollergirls 2007–present

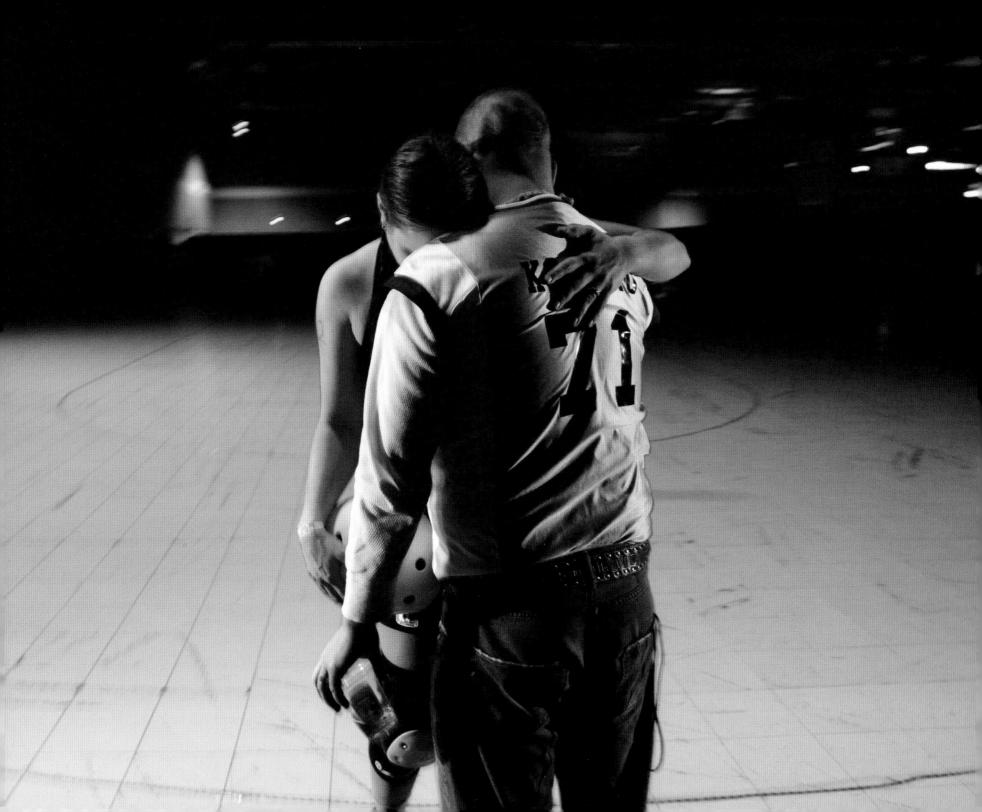

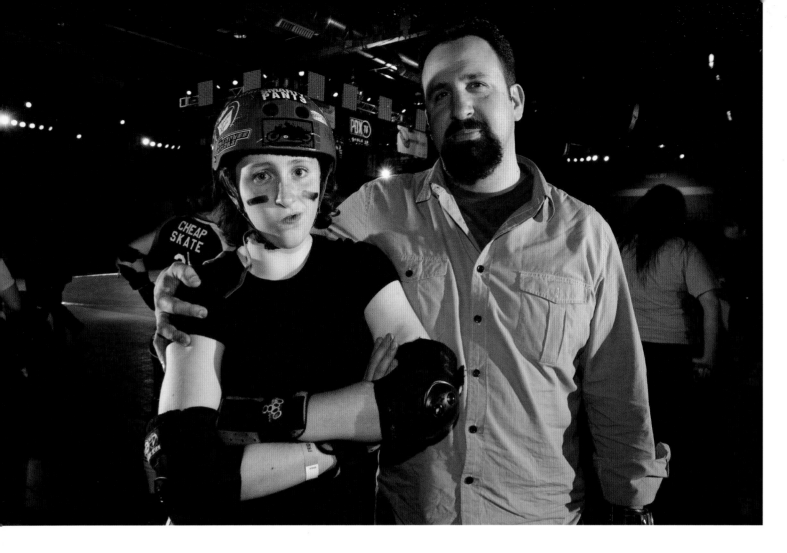

Hunt-Her-Down,
Seattle Derby Brats, 2008

"A child choosing to be involved in a full contact sport, and a proud parent supporting that choice. In many ways this generation of junior skaters are the first to be able say that they grew up playing roller derby."

—*Chris Hunter, father of Hunt-Her-Down*

"I had just played in the exhibition bout and it happened to be my birthday that day! I was probably thinking, 'Why does she want our picture, we are new to derby, and I'm gross.' It is important to keep in mind if you started derby at age twelve that this is what you looked like because you forget! At the time, I was naïve and cocky. I didn't really know much about the sport: the history or the great athletes that came before me. And I especially didn't know what was coming in the future for me and roller derby. I remember that weekend and how I built on friendships that I currently still have!"

—*Hunt-Her-Down*

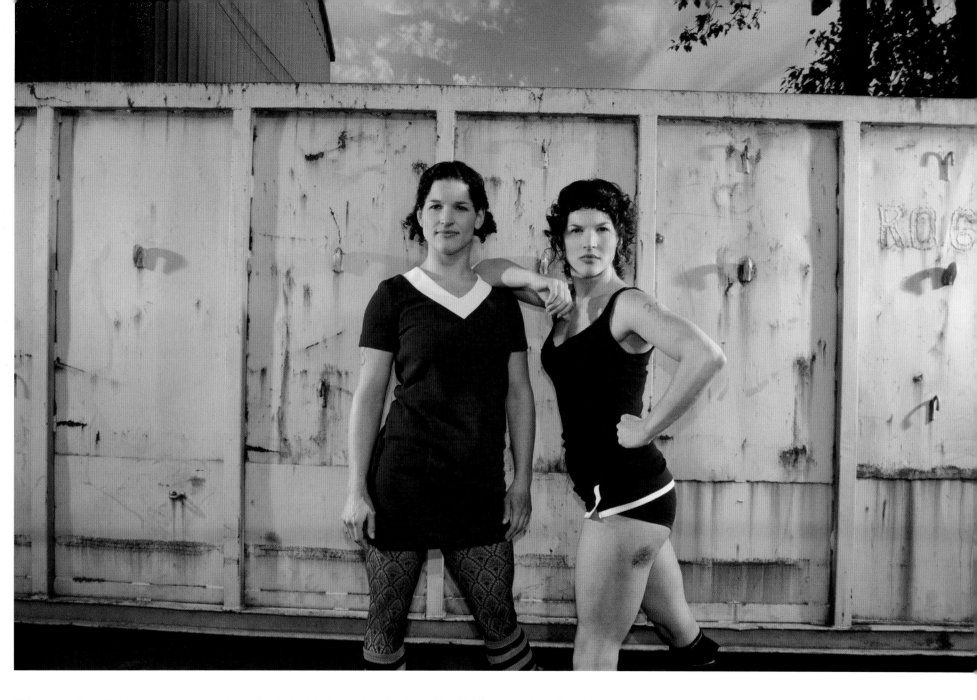

"I love to play derby, but never got into the intimidation/role-playing of it all. My twin sister has always been very dramatic and theatrical (and in my opinion she looks *way* scarier than me)."

—*Comet Atcha*

Comet Atcha,
Rat City Rollergirls,
and Romaniac,
Brewcity Bruisers, 2008

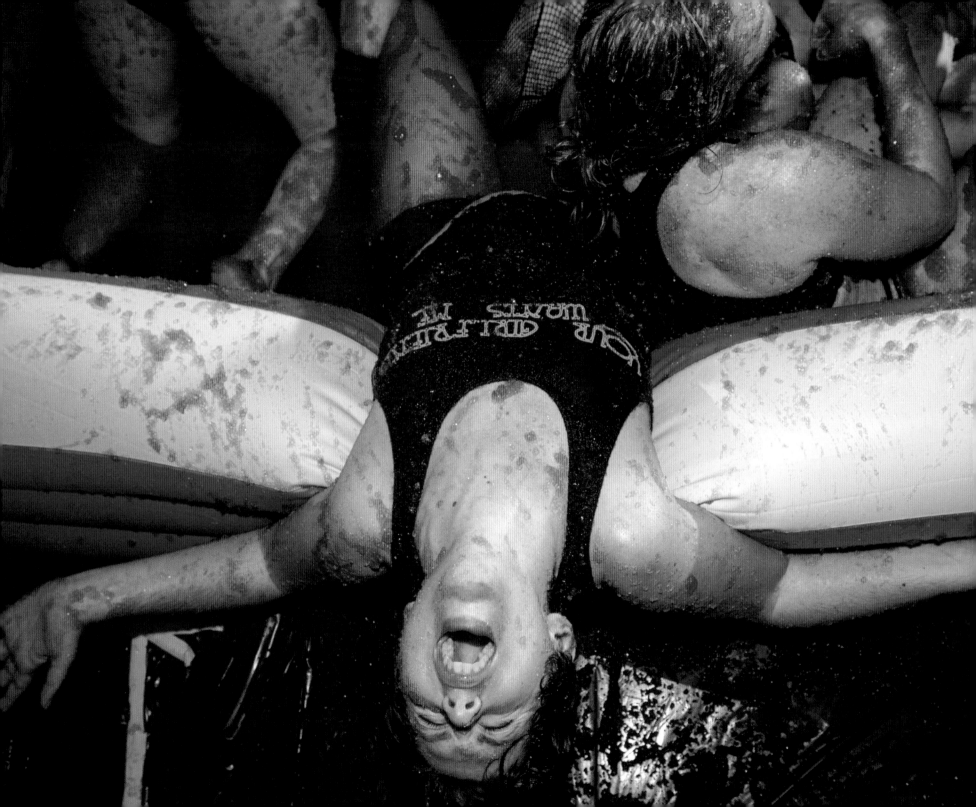

"I think I had a few seconds where I believed I might be drowning in Jell-O.
—*Dee Licious, Morristown Madams*

"I was a little worried that I might have 'wardrobe malfunction.' Our team toed the line of what competitive roller derby was back in 2008. Mainstream derby has moved away from these types of fundraisers and sideshows. But, oh, it was fun!

As a professional teacher, I can be confident that my sport is a respectable, tell-my-students-and-their-parents-about-it thing, and I don't have to worry about pictures of me with half my butt hanging out getting published in the local newspaper anymore.

—*Bozie Banger, Morristown Madams*

Juliette Lewdness, Lehigh Valley Rollergirls, 2008

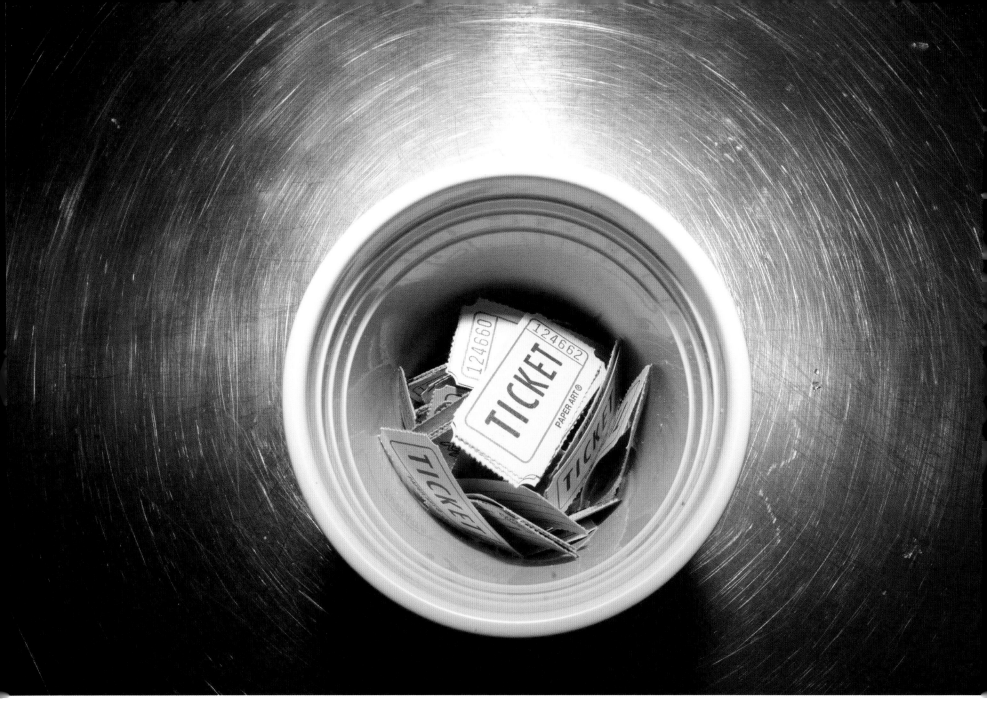

Untitled, 2008

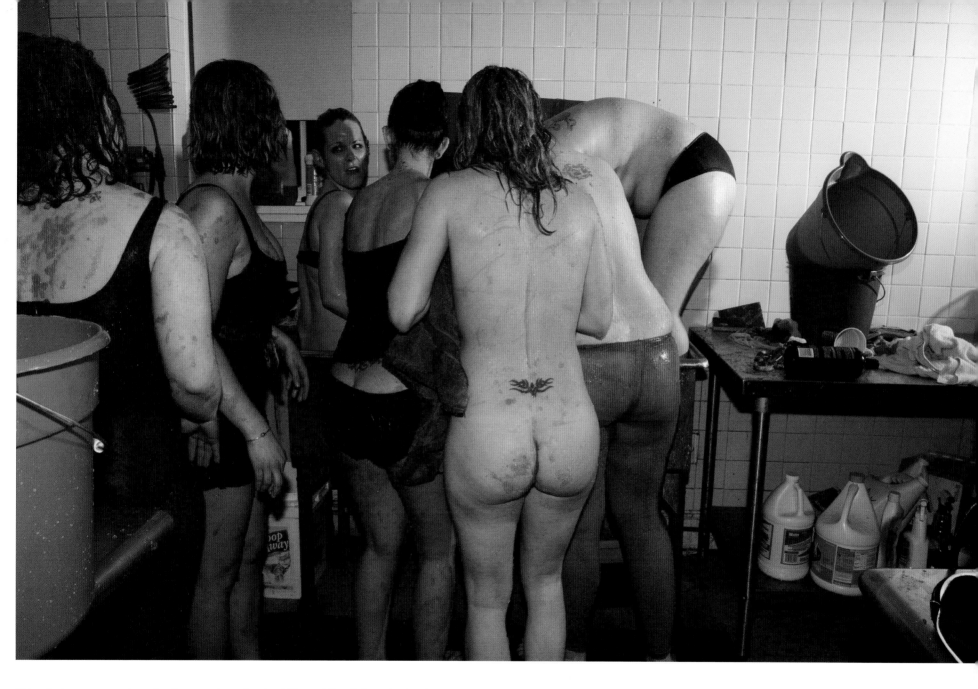

"I had always wondered what my butt looked like while doing derby. It was probably in the best shape of my life. I just think that the universe laughed at me because I got the picture I wanted; it's just not as flattering as I would have imagined with all the Jell-O stuffed in it."

—Dee Licious, Morristown Madams

Third Annual
Cran Jell-O Wrassle,
2008

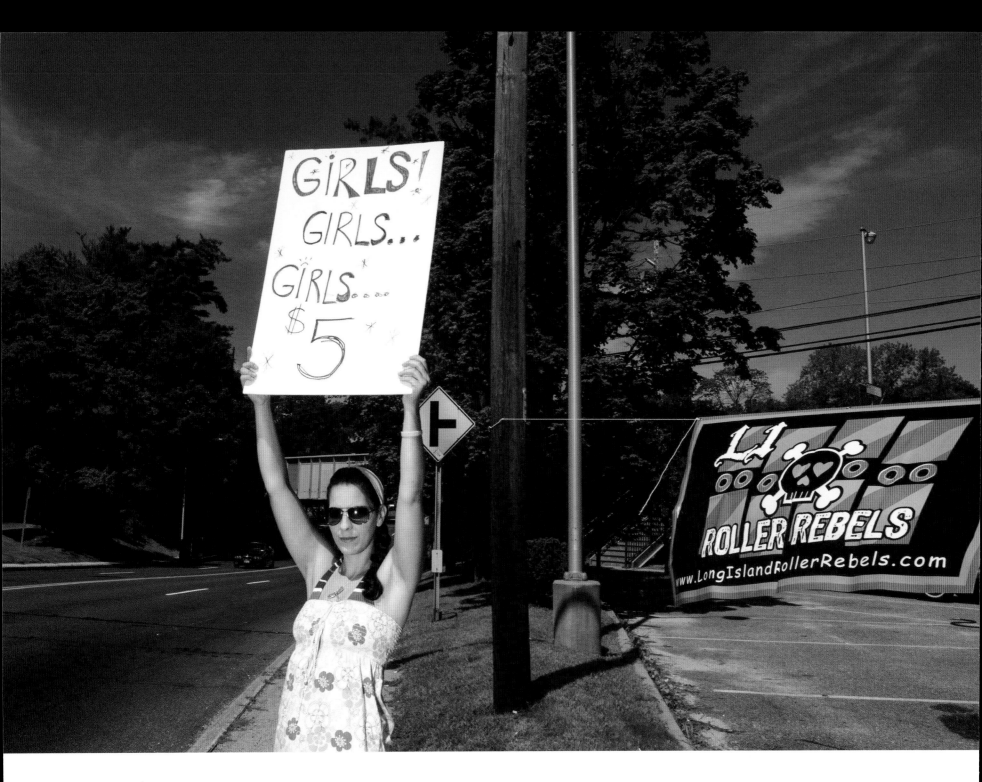

Girls, girls, girls, $5, 2009

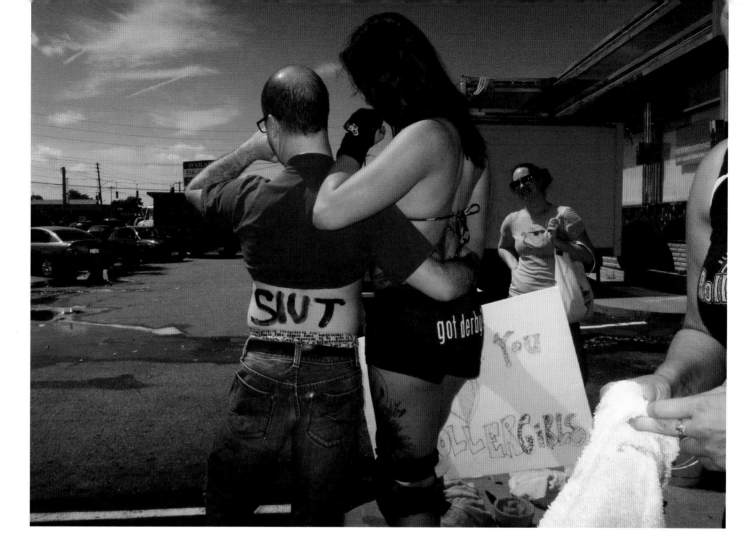

Car Wash, 2012

"Men and women will whore ourselves out for our leagues! Clearly, these ladies weren't sexy enough in their bikinis to bring in the 'dirty' cars, so I decided I'd get in the spirit of things, because there's nothing like a bespectacled, short, balding, pasty Jewish guy covered in body paint to bring in those much-needed car wash dollars.

"I'm 'supposed' to be the good, Ivy League-educated son/grandson, spending my weekends with my family, or out to find a nice Jewish girl. I'm not ready to be that boring... yet. Still, my association with these amazing women has altered what I look for in a partner and has raised my standards that much higher.

"Lil E Von Schtupp had just painted me up and I could feel her writing the word on my back. I thought to myself: 'Well, here's just one less thing to be proud of. I really hope no one ever sees this.'"

—*Jake Steel (aka CAPS LOCK), announcer*

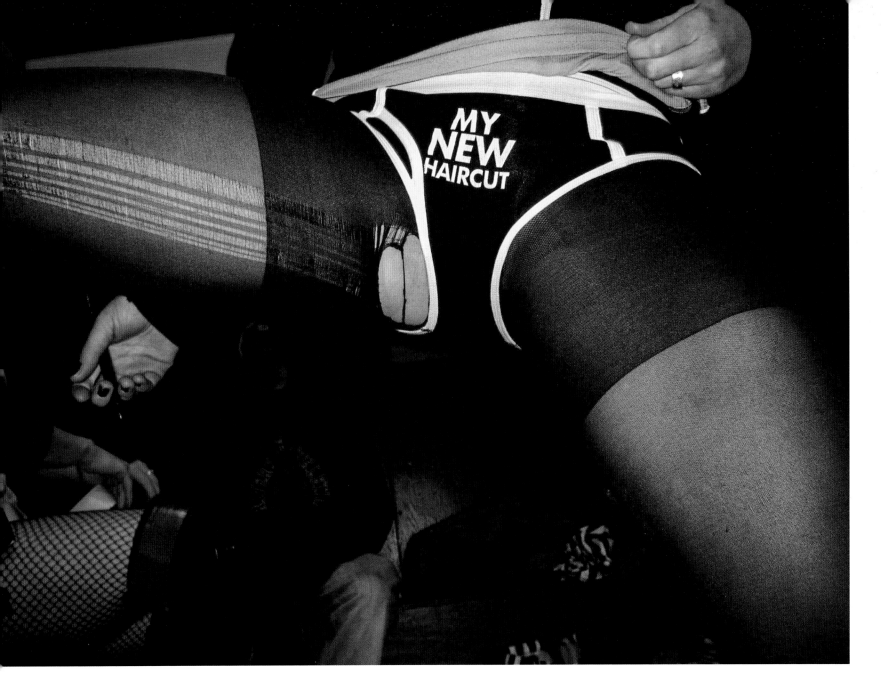

My New Haircut, 2009

"There is nothing universal about roller derby, period. My experience within it was a lot like this photo: brash, in your face, and thrown together, but it all worked in perfect harmony.

"I see myself as more of a lady, but whatever. Worse things have happened. I still skate in those tights and wear them under dresses."

—*Tail Gunner Flo, Long Island Roller Rebels*

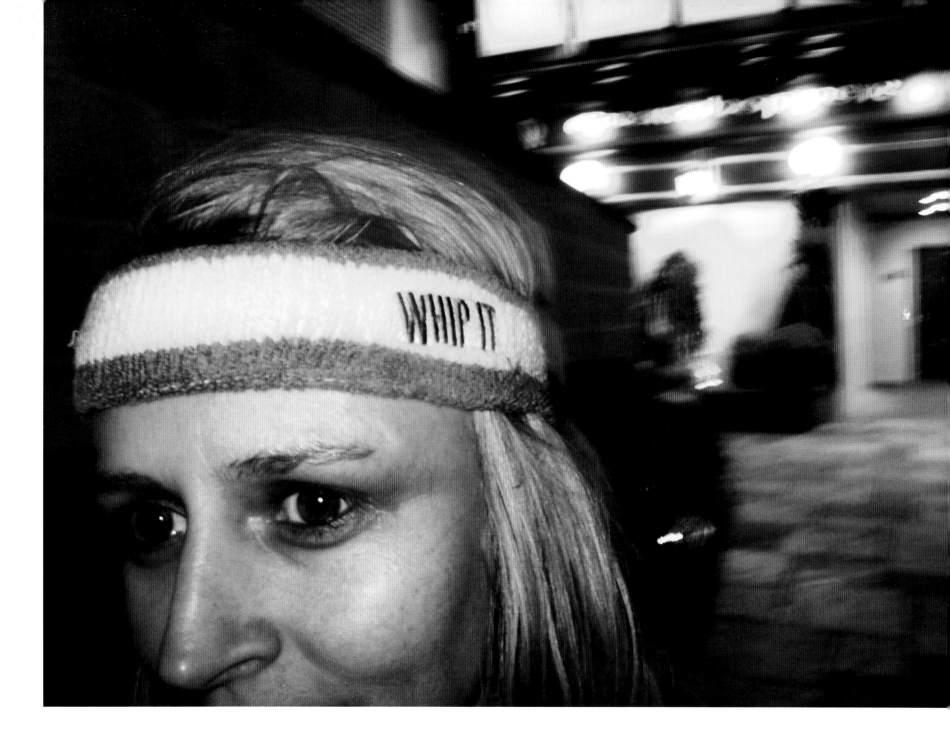

"I'm number 11 because I like that number, and it's also my phone number. Call me some time."
—*C-Roll, Long Island Roller Rebels*

Whip It, 2009

"I'm not sure how it started but that makeup became my signature bout look, which lots of skaters used to adopt and recreate for every game. I started doing it with lipstick, which is what is going on here. I moved on to red eyeshadow for a less dramatic approach the following years, and eventually phased it out completely now. People always used to tell me that I looked so scary when I wore it, and I felt that fit my personality very well.

—*Violet Knockout, Long Island Roller Rebels, 2008-2011*
Gotham Girls Roller Derby, 2012-present

Violet Knockout, 2009

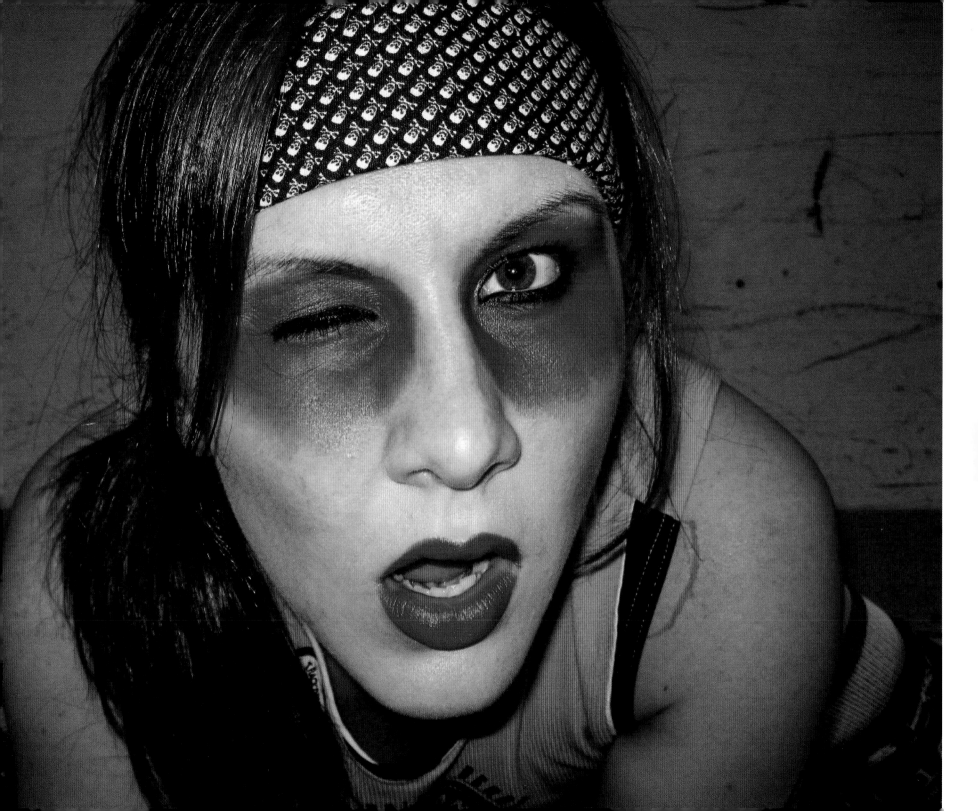

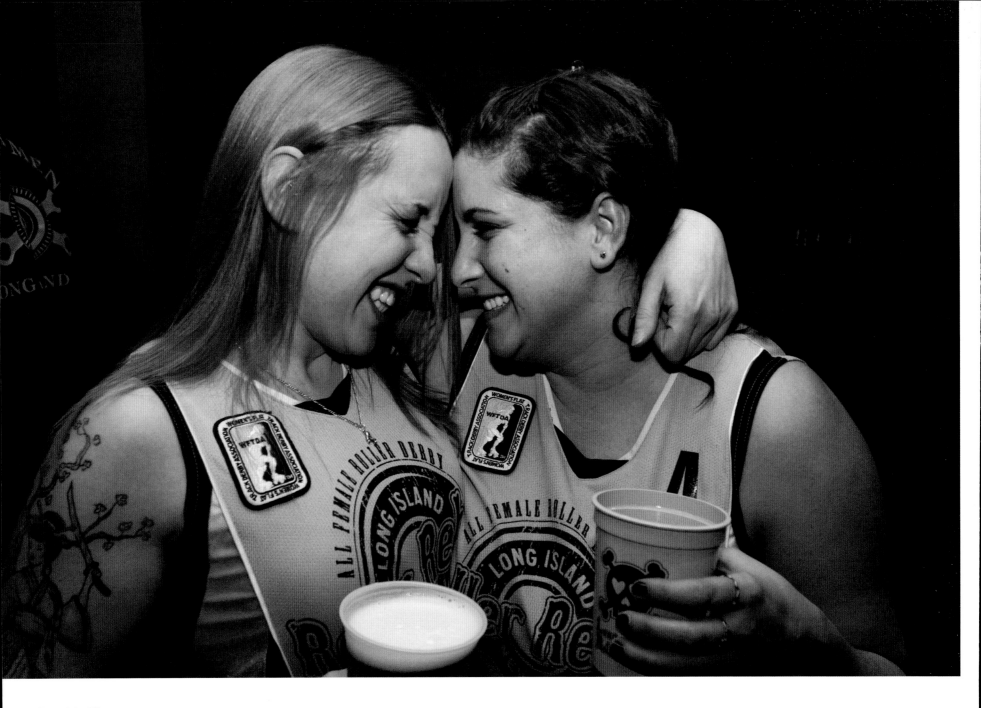

Cyanide Kisses
and Chest Blockwell,
Long Island Roller Rebels,
2010

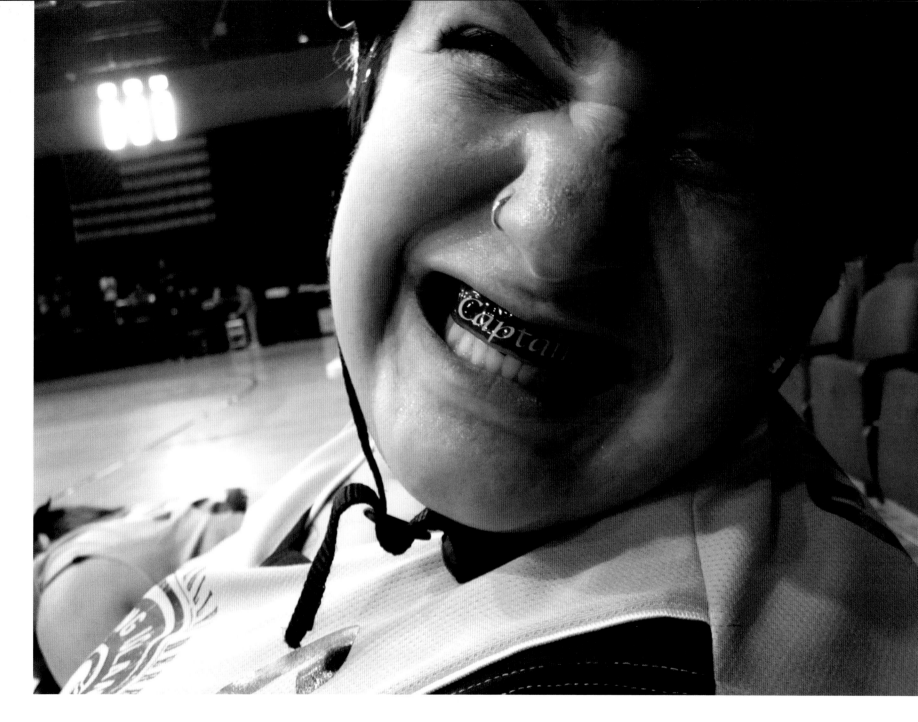

"I was captain of the All Stars, but my team had gotten so good I was an alternate. Derby used to be more fun based, but our league is now more competitive. We are no longer a drinking team with a derby problem."
—*Captain Morgan*

Captain Morgan,
Long Island Roller Rebels,
2010

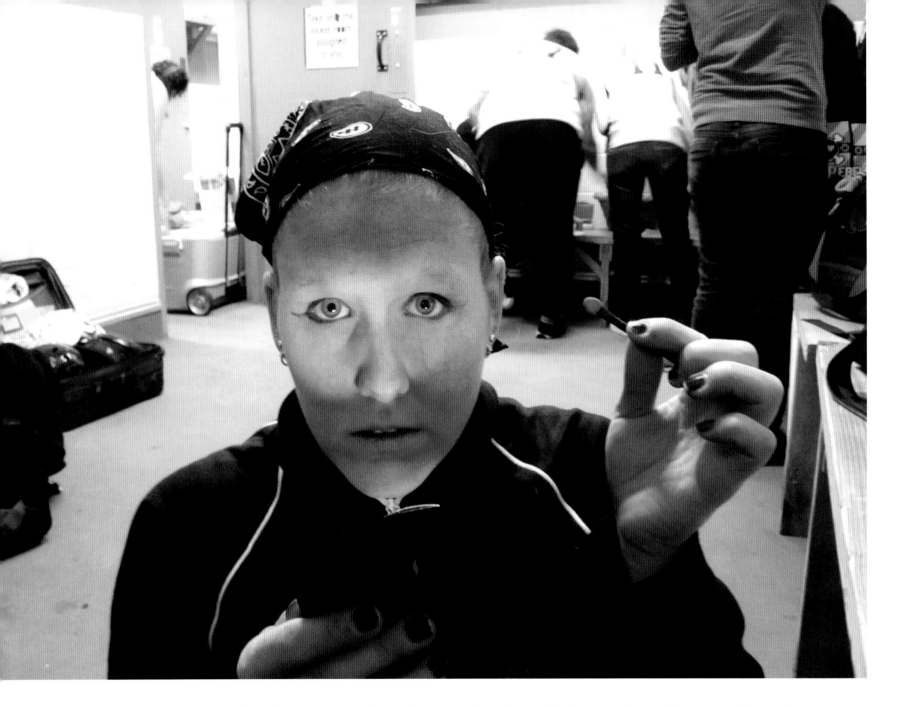

Celtic Thunder,
Long Island Roller Rebels,
2010

"Over the years, many skaters have transformed out of the heavy makeup, fishnets, and booty shorts to more of an athletic wardrobe. I really don't wear much makeup anymore on the track, as the sport has evolved. I chose to make the switch to a more athletic look. And because the sweat ran my makeup into my eyes!"

—*Celtic Thunder*

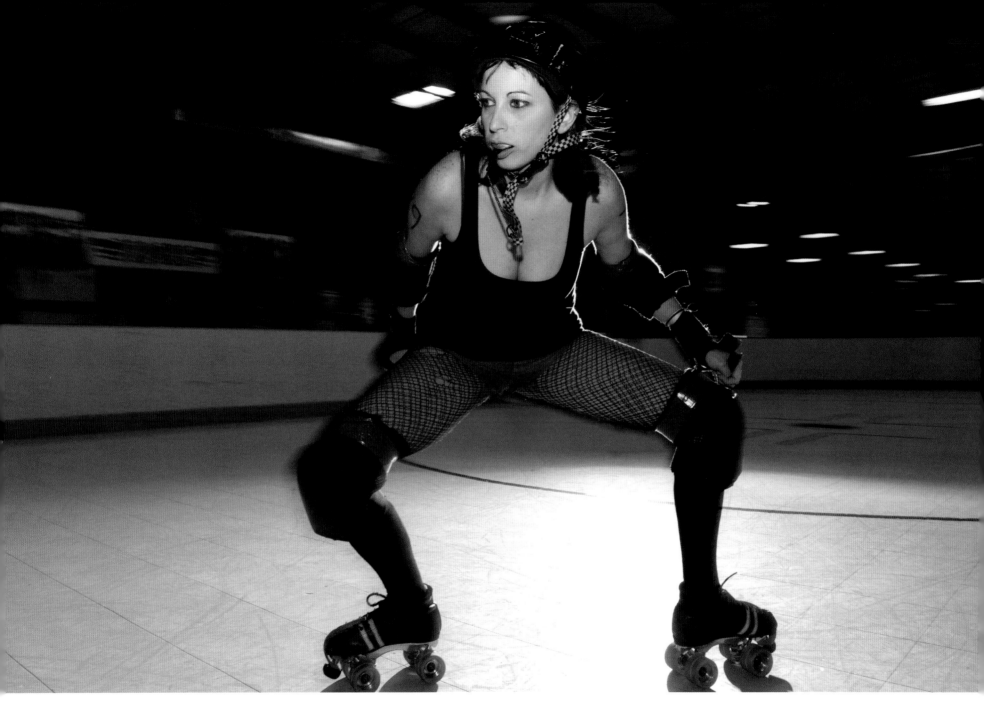

Breakneck Brie,
Long Island Roller Rebels,
2010

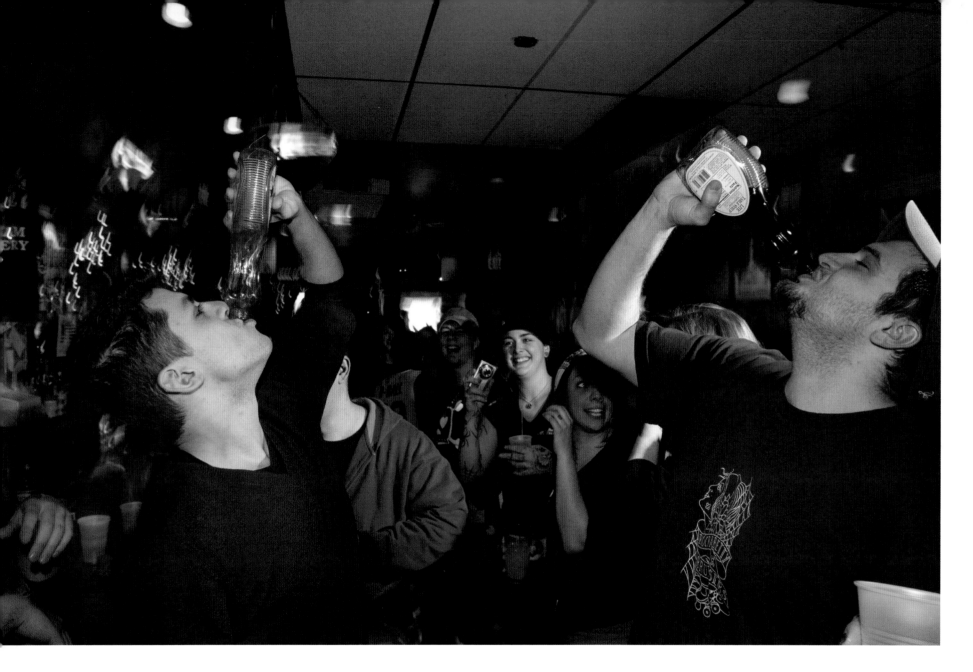

Pancake Breakfast, 2010

"A sweet and savory victory wherein it was further evidenced that no mortal man can defeat the Canadian Concoction Conqueror. After: A slew of cheers calling for the syrupy dance of victory.

"Part of the fun of roller derby is getting to be with friends and doing things like seeing how fast you can chug a bottle of syrup...or how many cherries soaked in moonshine you can eat...you know, stuff that ultimately gives you problems down the road but is fun as hell while you're doing it."

—Dave Gomes

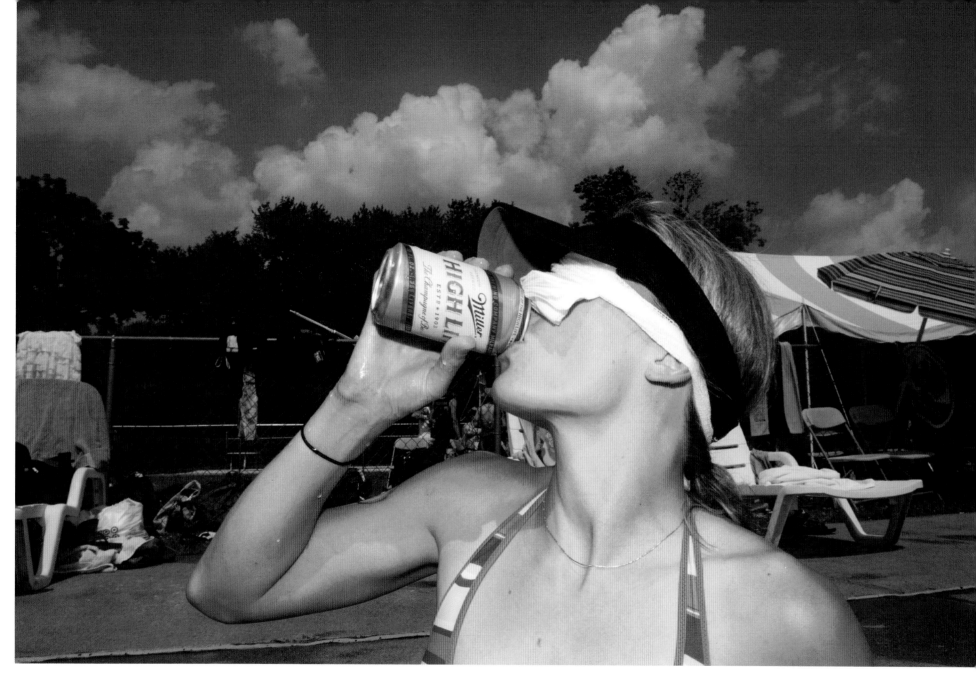

"There's nothing like chugging a cold beer on a hot day after a bout, wearing your derby badges of honor."
—*B. Zerk*

B. Zerk,
Gotham Girls Roller Derby,
2010

Untitled, 2011

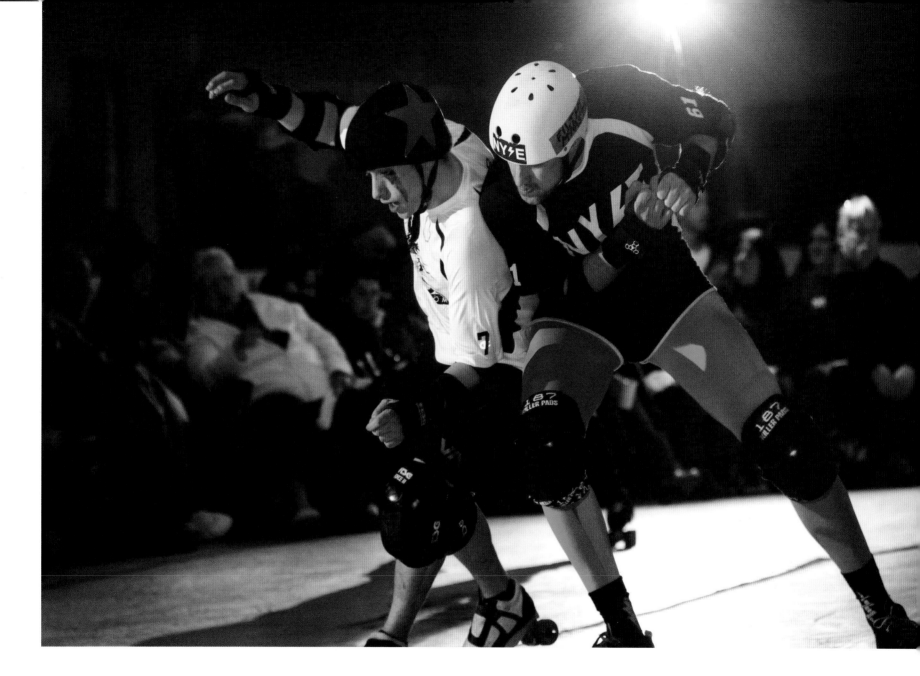

"Don't give up. You can never give up, even if they knock you down a hundred times. New York has a powerful team. Jamming against them is brutal, both physically and mentally. After many losses to New York over the years, we were finally able to beat them at the 2013 Mohawk Valley Cup, the third team to ever claim a win against them. If we gave up, if we had stopped fighting, we would have never seen how far we could go. That's why our team chant before every bout means so much to us. 'No rest until Valhalla!'"

—*Peter Rottentail, Mass Maelstrom*

The Adversaries (I), 2011

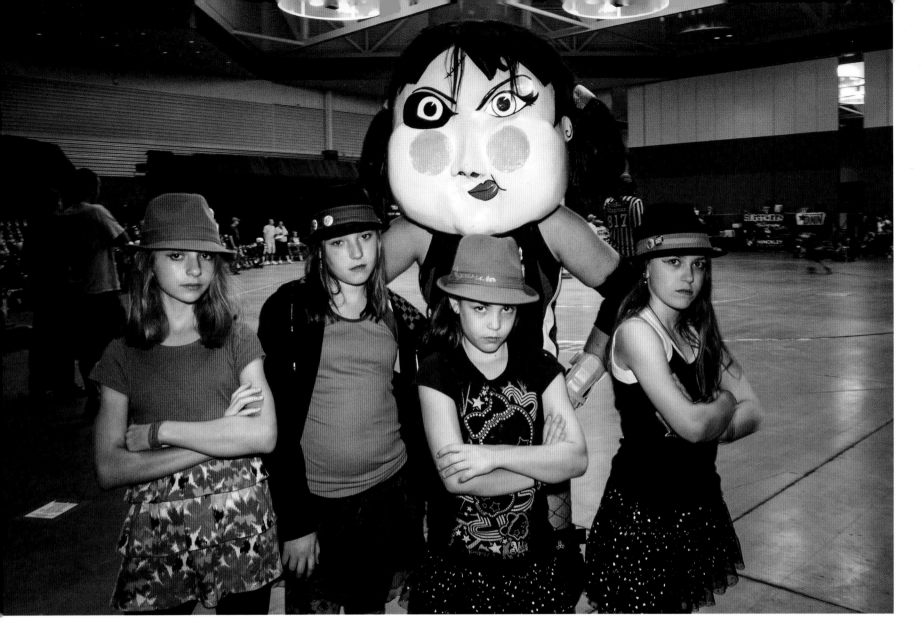

Mean Jean & Fort Wayne
Derby Brats, 2011

"It was at Spring Roll 2011. There were men's, women's, and junior roller derby tournaments that day. I was with some of my friends that I met in derby, Crazy Train, Thrill's Nightmare, Tick Uhoff, and Mean Jean. Mean Jean is the mascot for the Fort Wayne Derby Girls. These friendships are close and very important to me. My league and I are like a big derby family. Everyone is really supportive. We all love each other a lot."
—Sugar Cubed, Fort Wayne Derby Brats

"I couldn't see very well and it makes you nervous wearing the fat head while on skates."
—Mean Jean (aka GoGo Beware), mascot, Fort Wayne Derby Girls

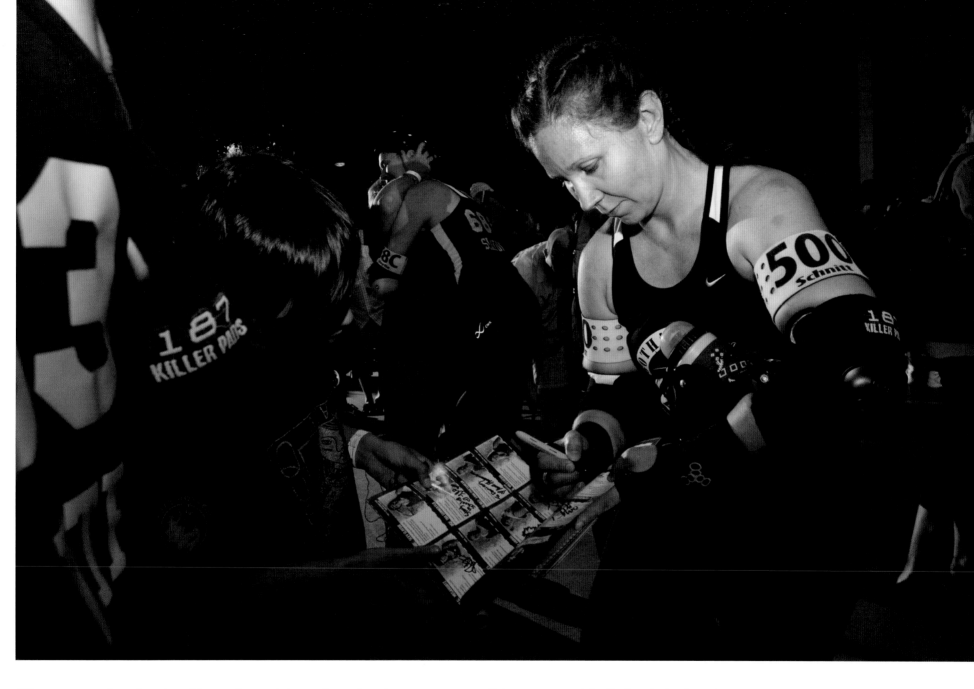

"There are too few female athlete role models, and too few that are so accessible to young girls. Roller derby is unique. Through the junior derby leagues across the country, we are the ones training the next generation. They come to a game, they fall in love, they decide they too want to play, and then they learn from the same people they watched."

—*Papierschnitt*

Papierschnitt,
Gotham Girls Roller Derby,
2011

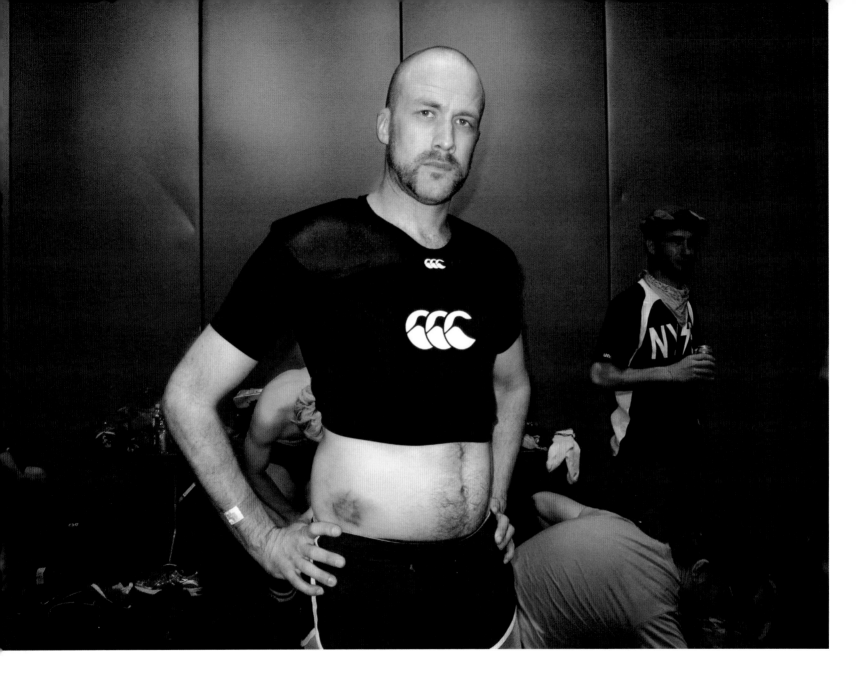

Filthy McNasty,
New York Shock Exchange,
2011

"I think that shoulder pad getup has been worn by at least three members of NYSE. I got it from Ronnie Mako. I had broken my shoulder (fractured my greater tuberosity) in December of the year before, and slightly separated the other one in a bout a few weeks before. I passed it on to Maulin Brando when he was having shoulder issues. Abe Drinkin may have used it as well.

"The hip is the only place I really bruise."

—*Filthy McNasty*

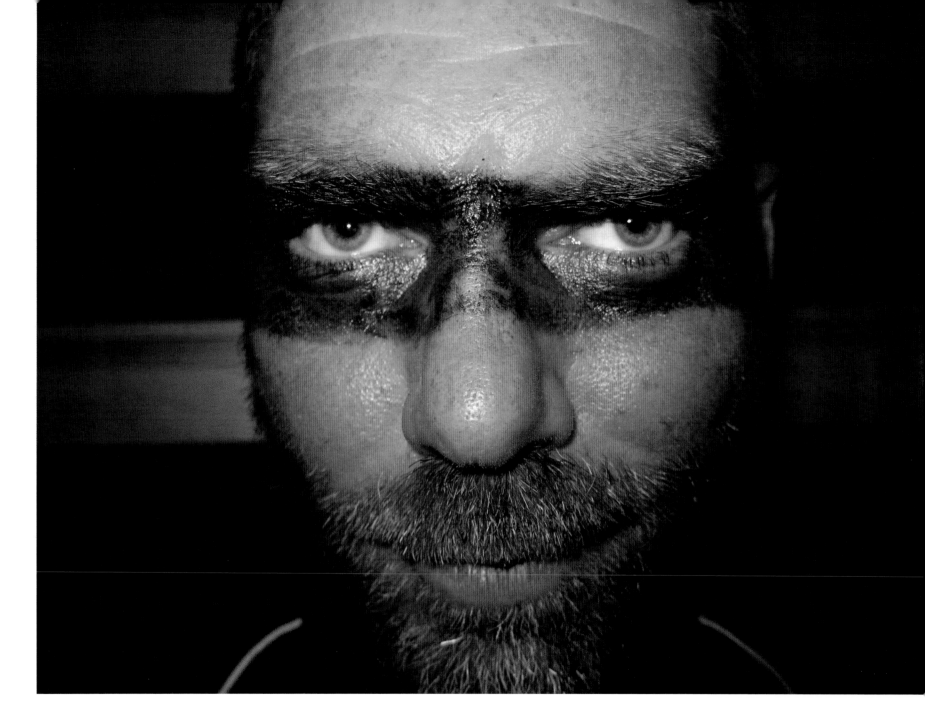

"This is The Rev. This is what I look like when I play derby. This is the face of enlightenment. When I put the paint on, I become The Rev."

—*The Rev*

The Rev, 2011

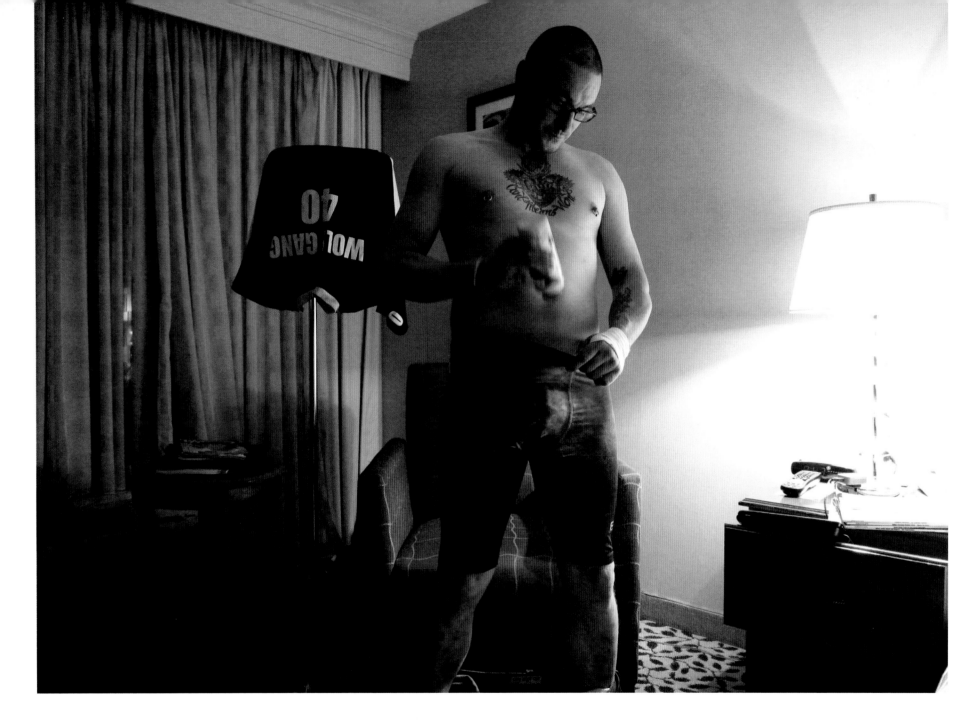

Wolfgang Von Stomp,
New York Shock Exchange,
2011

"A good friend of mine once said, 'If icing your balls doesn't fit derby culture, I don't know what does!' A lesson I learned all too well. During our bout earlier that day, I took a skate wheel to the baby-maker. After the bout I realized why derby is *so* awesome: there is no room for the weak, just as my Spartan ancestors intended!"

—*Bane-ana on Skates*

Bane-ana on Skates,
New York Shock Exchange,
2011

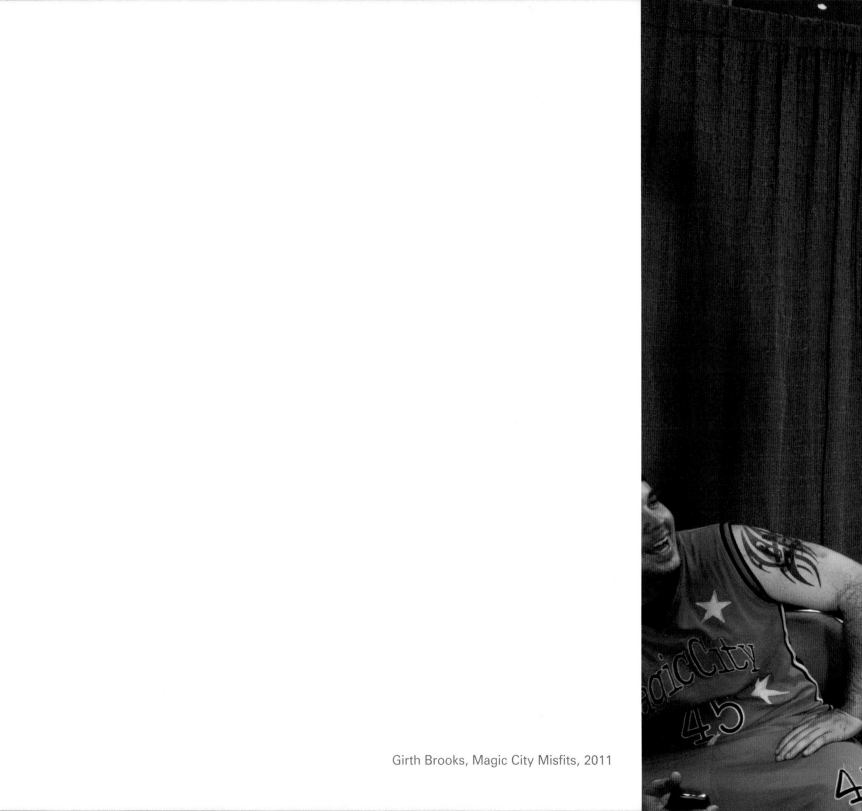

Girth Brooks, Magic City Misfits, 2011

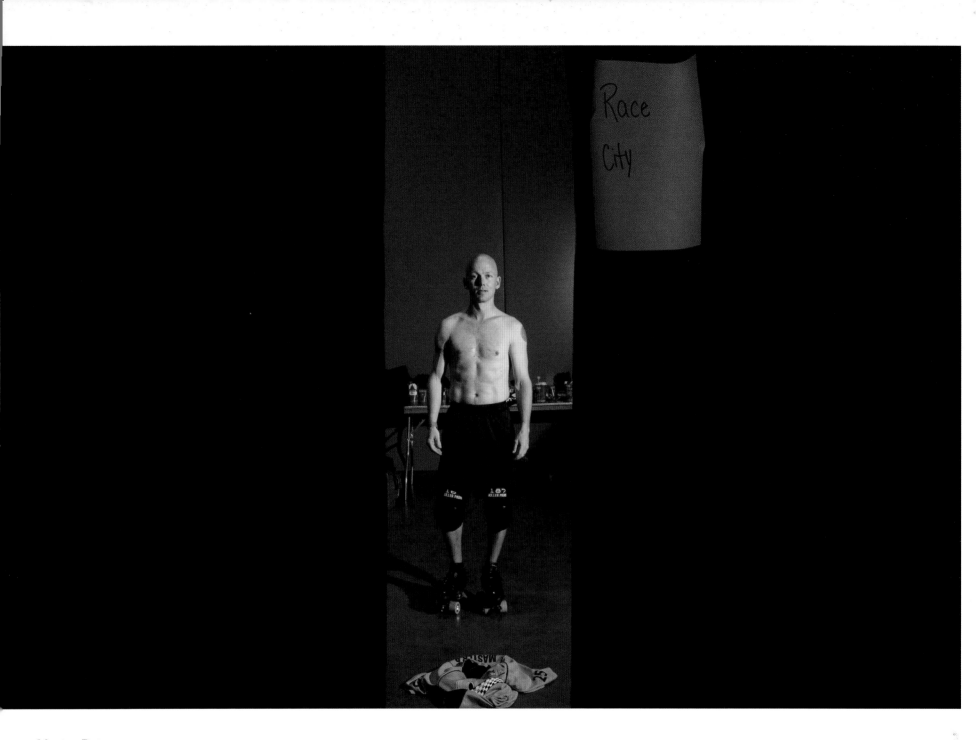

Master Beta,
Race City Rebels, 2011

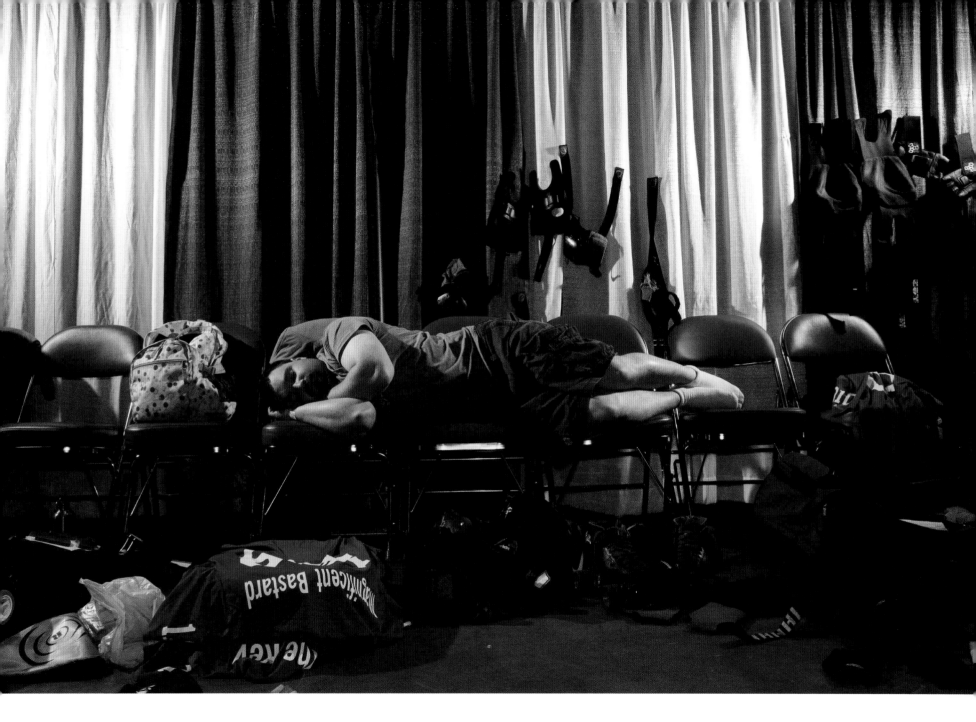

"I couldn't decide on a name months after joining. It's a tough one, has to capture your personality! The Shock Exchange guys even tried to give me a name, Gerbil Assault. Thank God it didn't stick."

—*Magnificent Bastard*

Magnificent Bastard,
Harm City Homicide, 2011

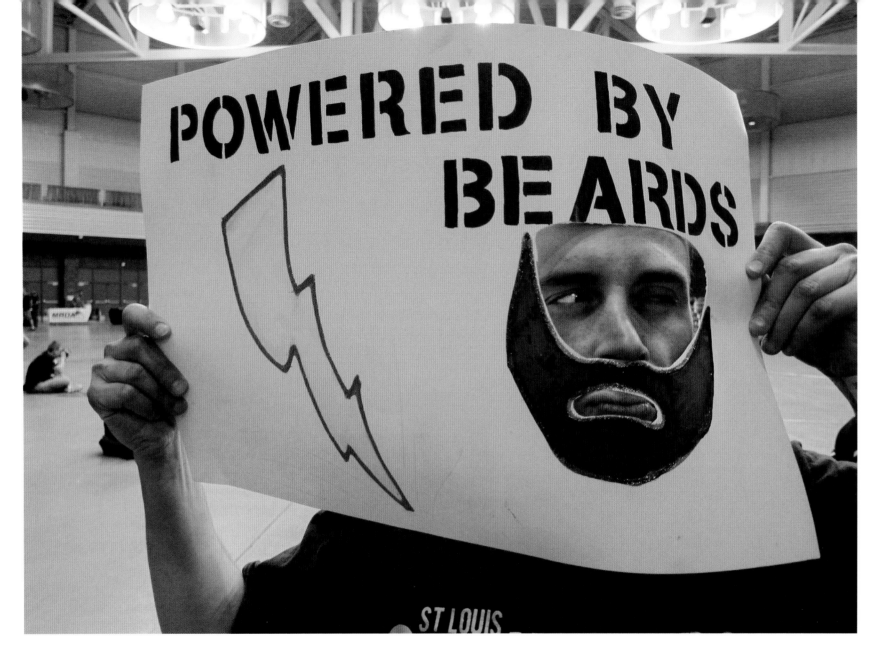

Powered by Beards, 2011

"We had just beat the undefeated New York Shock Exchange. I was on top of the world. We made our mark! I have the highest respect for the NYSE. I felt like we were a bunch of nobodies who took down the New York Yankees. NYSE I think will always be that team that has that bit of nostalgia about them, and that win over them made all those long practices and bumps and bruises along the way worth it.

"Our team motto going into Spring Roll was 'Fear the Beards.' Roller derby culture allows you to do the crazy stuff. Where else can you find a team of people with dyed beards?"

—Juke Blocks Hero, St. Louis GateKeepers

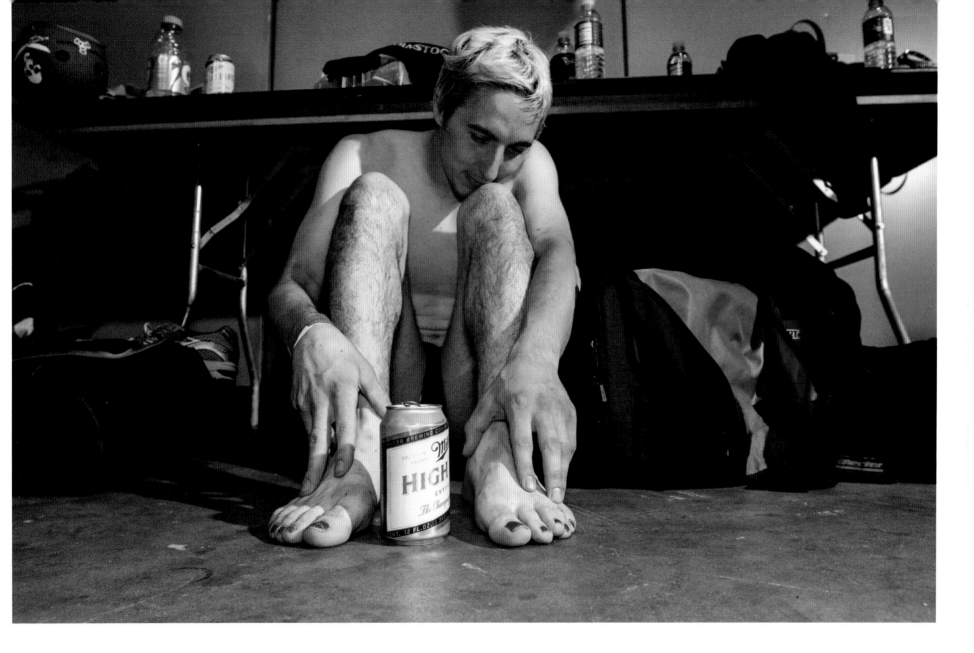

"We had just lost our first game ever, which was against the St. Louis Gatekeepers. It was disappointing to lose knowing we gave it our all, but very easily tempered knowing it was to a team that deserved it.

"Spring Roll '11 was a watershed moment: the first time the top men's teams from all over the country came together, played, hung out, and reached common ground. I had met many of the skaters from other teams throughout the prior years at random bouts all over the U.S., but seeing everyone in a competitive, organized, regulated environment just showed me how quickly this sport had grown and what amazing talent men's roller derby had to offer. My mind was blown."

—*Rinkworm*

Rinkworm,
New York Shock Exchange,
2011

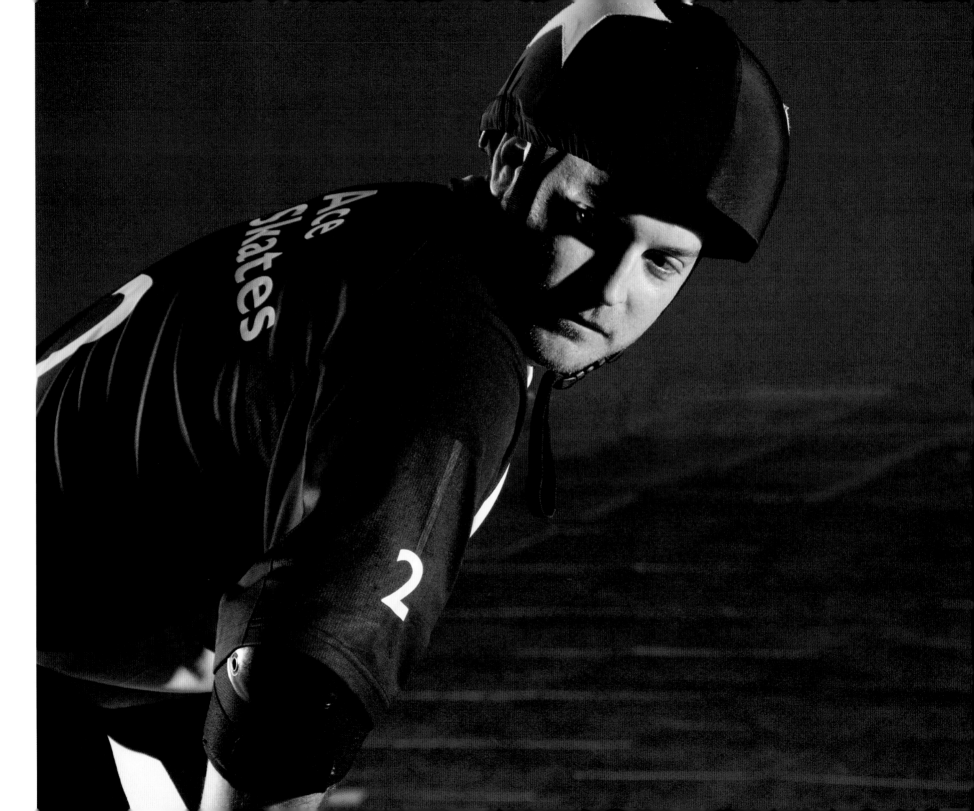

Ace of Skates, New York Shock Exchange, 2011

"Ace of Skates and I giving each other the business coming into the turn. I think our eyes tell the whole story.

The switch is turned off, I'm remembering that I am tired, or thinking about that big hit that landed me on my butt, or how to get through, instead of letting myself just flow and work the pack. This is me at a wall, not a hurdle. Hurdles come often as a jammer, and I get over them by doing what I do best, creating environments that cultivate my own success instinctively. This is a wall. Walls stop this process and make me have to think. Thinking is great because you can build new patterns, revisit whatever issue exists, and hopefully build more patterns and tools that are effective.

I still find myself hitting walls, but they are fewer, farther in-between, and much bigger! In the past few years I've been riding the rising tides of the skills and mindset it takes to perform in high-level derby today.

—*Jurasskick Park, Pioneer Valley Roller Derby's The Dirty Dozen*"

The Adversaries (II), 2011

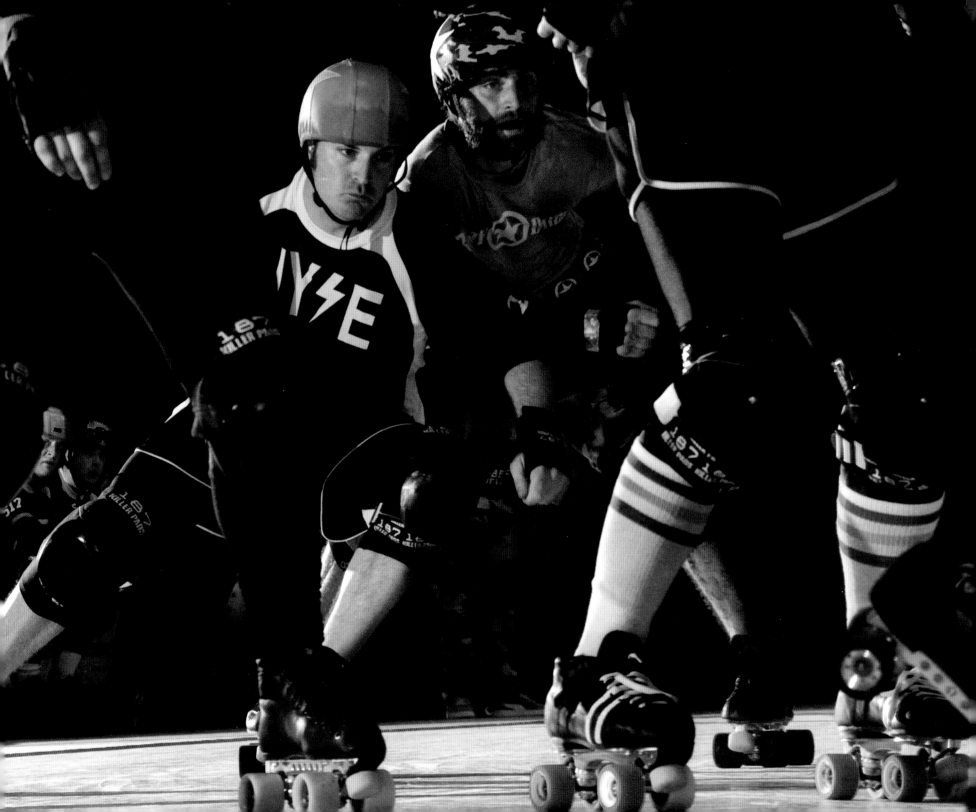

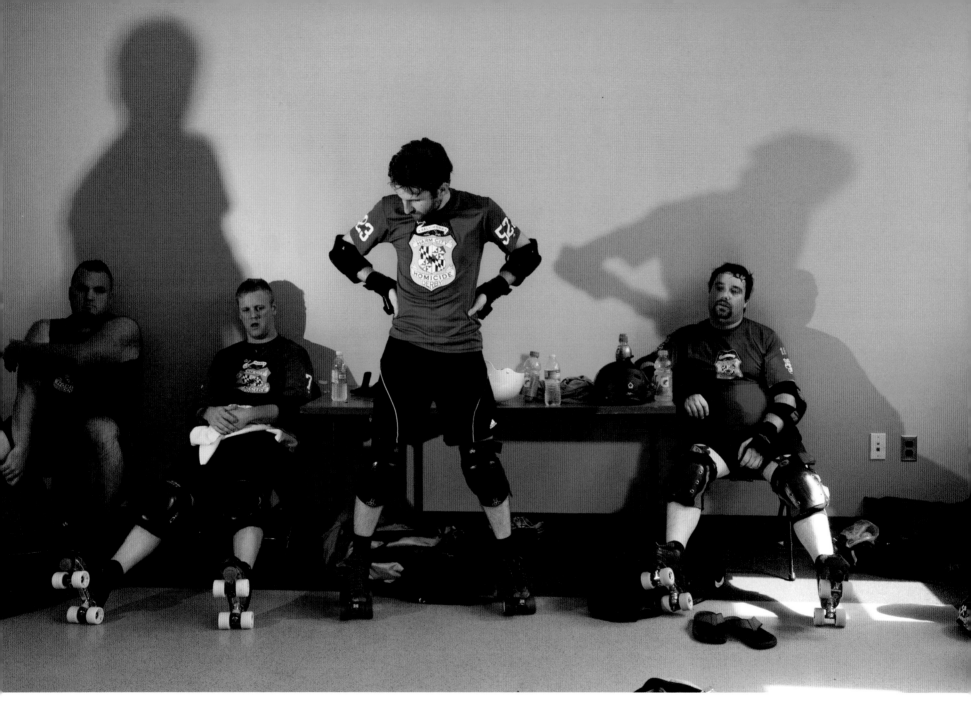

Harm City Homicide,
Aviator Field
(Brooklyn, New York), 2011

"There is a moment of regrouping that has to happen to all teams—a point where, even in the midst of an overwhelming loss, you have to pick yourself up and keep fighting until the final whistle."

—*Virginia Slim, Harm City Homicide*

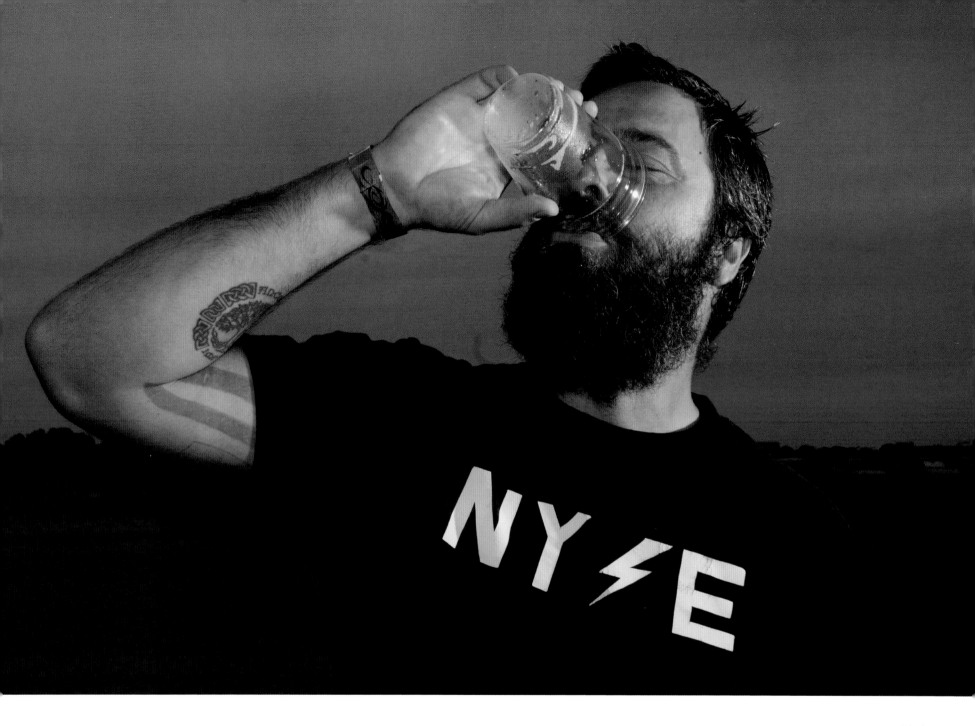

Vader,
New York Shock Exchange,
2011

Untitled, 2011

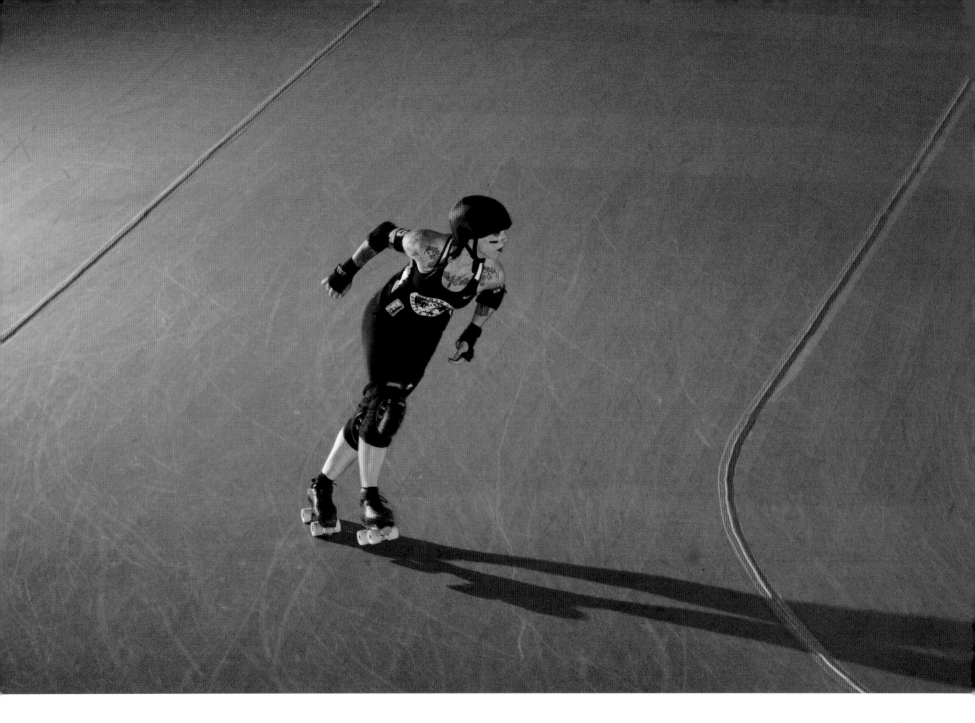

Suzy Hotrod,
Gotham Girls Roller Derby,
2011

Carnage Asada,
Harm City Homicide, 2011

"We are waiting outside of the rink until a birthday party was over so we could come in and set up for the bout.

"Roller derby doesn't usually happen in big arenas or stadiums. We hold our practices and bouts wherever we can. It happens in school gymnasiums, small-town roller rinks (a dying institution), outdoors in basketball courts and public parks, and in warehouses with no heating or air conditioning. We appreciate what we have and make the best of it."

—*Carnage Asada*

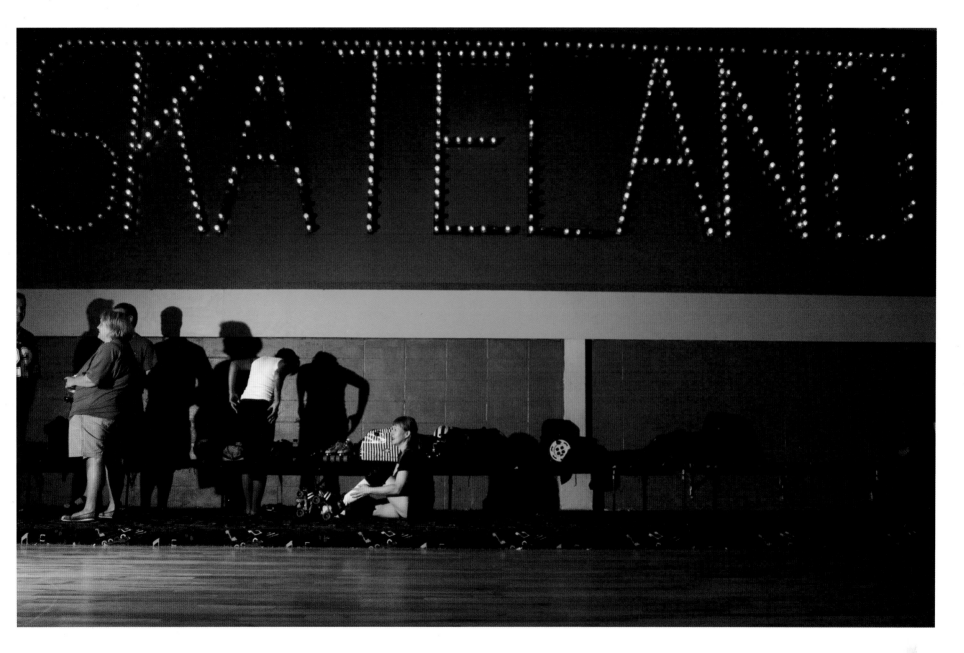

"I loved this rink floor—old school wooden roller rink floors are the best." —*Miss Trial, Head Referee, New York Shock Exchange*

Skateland North Point
(Dundalk, Maryland), 2011

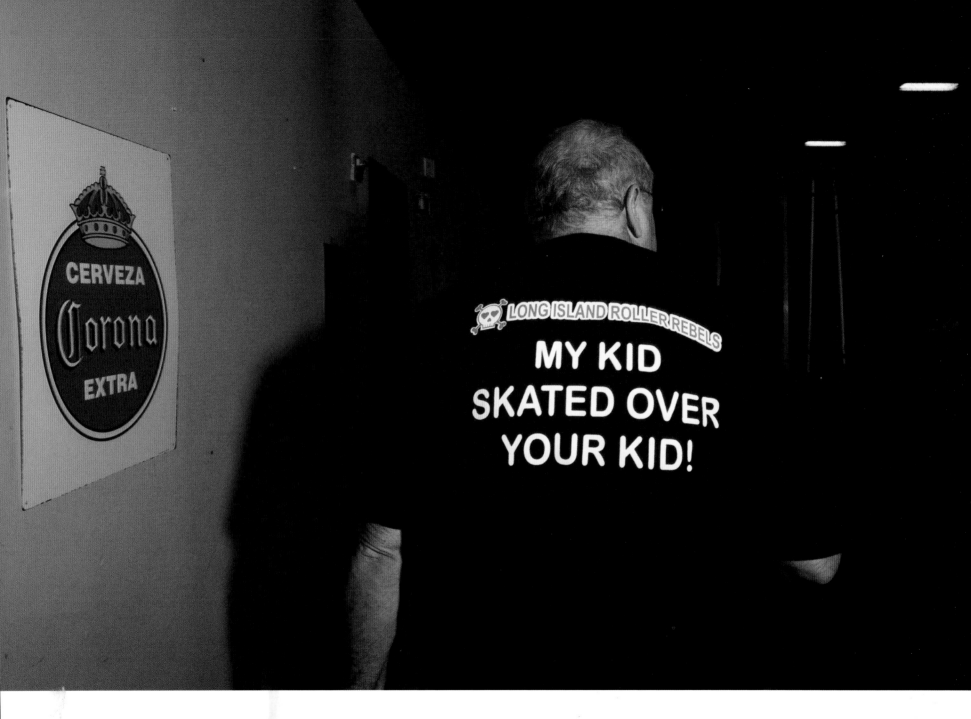

Derby Dad, 2011

"My parents have been extremely supportive of my brother (Jefferee, who skates for the New York Shock Exchange) and me. They come to every home game regardless if we are playing or not. They even travel with us for the most part. I am lucky."
—*Captain Morgan, Long Island Roller Rebels*

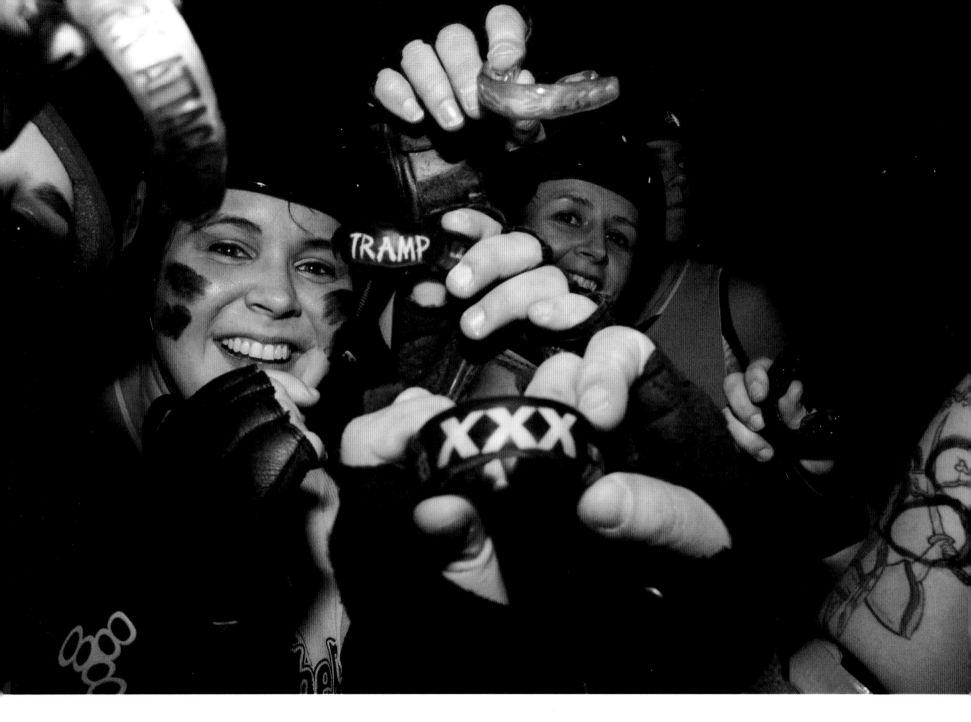

"The sport should not be taken so seriously all the time. You should have fun."
—*Anna Tramp, Long Island Roller Rebels*

Long Island Roller Rebels,
2011

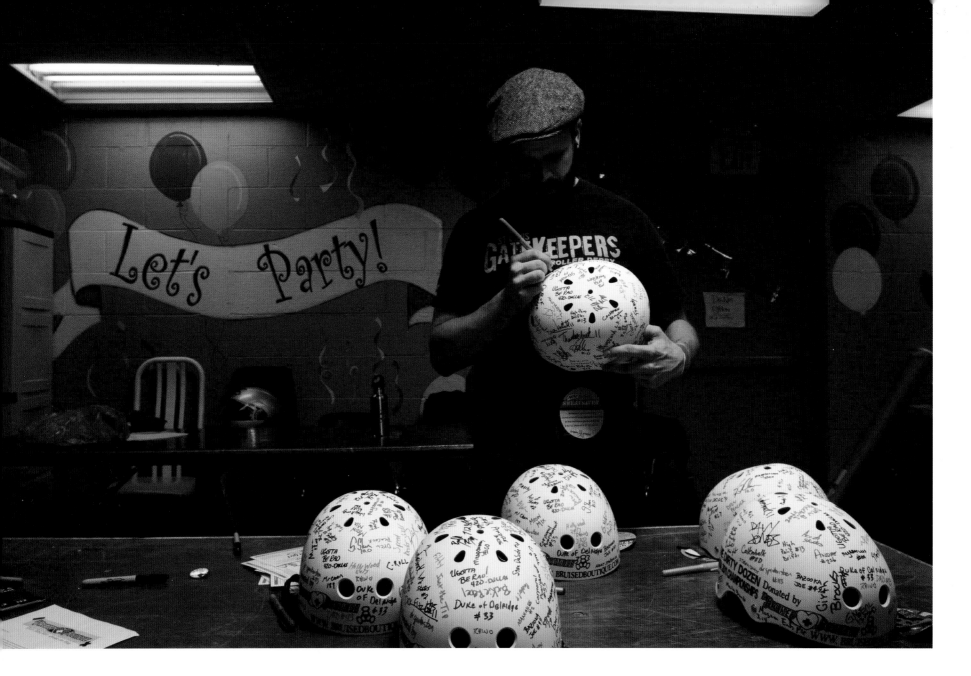

Men's Roller Derby
Association Championships,
2011

"I was a mixed bag of nervousness and excitement. My mind in a million places. I hope I spelled my name correctly. I never signed an autograph of any sort in my life. In everyday life, all of our signatures are only worth something if we are signing a check. It sounds kind of funny, but it really meant a lot to me to get to slap my name down on something that all the skaters I look up to and respect put their names on. I was judging how lame mine looked compared to everyone else. Not gonna lie, Quadzilla has clearly practiced his a bit."

—*Juke Blocks Hero, St. Louis GateKeepers*

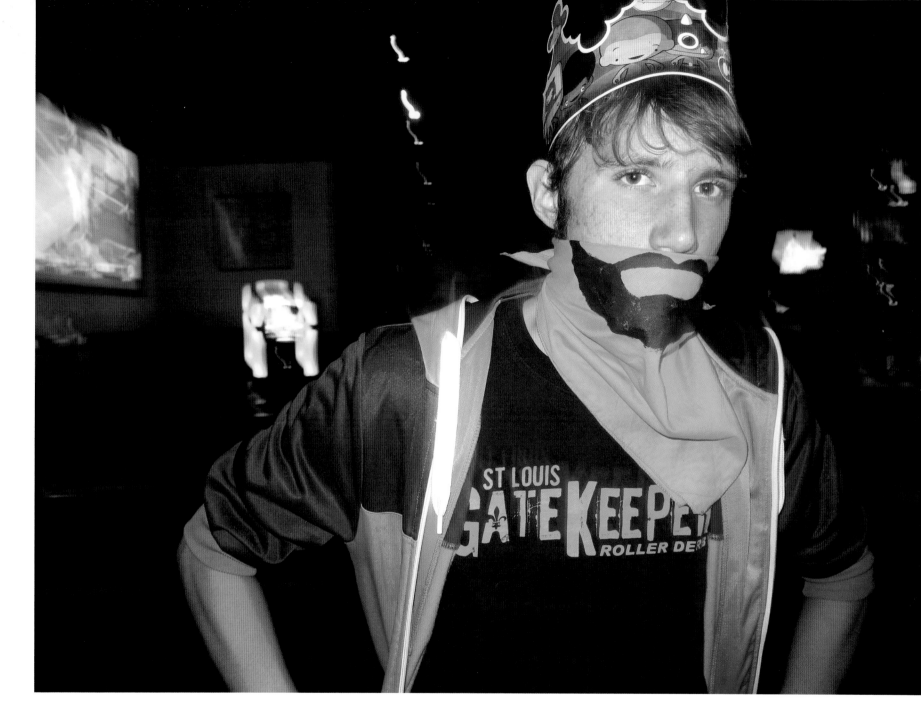

"I'm pretty happy about my sweet beard bandana and Burger King crown. Please stop asking if I was old enough to be in that bar. I wasn't. Joke's old, brah."

—*ShaneGo Fett*

ShaneGo Fett,
St. Louis GateKeepers, 2011

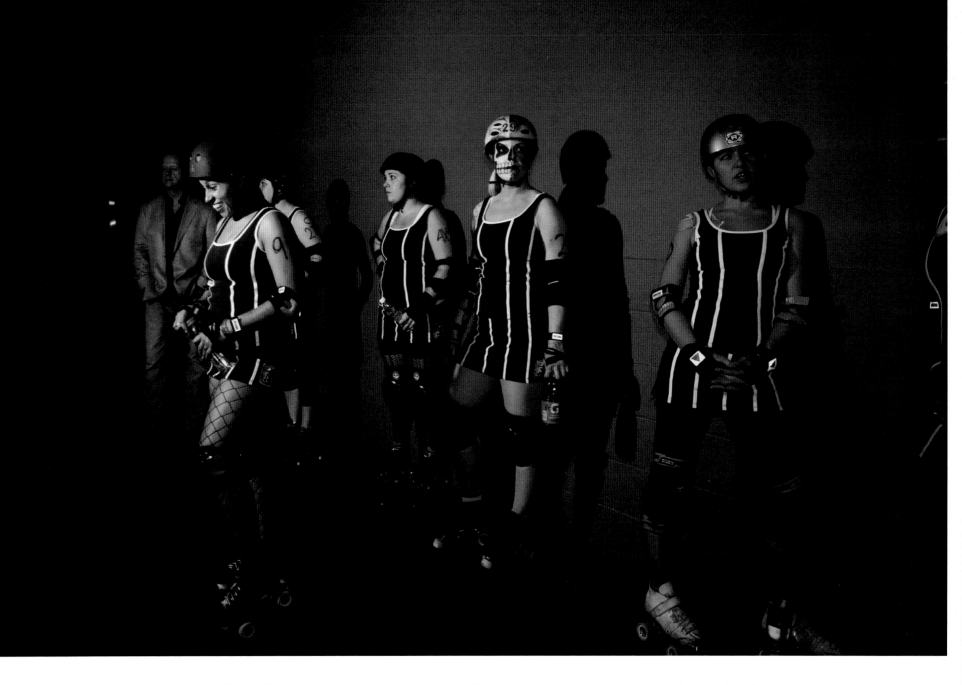

Oly Rollers,
WFTDA National
Championships, 2011

"Generally I am nervous before bouts but this was a completely new scenario for me. I had never played derby at this level, and I felt like I had many fingers ready to be pointed at me if I didn't deliver. I had lots of those emotions going through, but once the game started everything was gone, and I was able to focus on the game and do my best."

—*Stella Italiana, Oly Rollers*

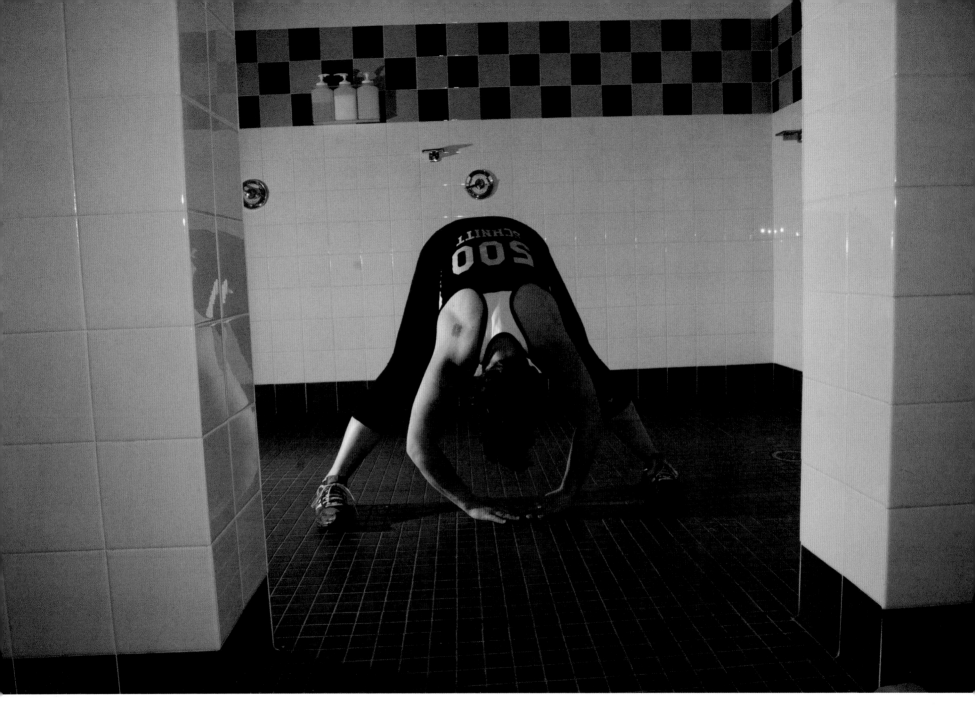

"There's a lot of together time. Sometimes you just need to be solitary. Having some time with yourself can help you visualize and clear your head."

—*Papierschnitt*

Papierschnitt,
Gotham Girls Roller Derby,
2011

My brother, sister, and I secretly all decided to fly out to Denver and surprise my sister for the last bout of her career in Denver. My brother flew out from Kansas City and actually had to hide from Kristin who was on the same flight. We all linked up and surprised my sister the night before her first match.

We 'borrowed' some of my sister's sequin booty shorts to wear for her match. My brother Colin and I actually put those shorts on while we were sitting in the seats and while our jeans were on. We are quite flexible.

I loved watching my sister during her career. She really knows how to open a can of whoop-ass on some girls.

—*Doug McFarland*

I really just loved watching my older sister play. I can't really describe the emotional ride of watching a sibling be kickass. It is an extension of yourself.

It was nice to reunite the clan for a crazy weekend. All three of us were sleep deprived, intoxicated and were not receiving proper circulation to our brain from how tight those booty shorts were. And we were trying to breathe (not used to the altitude).

It was a family affair, and we were *the* loudest people in the building. No fans will ever match what the McFarland Clan brought to that weekend. No player will ever match Eclipse #0.

We partied with the roller derby girls at a Denver line dancing bar after some of the games and we kept taking our pants off. Needless to say they didn't like that.

— *Caitlyn McFarland*

My sister could have been in competitive basket weaving, and if they'd let me come watch and drink, I'd have been there.

— *Colin McFarland*

Having my 'original pack' there to see me play my best and to cheer for me, to this day, brings tears to my eyes. If I could bottle up the feelings and sell them, I'd be a rich woman.

—*Eclipse (aka Kristin, née-McFarland Clarke), Kansas City Roller Warriors*

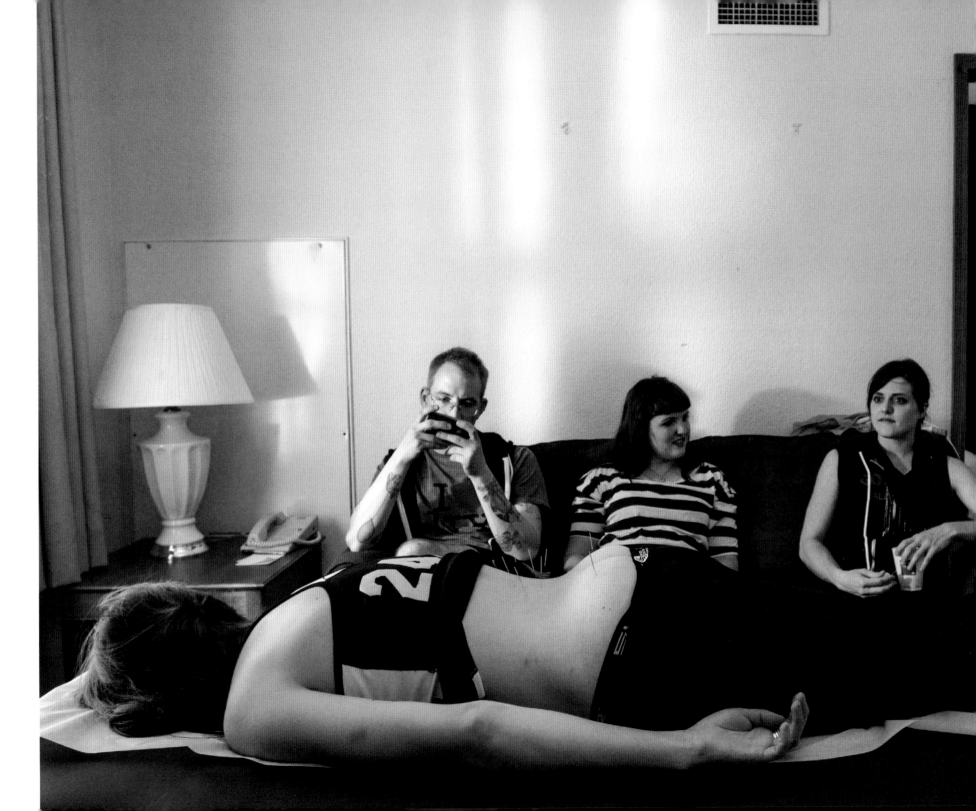

"I like that my butt looks bigger than it is in real life, which is kind of exciting. I mean, it was the end of the season, so it's usually bigger at that time anyways, but it looks extra large. Big butts are definitely a universal aspect of roller derby culture. The exercises we do make our glutes bigger.

I remember being in college and freaking out that I was gaining weight, which happens to almost everyone when they hit 19-20, and then I realized that that was dumb. Now if asked, I generally guestimate my weight higher than it actually is and am sad if I lose poundage because that usually means that my muscle is turning into fat (heeeello holiday/off-season!).

—*Fisti Cuffs, Gotham Girls Roller Derby*

"My sister, Diva Emily, front and center getting pampered. That's what it's been like for me ever since she started in Tucson. Although, I don't mind. Sometimes I get a bite of whatever fancy delicious food she has, and it's really awesome to watch her be focused on crushing the other team.

—*Gratuitous Violet, Arizona Roller Derby*

Acupuncture, 2011

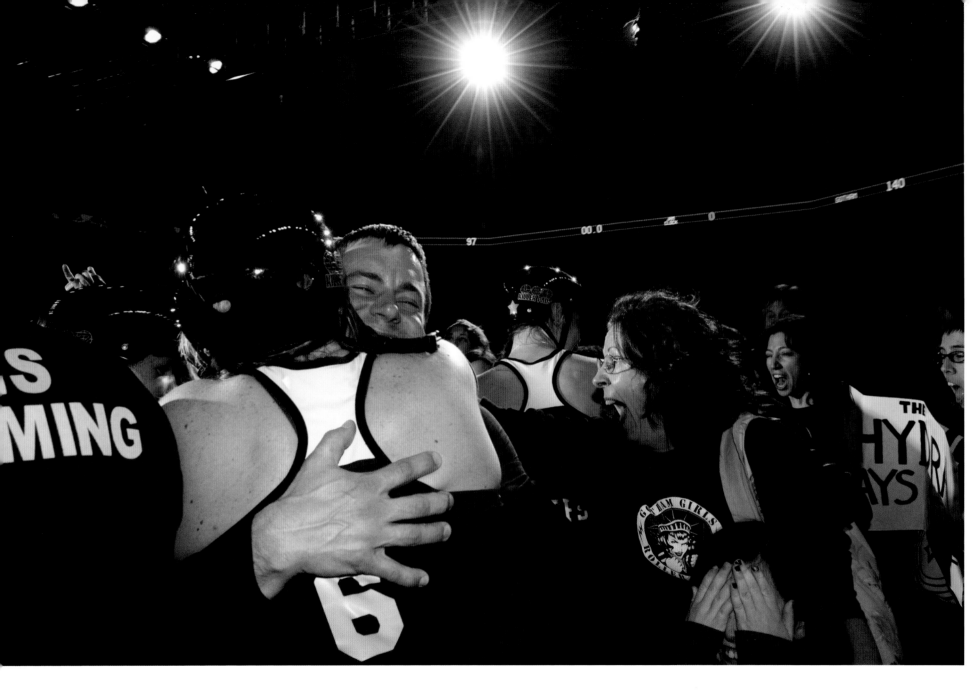

National Champions, 2011

"This is the season that our mantra became 'Hard, Smart, Together, Gotham!' In 2011 we decided at the beginning of the season that if we wanted to win against Oly and Rocky, we would have to out-train them. Both of those teams had amazing players who had been skating since they were old enough to walk—world champion speed skaters and hockey players. We knew that we could not out-skill them without years more practice but we could 'outsmart, out-train and out-team' them."

—*Buster Cheatin, Gotham Girls Roller Derby*

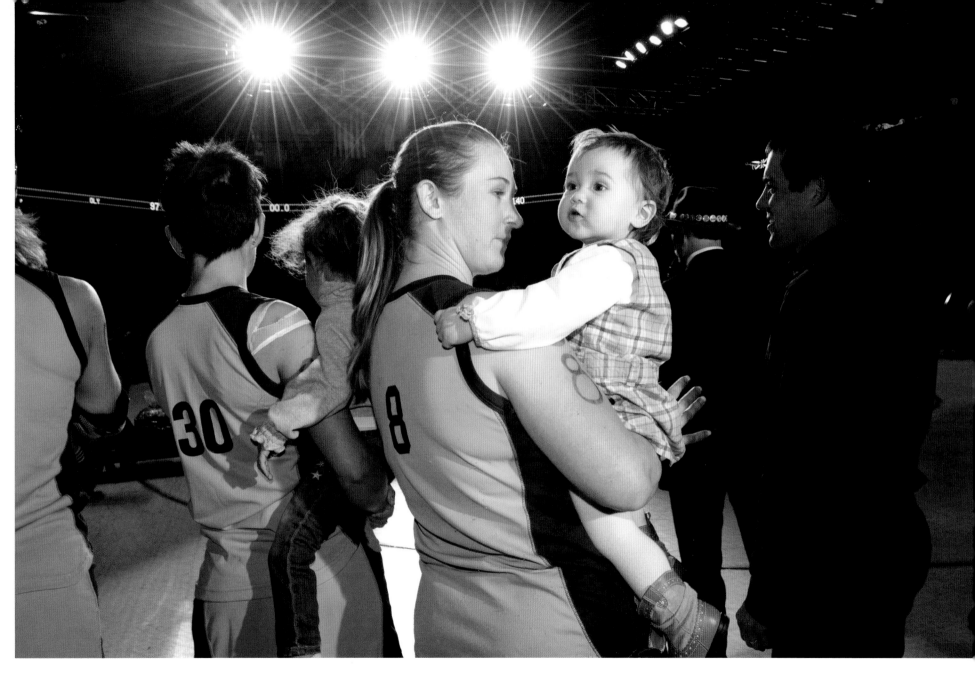

"We had just skated our hearts out in the championship game against Gotham. Even though we lost, getting second is such a huge accomplishment in this sport. I was so proud of my team. I was so happy I was able to have my daughter with me to share this experience with her."

—D-Bomb, Oly Rollers

D-Bomb, Oly Rollers, 2011

"The heavier the trophy is, the better.
—*Fisti Cuffs, Gotham Girls Roller Derby*"

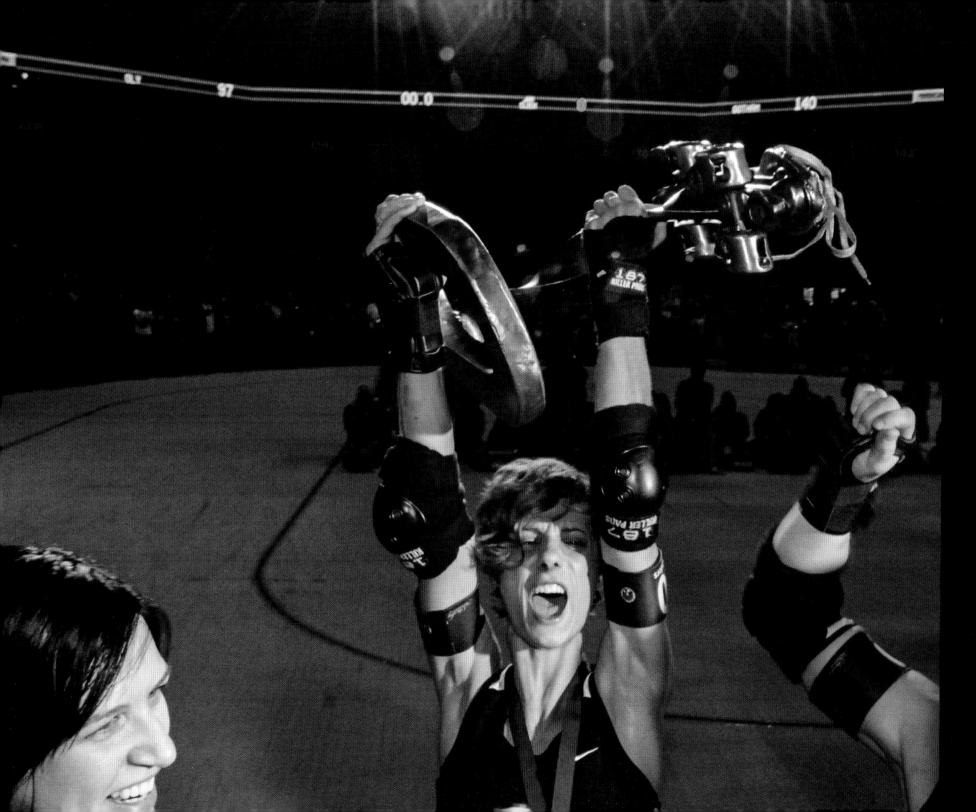

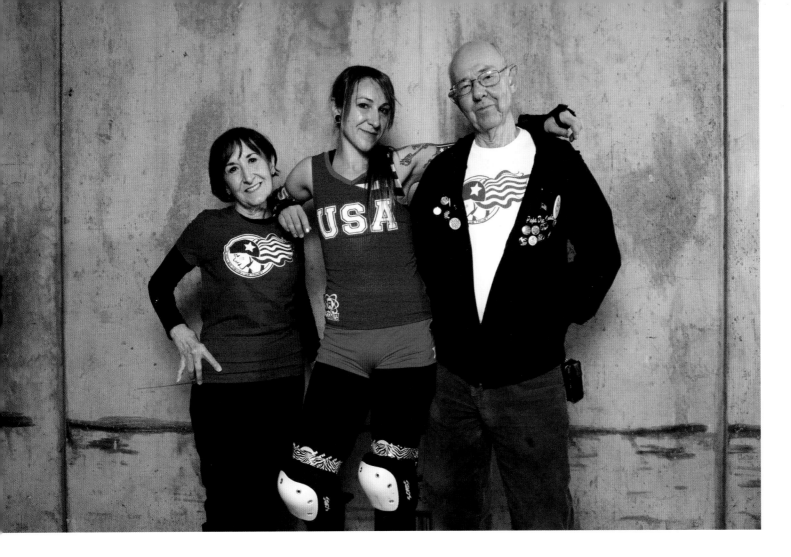

Varla Vendetta,
Team USA, 2011

"My parents (well, my entire family) have been by my side since the day I entertained the notion of playing derby and our league was just a fledgling group of women dreaming big. My mother and father, Mama Vendetta and Papa Doc Vendetta, got involved as medics early on in the sport (they are a doctor and nurse by profession), and I think are perhaps pioneers in the position for flat track derby. Windy City Rollers is one of the few teams (if not the only team) to have and have had a full-time, traveling medic crew. My parents have gotten to know and have attended to skaters all over the world, and my dad wrote articles for *Blood and Thunder Magazine* and *Derbylife*, and even wrote his own derby medical handbook to help leagues with basic care and tips, which connected him to leagues worldwide even before the World Cup. My mother was featured for her work in derby in a documentary book on unusual nurses in America. They understand and love the spirit of the sport.

"My father was in the Air Force. My mother was first generation born in this country. I was raised to cherish my country and respect what it means to be an American. Team USA found me a way to show that pride. Being named to the very first Team USA for the inaugural Roller Derby World Cup meant so much to everyone in my family."

—*Varla Vendetta*

"Derby is a family—sometimes by genetics—but always by the derby experience." —*Papa Doc, medic, Windy City Rollers since 2005*

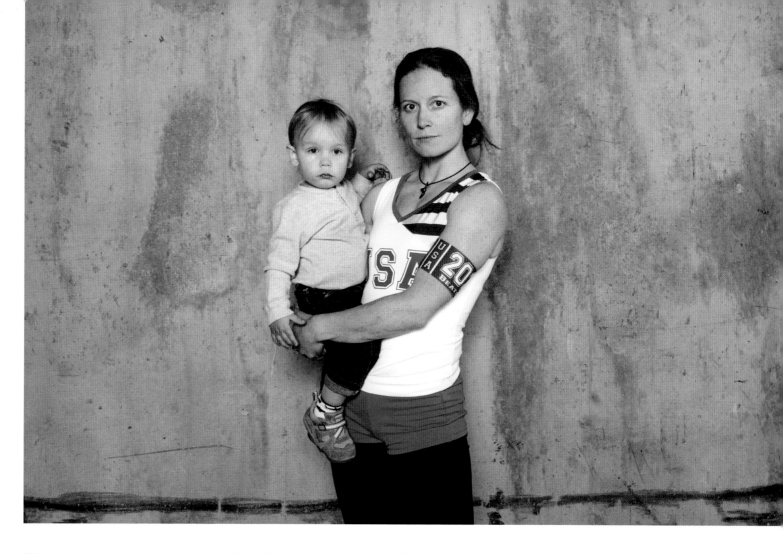

"My son is so handsome and I just love him to pieces. I'm sure he won't remember it, but I was also very proud to have him there watching me doing something I love and making history with Team USA.

"There are so many mothers who play roller derby. To do so, we must juggle many obligations. Roller derby is often the one thing that we get to do for ourselves and it is truly empowering. It is also something that makes us strong examples for our children."

—*Frida Beater*

Frida Beater,
Team USA, 2011

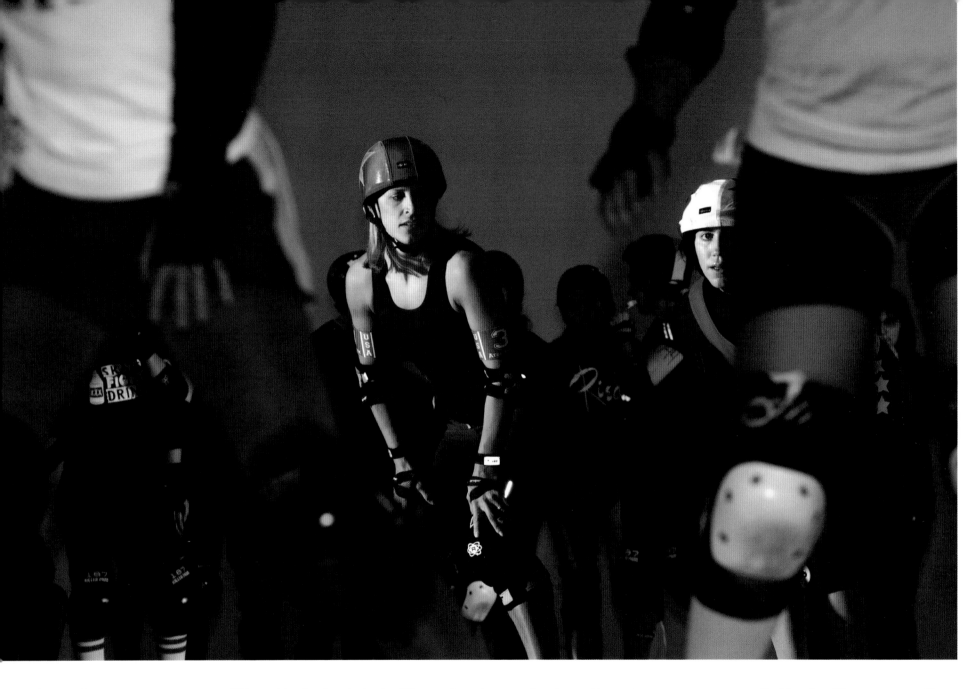

Atomatrix,
Team USA, 2011

"The spirit of roller derby is different than the speed racing culture where you are not usually friends with your competitors. I like the laid-back approach—let's compete and be fierce on the track, then shake hands, have a hug, and some drinks at the after-party."

—*Atomatrix*

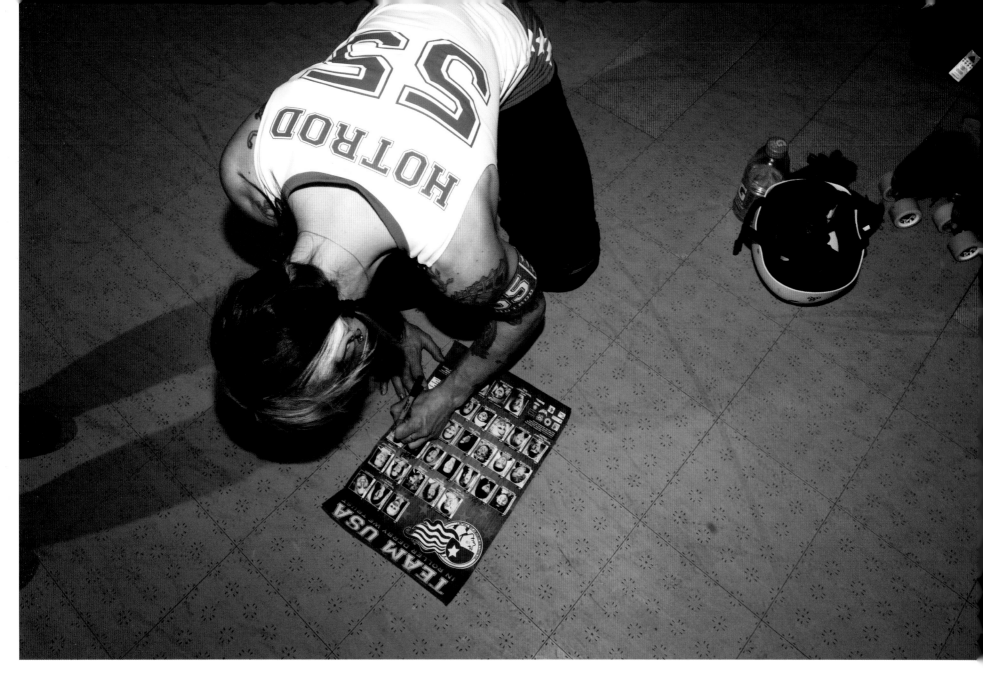

"I sign autographs at roller derby. I sign expense reports the other 90 percent of the year. I guess you can say I am 'derby famous.' In our niche world, I may sign hundreds of autographs at Rollercon and then walk outside and be an anonymous nobody. It's the perfect touch of fame because I can be well known in one building on one day of the year, then be a regular everyday person the rest of my days."

—Suzy Hotrod

Suzy Hotrod,
Team USA, 2011

Haka Mo Nga Wahine

KO TE WHAKARIKI, KO TE WHAKARIKI
NAU MAI NGA HINE KIA HAERE TATOU

Leader (Hori/Sarge):
HE TAUA, HE TAUA
KO TE MEA NUI TE PUHI
KO TE MEA NUI TIRAWA

(Intro to Marching):
KIA HIWARA, KIA HIWARA
KIA HIWARA KI TENA TUKU
KIA HIWARA KI TENA TUKU

Solo (Hori):
KIA TU, KIA OHO, KIA MATARA

Leader (Sarge):
E HINE MA WAEWAE TAKAHIA

(Everybody):
HAERE MAI TONU RA E NGA MANUHIRI
I RUNGA I TE UPOKO HOU I TE PO
MARANGAI I TE PUEHUTANGA O TE AROHA
AU WHAKARAU, AOTEAROA KAKITE
WHARE TE MANUHIRI UIA MAI, UIA MAI
NGA KANOHI KI TE RAU O TE AROHA
I AHAHA
HI

This roughly translates as, 'Welcome all women. We will go as one in our teams. We stand. We recognize we are strong. Keep coming our visitors into this game of the night. We embrace you with love and bring the heart of our country with us as we are all one people.'

—*Solid Sarge, Team New Zealand*

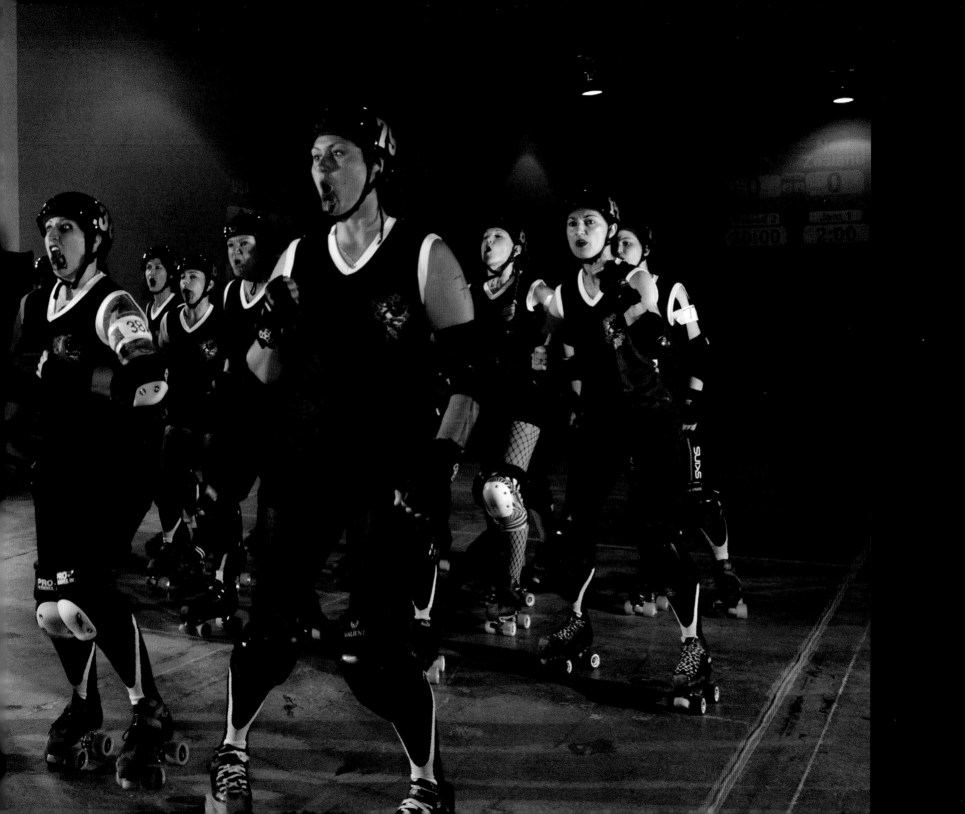

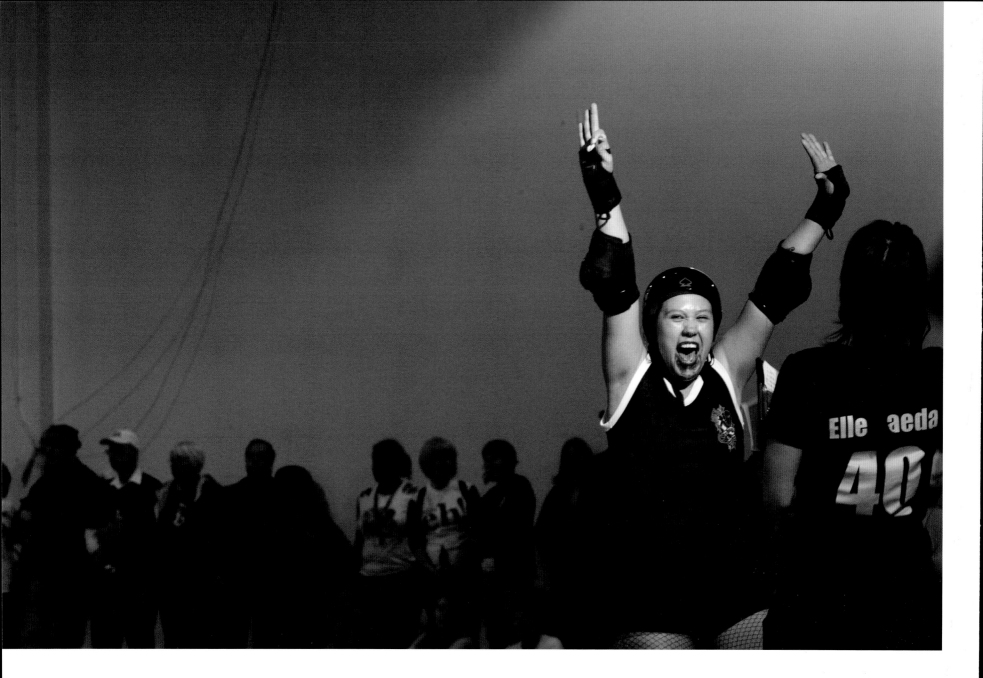

Skate The Muss,
Team New Zealand, 2011

"When Axl Slasher scored the first points against Team USA, the whole crowd erupted in cheering because Team USA are so ridiculously good. The relief of scoring against such an amazing team, the pack having to work its arse off to get jammers out was just crazy. Muss came up to the bench coach right at the very end of the game and demanded to jam. And she scored! She wasn't lead jammer, but Atomatrix got stuck for a minute behind our wall and Muss snuck past. She stole the points and we couldn't have been happier. I just wished she had jammed from the start..."

—*Pieces of Hate, Team New Zealand*

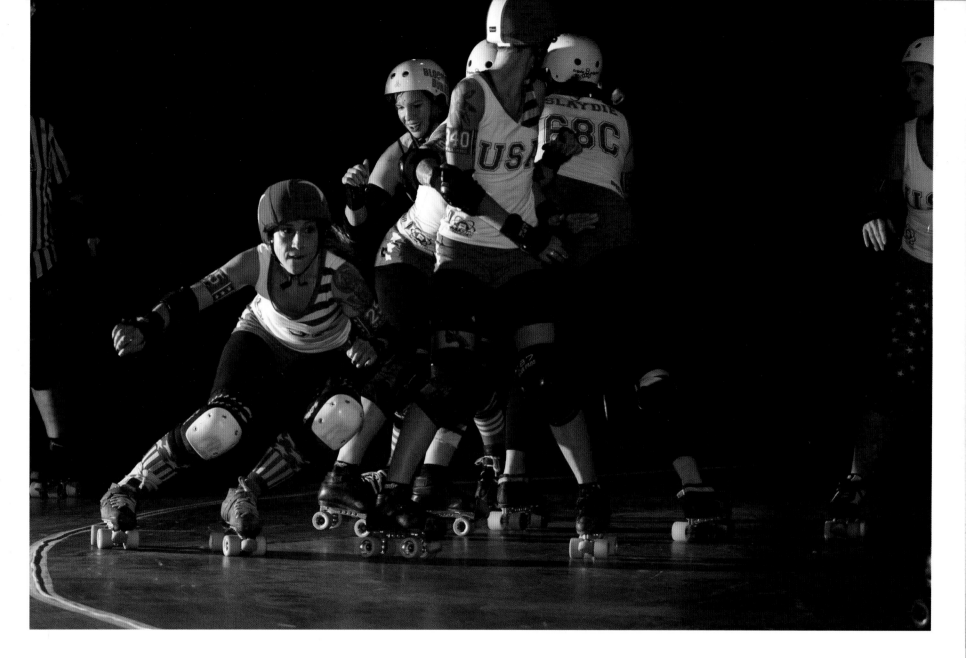

"I remember being in one of the early 2004 practices of my Chicago league, the Windy City Rollers, one of the original WFTDA leagues, and our league founders asking if we wanted to try and have a public bout. That was a huge deal: just trying to organize fifty to sixty women to put on a game in Chicago. Fast-forward seven years, and I am representing my country in a tournament involving thirteen countries, playing on foreign soil. It speaks a great deal to the initiative of those involved in the flat track resurgence. That's something I've always loved about those in the flat track community: the ability to get it done."

— *Varla Vendetta*

Varla Vendetta,
Team USA, 2011

Justin and roller derby were so intertwined in my life that I don't think I could have separated them. We had been together for seven years at the time of the World Cup. He managed almost every team I was on. Without Justin, I wouldn't have continued to play roller derby at all, and I certainly wouldn't have been on Team USA.

Not only was it an emotional time playing on our country's inaugural national roller derby team, but a relationship that had lasted almost the entirety of my adult life was in the process of ending. The idea of either separating him and roller derby or giving them both up was terrifying. I was terrified that he or I would have to quit roller derby if we broke up.

We broke up five months after this picture was taken, and I think this might have been the last time we kissed.

Luckily things worked out really well, and I still don't exactly know how it happened. We're still great friends. We were able to transition our relationship into something more akin to family, and I wish I knew how we did it because I don't think it happens very much but I think it should. Maybe I'll figure it out eventually and then write a relationship advice book and make a lot of money.

Things may change in roller derby culture, but coaches and players will still have awkward kisses after games.

—*Fisti Cuffs, Gotham Girls Roller Derby*

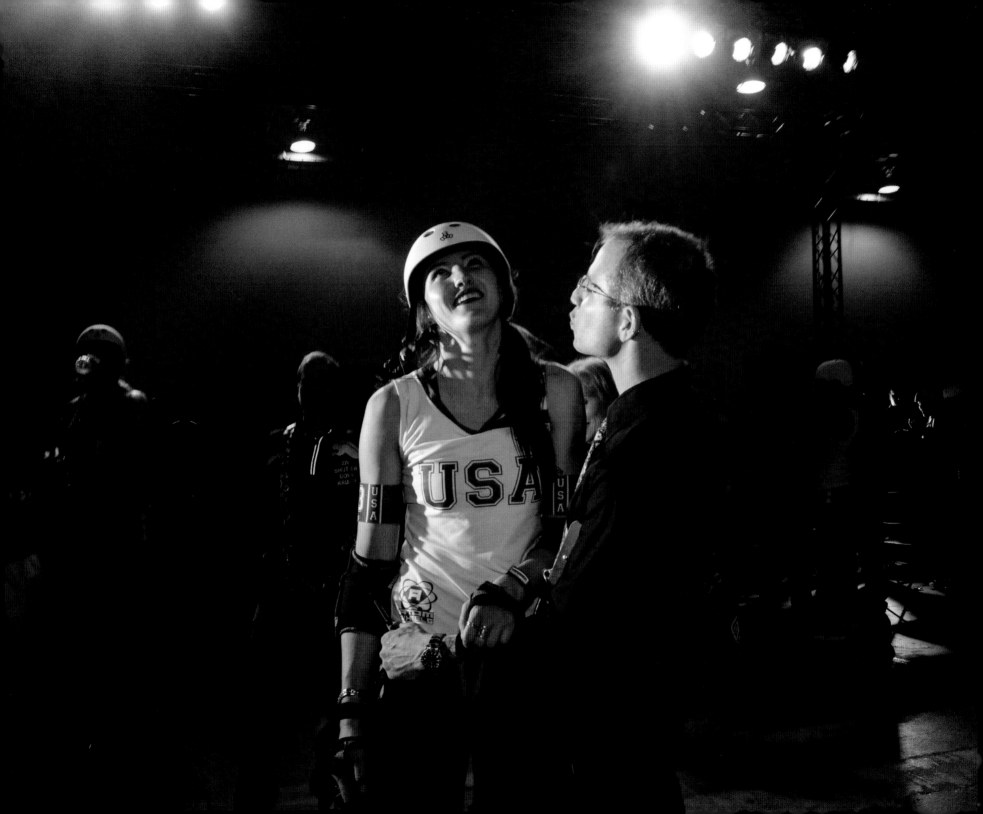

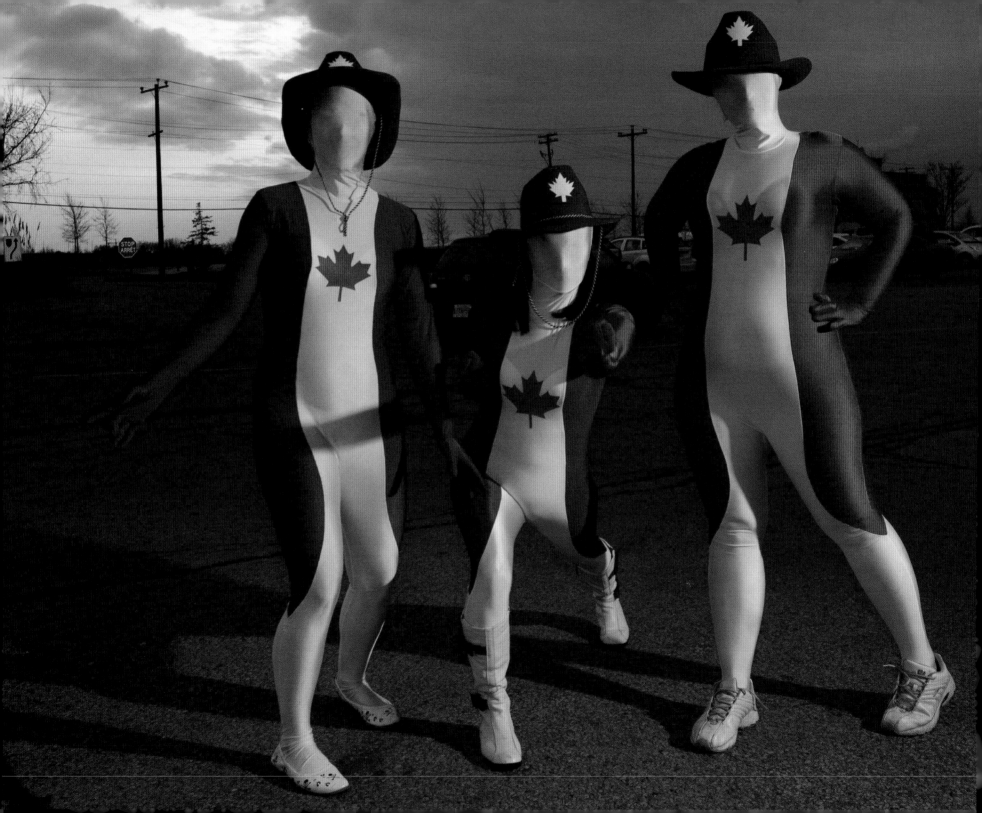

"We have already been asked by our American opponents to please bring the person in the morph suit to the next World Cup. Roller derby has given me the confidence to pretty much do anything and never feel embarrassed or worry about what other people think. For every 1,000 that think you are crazy, there is at least one other person that is either a) cheering you on or b) doing it with you.

—Anya Face, Forest City Derby Girls

Team Canada superfans, Roller Derby World Cup, 2011

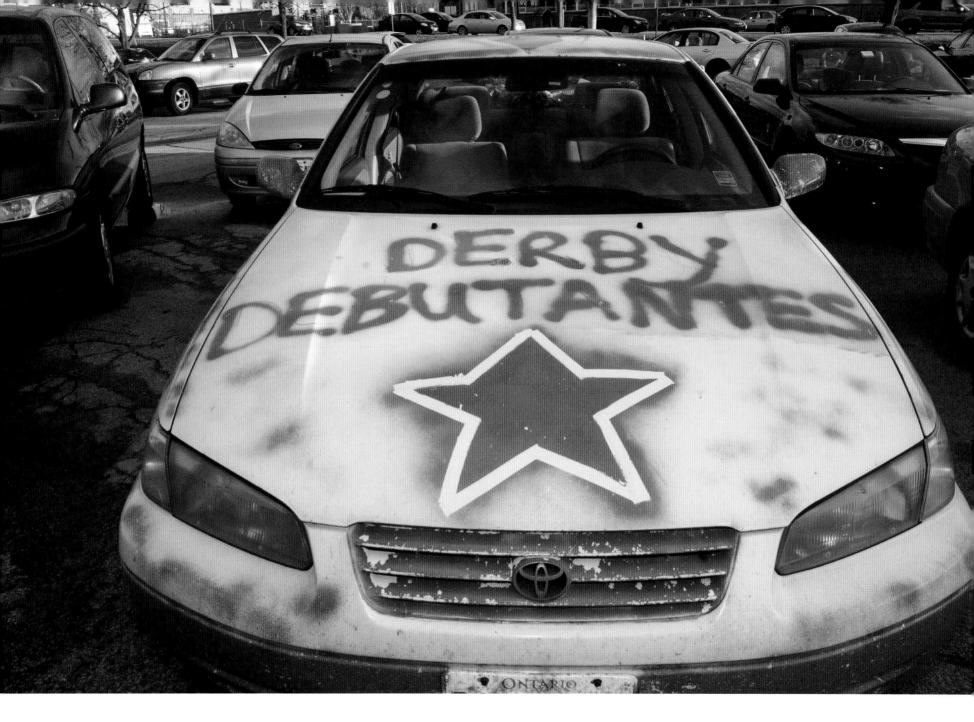

Derby Debutantes, 2011

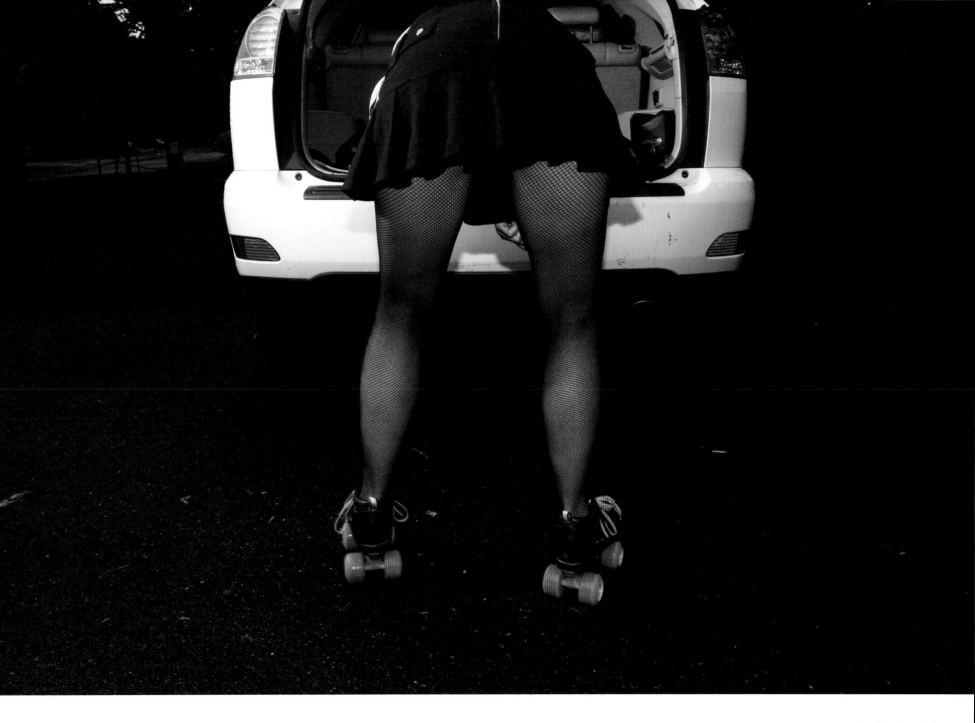

Untitled, 2008

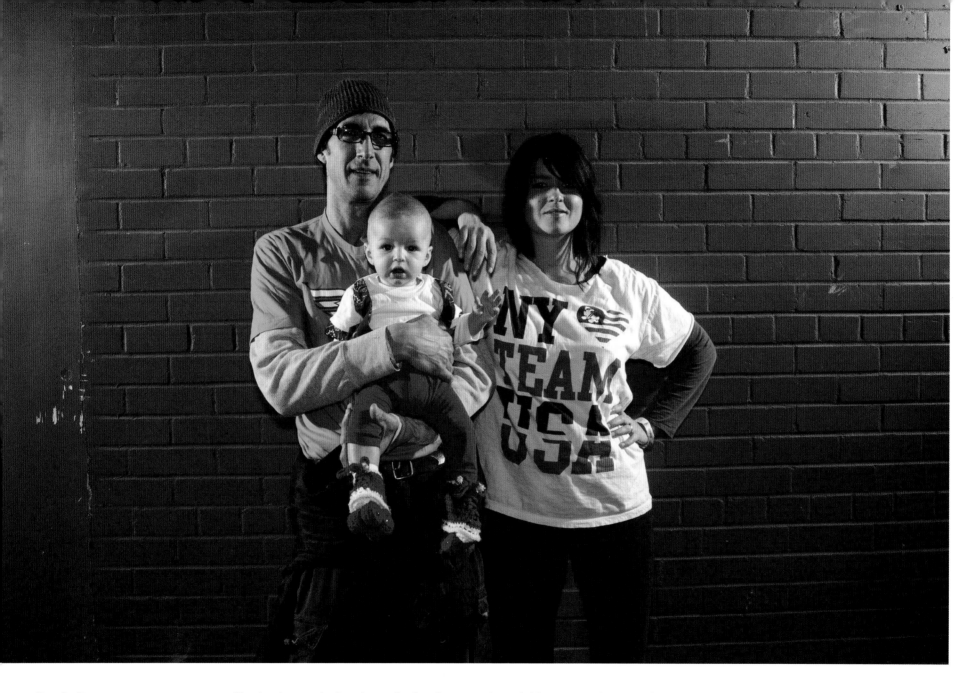

Sarabellum,
with Babybellum,
and husband, George,
Roller Derby World Cup,
2011

"Derby demands that the entire family get on board. My son was in about five bouts in utero."
—Sarabellum, Ithaca League of Women Rollers

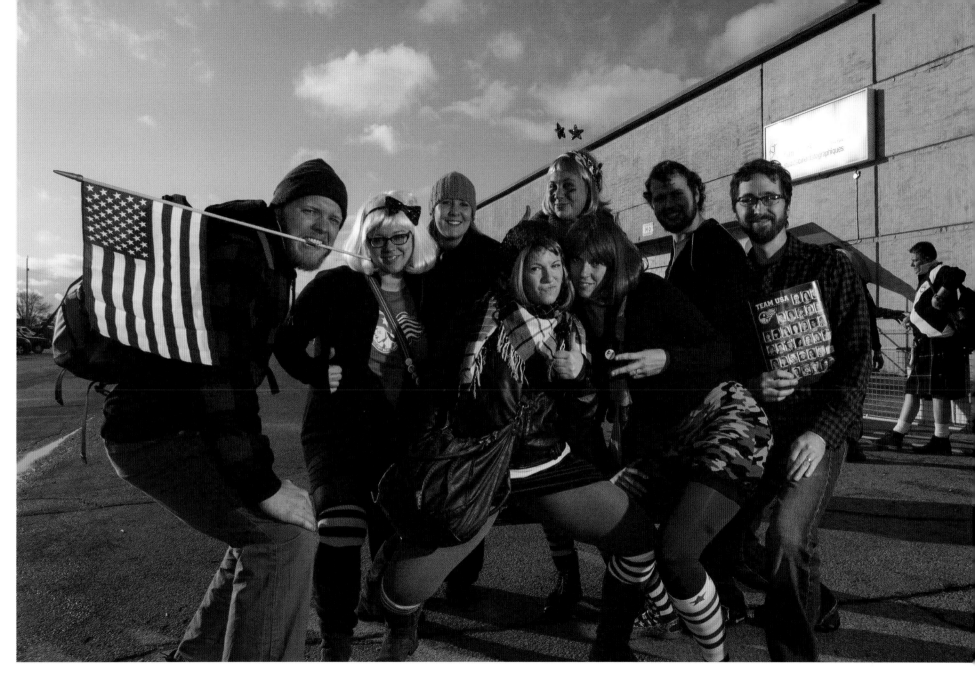

"Here are teachers, a physician's assistant, a piercer, computer technician, photographer, speech pathologist, and a lawyer. All participate in roller derby in some capacity, whether it's skating, reffing, announcing, or volunteering. Roller derby is an all-inclusive sport, where everyone has an integral part to keeping leagues running.

"Obviously none of us are camera shy."

—*Teachy McKill, Plattsburgh Roller Derby*

Team USA superfans,
Roller Derby World Cup,
2011

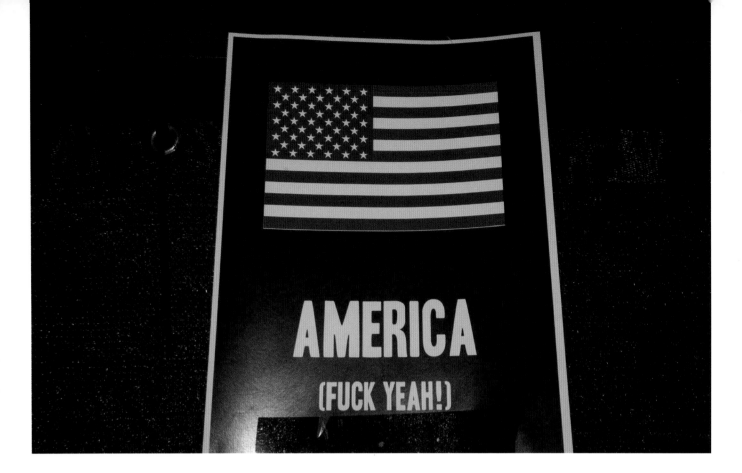

America (Fuck Yeah!), 2011

"In roller derby, we pride ourselves in being offbeat, nontraditional, part of a counterculture. We're not what you might think of when you think of your stereotypical, patriotic American citizen. But when you play for your country, something special is going on. You're representing America, and that's a big deal. You're the best of your country, and feelings happen. I tend to not be sentimental about things like American pride or—you know—*feelings*; but something happens when you play for your country. Feelings happen."
—*Fisti Cuffs, Team USA*

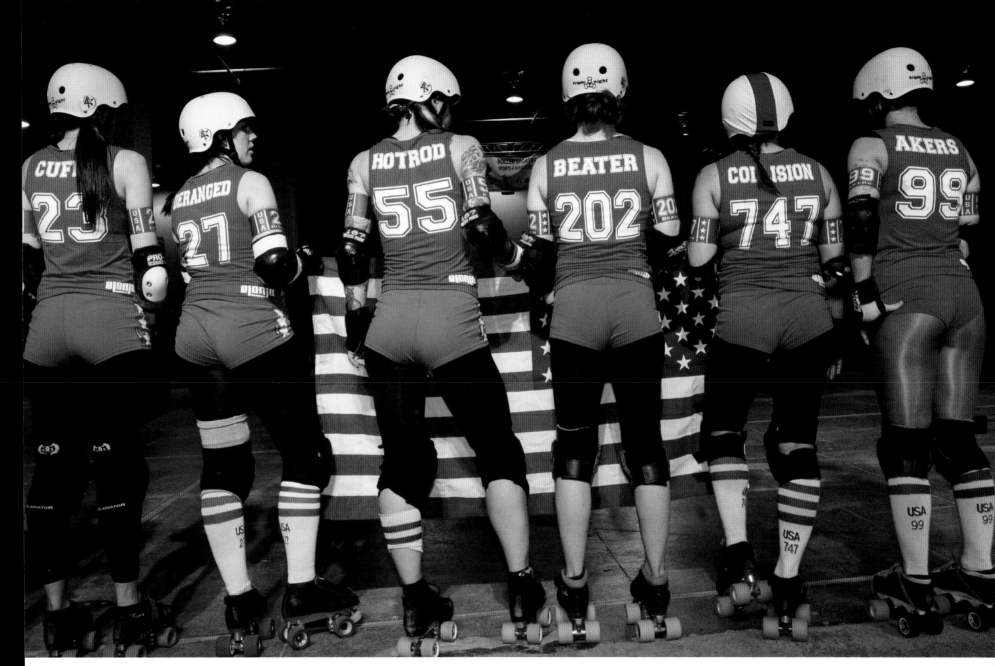

Team USA,
Roller Derby World Cup,
2011

> "If someone hands you a World Cup with champagne in it, you drink!
> —*Sexy Slaydie, Team USA*"

World Champions, 2011

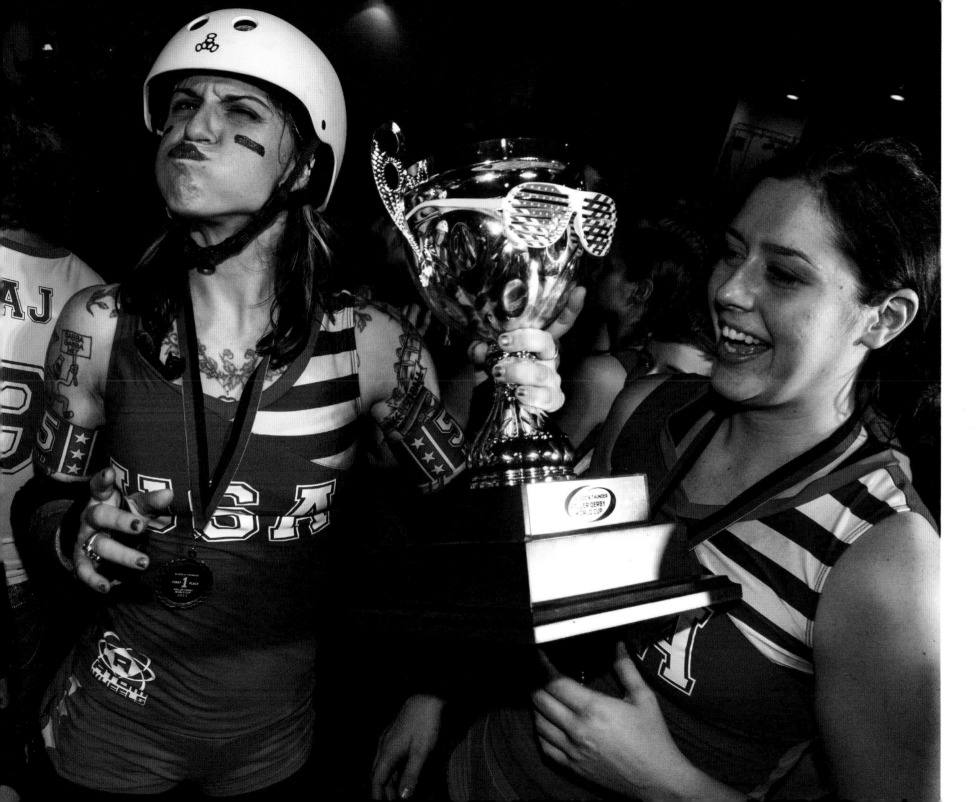

Sammy Dangerfield, 2012

"Bright lights, funny names, silly bars. Those were the days, I tell ya.
—*Sammy Dangerfield, New York Shock Exchange*"

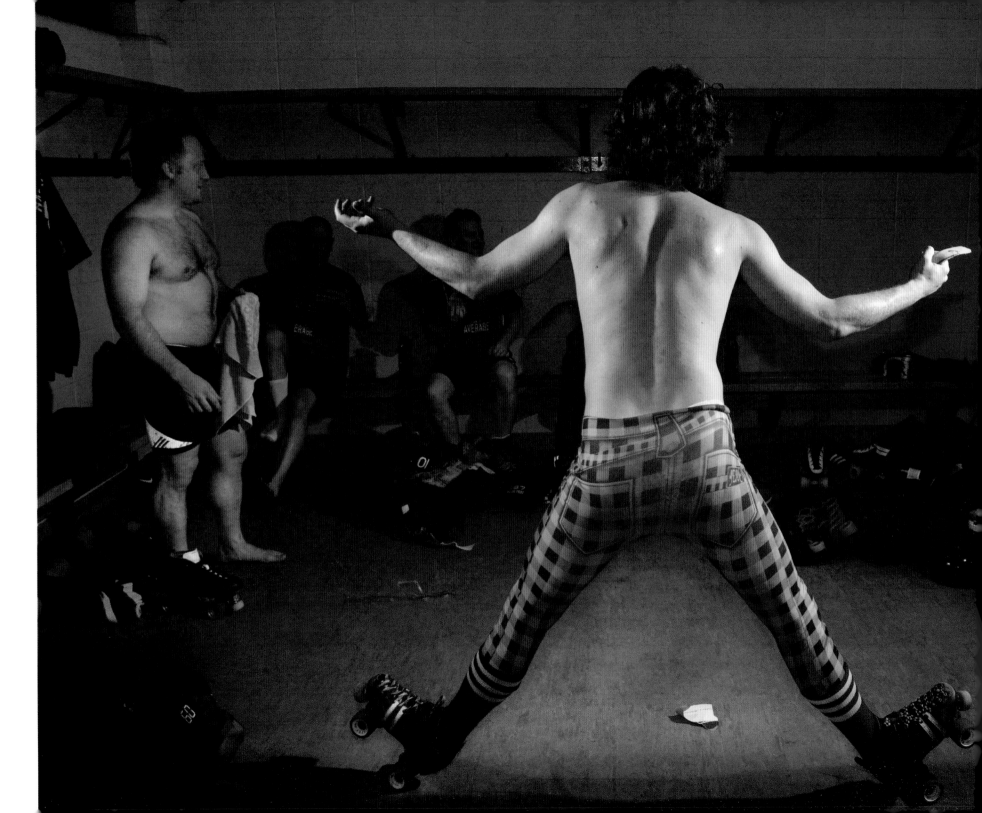

Sammy Dangerfield, New York Shock Exchange, 2012

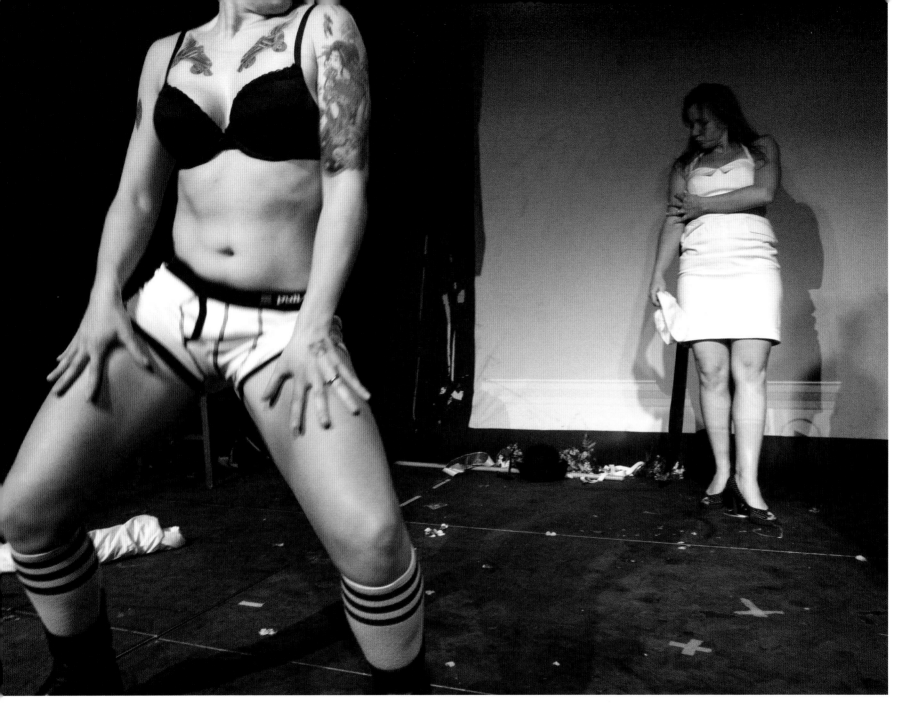

Derbytaunt Ball, 2012

"This is just before Sk8 Crime was chosen as the dance-off winner, and I was probably thinking that it would be bullshit if the dance contest was won based on how much clothing was removed."

—Nikki Nightrain, Gotham Girls Roller Derby

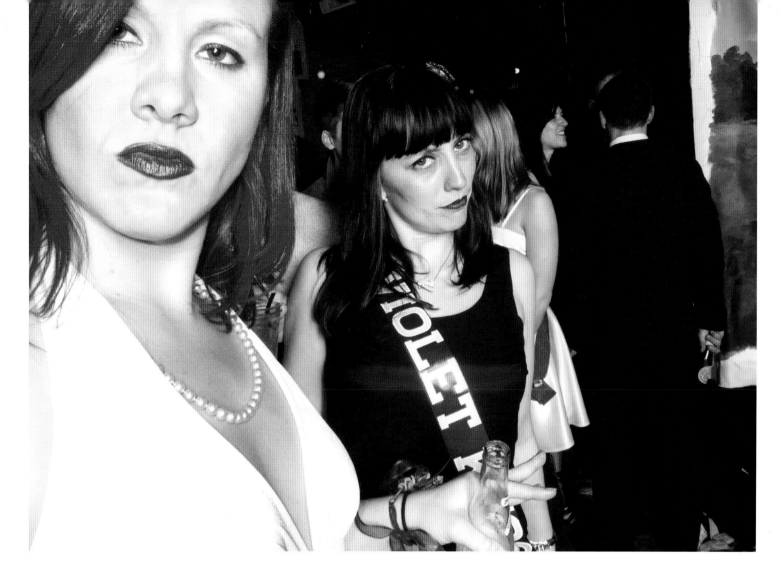

"I was on top of the world. I had worked so hard, and now I was a part of the number-one team in the world. Words cannot describe how elated I was. My friend Hardcory is there to support me, which means stealing my sash and feeding me booze all night.

"I never made it to any of my high school proms, so this night felt very special for some reason. My boyfriend knew that and had bought me the corsage on my wrist. I just loved it so much."

—*Violet Knockout, Gotham Girls Roller Derby*

"We're both giving our best bitch face. Well... maybe not our best. Violet Knockout will always be my favorite bitch."

—*Hardcory, Long Island Roller Rebels*

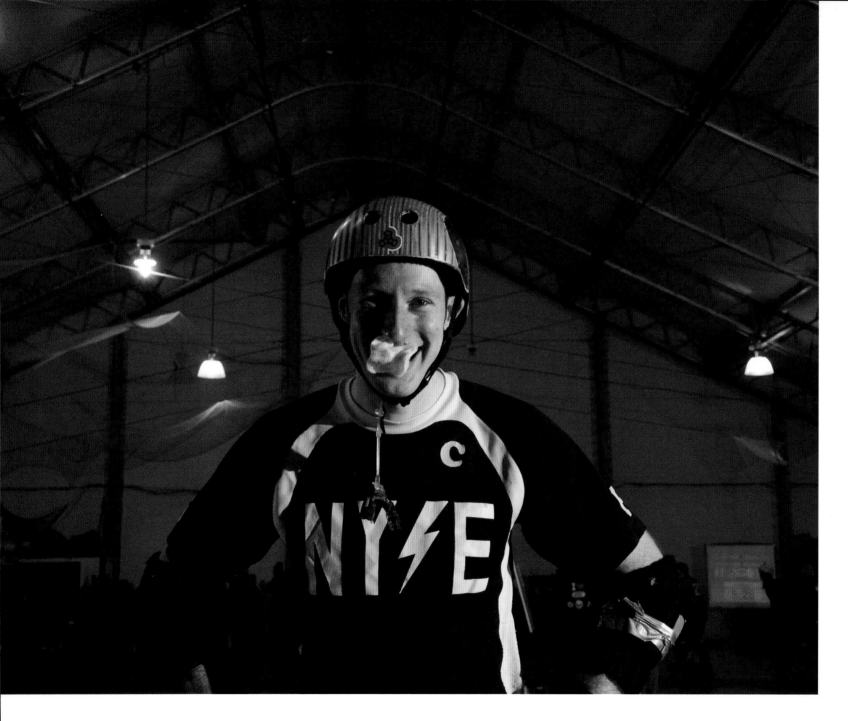

Jonathan R,
New York Shock Exchange,
2012

"My nose was bleeding from a hit I took to the face. I thought I would look tough but instead I just look goofy."

—*Jonathan R*

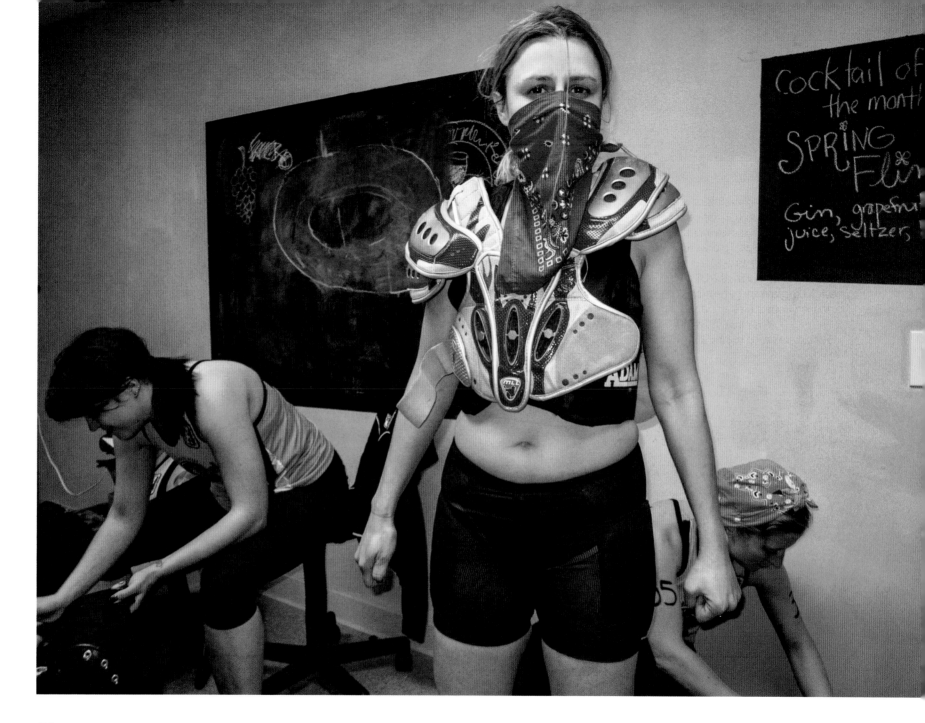

"My team was getting ready to play against the Gotham Girls All Stars. Unfortunately, after I tried to put my jersey on, I realized there would be no way I could wear all this gear."

—*C-Roll*

C-Roll,
Long Island Roller Rebels,
2012

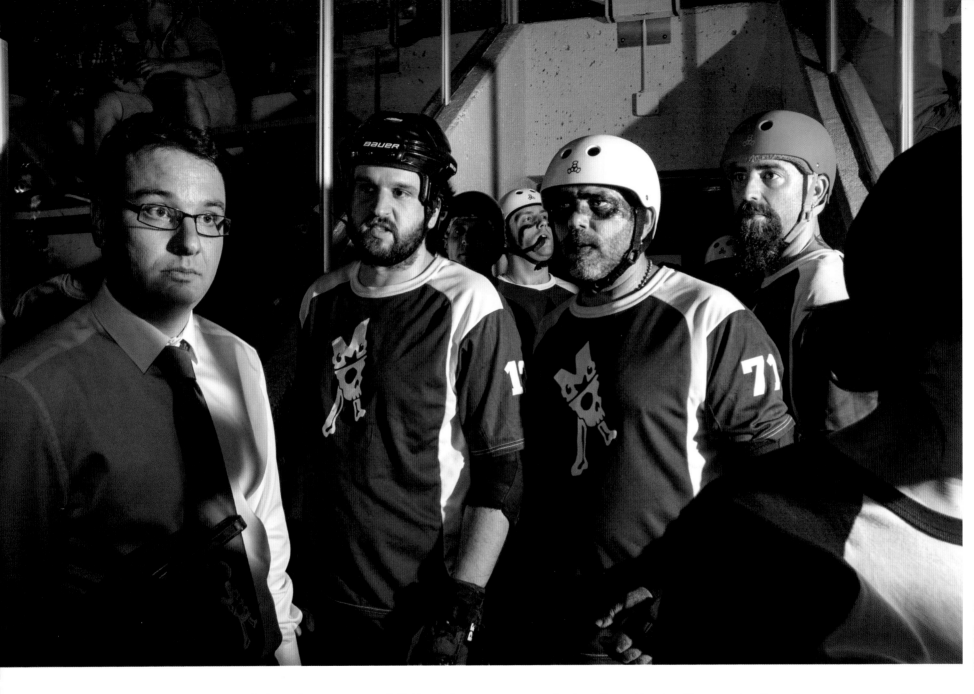

Montréal Mont Royales, 2012

"J'étais vraiment nerveux à l'idée de jouer contre une équipe d'aussi haut calibre que les Dow Jones Average de New York. Je pense que peu importe l'adversaire, chaque match a toujours son lot d'anticipation et de fébrilité. Pour m'aider à me détendre, j'ai commencé à faire des exercices de visualisation. Désormais, je me sens moins intimidé, mais je continue à faire de la visualisation."

—Tank, Montréal Men's Roller Derby

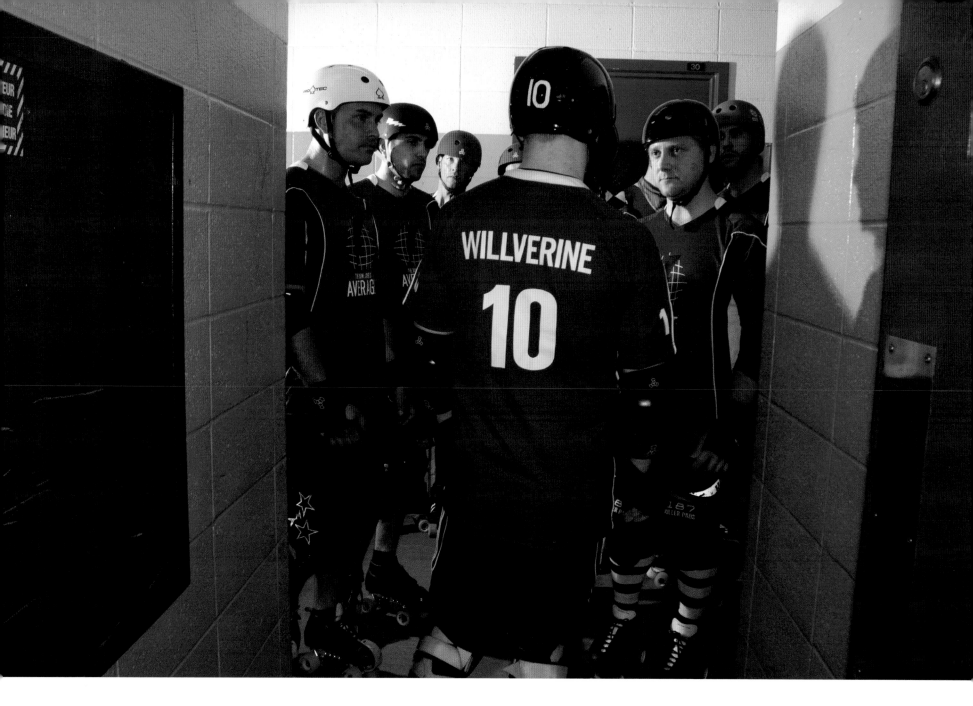

"Before I started playing derby it had been a long time since I'd been part of a team—I'd forgotten how much I love it. We're in this together and we've got each other's backs. That we go out on that track as a unit with one goal in mind. That we're there to win, to welcome adversity, to never back down, to keep fighting until the end."

—*Willverine, New York Shock Exchange*

Dow Jones Average,
Montreal, 2012

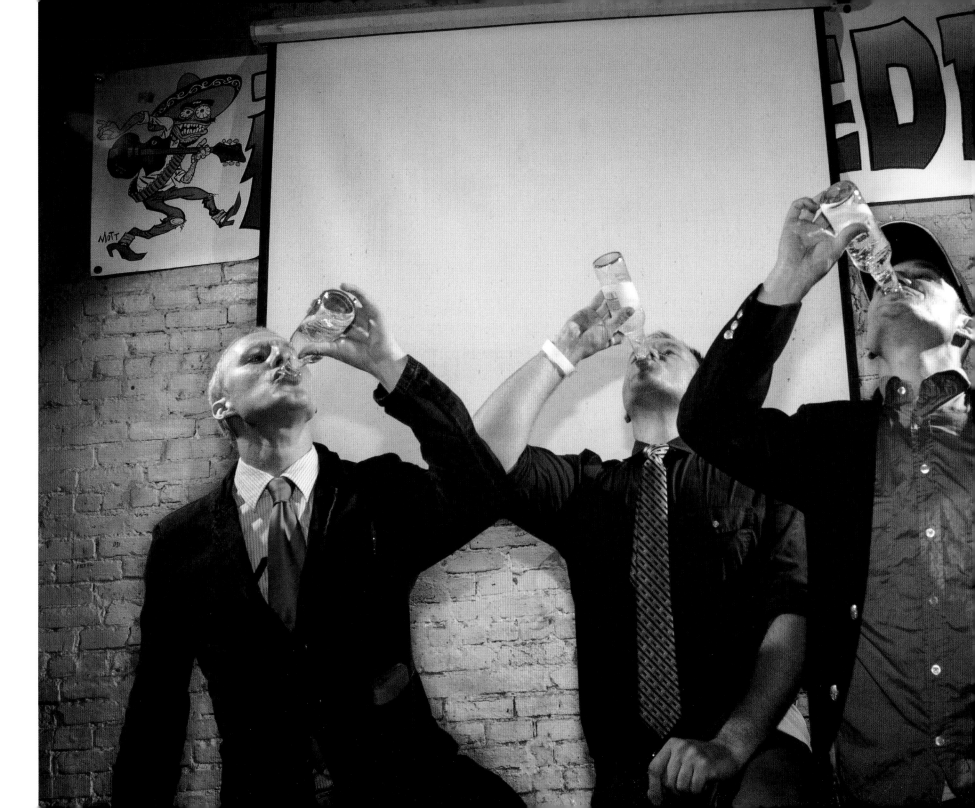

"Icing is a game where someone surprises you with a Smirnoff Ice and you have to chug it. There is more time spent training to be competitive than partying hard in roller derby now, but the jovial brotherhood I have with my teammates has not changed.

—*Jonathan R, New York Shock Exchange*"

"I had actually put together the gift on behalf of the team, and had intended for Abe Drinkin to be in my place up on the stage. The drinks were hidden inside a gift package and presented to the group by the infamous Sammy Dangerfield. I think that when Abe saw what was happening he figured it out right away and refused to take the stage and the only way to get the other two to fall for it was for me to be his stand-in. So I went up and took my punishment.

—*Ladies Knight, New York Shock Exchange*"

"I think NYSE are the only people in the world still 'icing' each other. In the middle of the ceremony at the NYSE fundraiser, I thought I was being given a gift for my services as league president. I was wrong.

—*Maulin Brando, New York Shock Exchange*"

Tradition, 2012

"I was feeling like if I could just find the right words or emphasize the point clearly, the talent the Shock Exchange has working as a unit would be unleashed.

Individual talent is a mere ingredient in a complex recipe that must mull and mix into team. Unity and teamwork rule over individual glory. Play to love each other on the track. Stay in your wall to stay out of trouble, and beyond all beliefs, believe in your players.

Fighting for the hearts and souls of men turns my eyes more green."

—*Raggedy Animal, manager, New York Shock Exchange*

"Having the self-control to keep calm, and having a manager who is able to help bring you back to a calm space is essential. Animal has a very motivating and powerful way of speaking. She is able to pull people from chaos into a centered space of acceptance and control."

—*Florence Fighting Gal, manager, New York Shock Exchange*

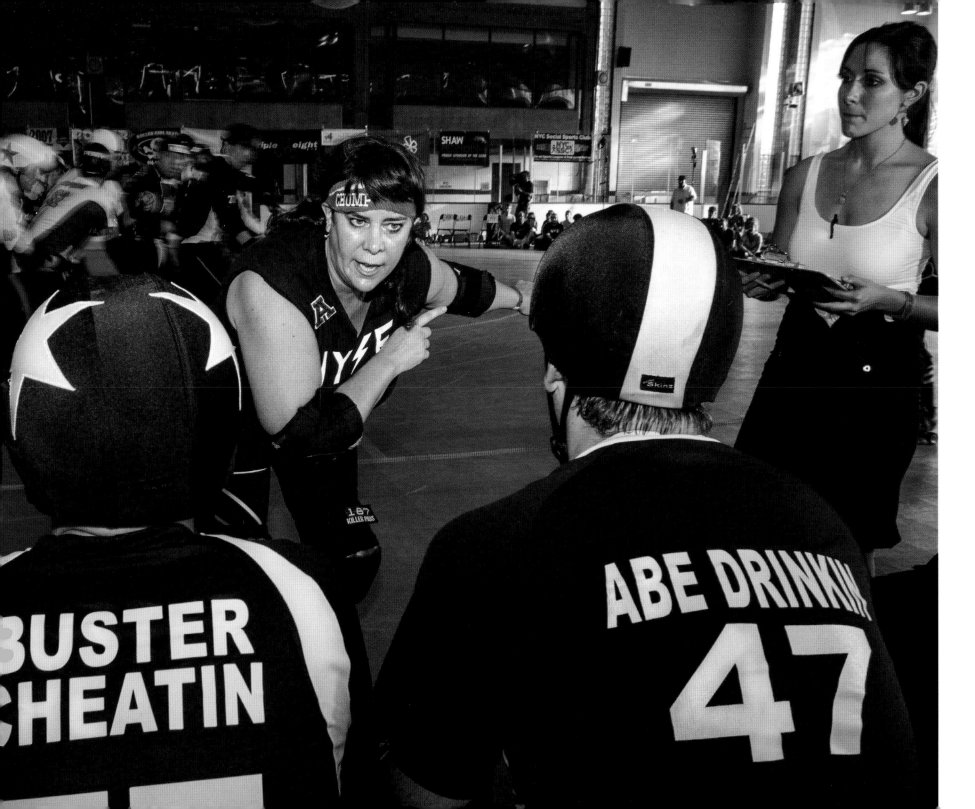

"I was recouping after a very hard first half against possibly our greatest opponent, the St. Louis Gatekeepers. I was reflecting on the play in the first half, and gathering my energy for the next thirty minutes of intense exertion. I was getting ready to get out on the track and kill it.

Being in the primary jammer rotation for the New York Shock Exchange carries a lot of pressure and responsibility. I'm sitting in that chair catching some air from the fan, trying to refresh my wits, and thinking about what I'm going to have to change in my game for the second half.

NYSE is a tough team, and we never give up. We have been down by 70 points in championship games against the best men's teams in the world and come back to win. I am infinitely proud that we are a band of brother skaters who will fight to the bitter end."

—*Ladies Knight*

Ladies Knight, New York Shock Exchange, 2012

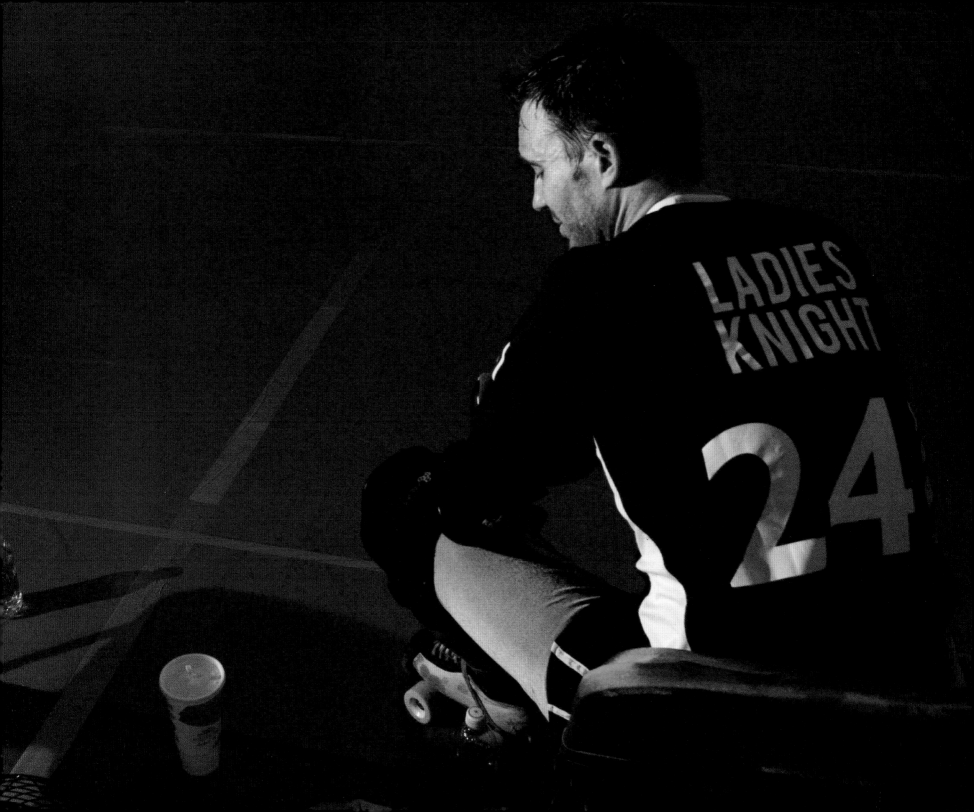

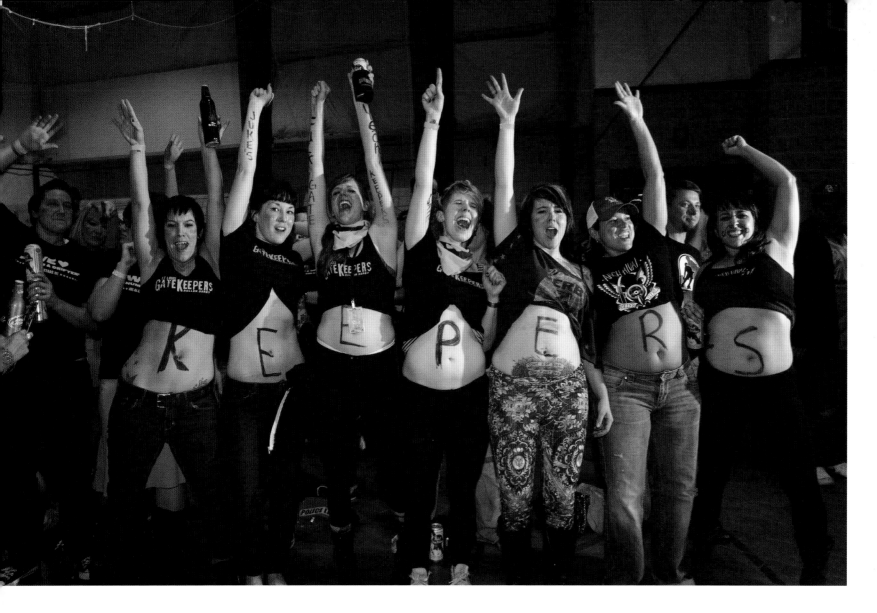

The Sixth Man on the Track, 2012

"We made quite the spectacle of ourselves but loved every minute of it because we knew the boys on the track could hear us and see how much we were rooting for them. We all knew what was at stake for our boys that night, so even though we were flashing our stomachs and having fun, it was still pretty intense and emotional.

"A brotherhood and sisterhood has developed between many leagues throughout the nation. We are all shamelessly and proudly supporting our brothers in derby because, quite honestly, they were the ones who had supported us for so long throughout the years. The fact that male and female skaters can support each other, train each other, and learn from each other while still having independent leagues is really unique to this sport and culture."

—*Starry Starry Fight, Arch Rival Roller Girls*

Untitled, 2012

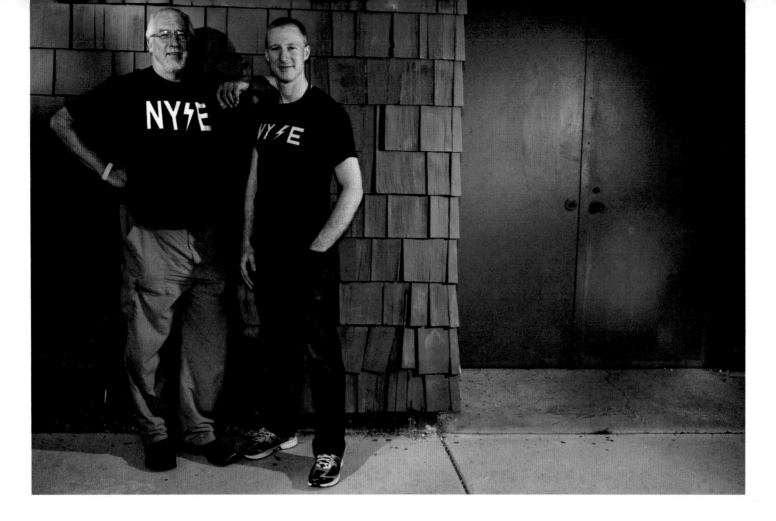

Father and Son, 2012

"I have been skating recreationally since the 1960s; participating in artistic competitions, teaching roller skating basics to beginners, and working floor guard at a local rink.

"Starting in the mid-1980s, I began bringing my son Jonathan along to the weekend rink-skating sessions. He quickly became very adept at session skating. Soon he was helping his dad to teach roller skating lessons as well. Before long, Jonathan was also competing in local, regional, and national artistic freestyle meets (where he gathered many awards).

"Upon his freshman year, Jonathan retired from competitive skating to join the high-school football team (although he continued to attend skating sessions, and teach skating skills, at the rink). There wasn't any chance to participate in roller derby back then."

—Joe Rockey

"My dad has always dedicated a great deal of time to his family and hobbies. I'd like to think that my success comes from me doing the same. When I decided to get serious about starting a roller derby team, my father gave me his speed skates. In the four years I used them, from the first modern men's roller derby game to the first Men's Derby Coalition Championships, they never lost a game."

—Jonathan R, New York Shock Exchange

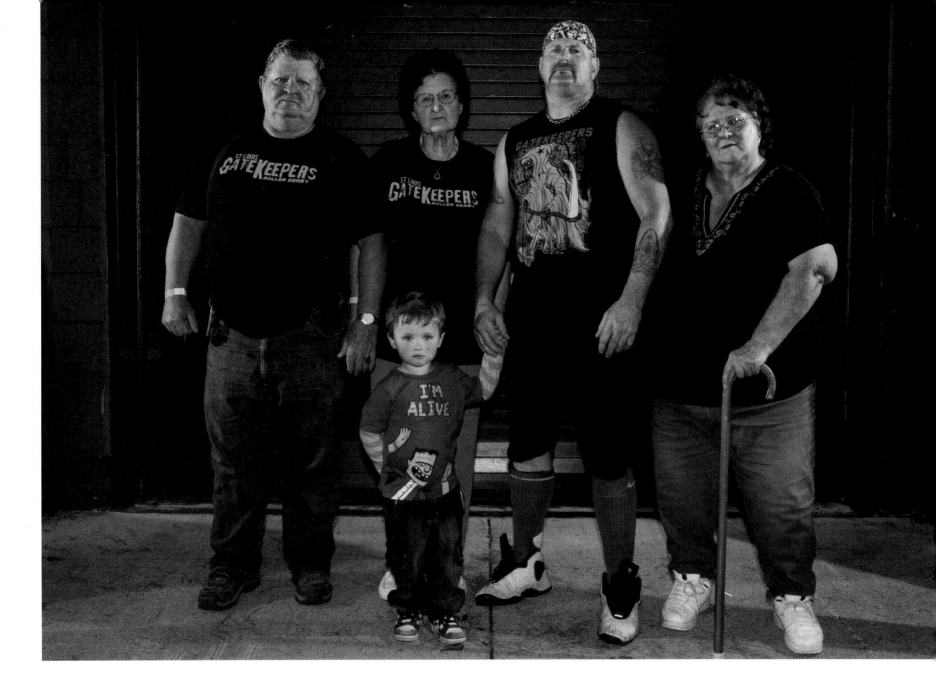

"People of all ages love the sport. Family support is special in any sport. Four generations of my family come to every home bout. I really wanted to win a championship in front of our home crowd."

—*Wrecking Bill*

Wrecking Bill, St. Louis GateKeepers. his uncle Jim, his mother, his grandson and his grandmother, 2012

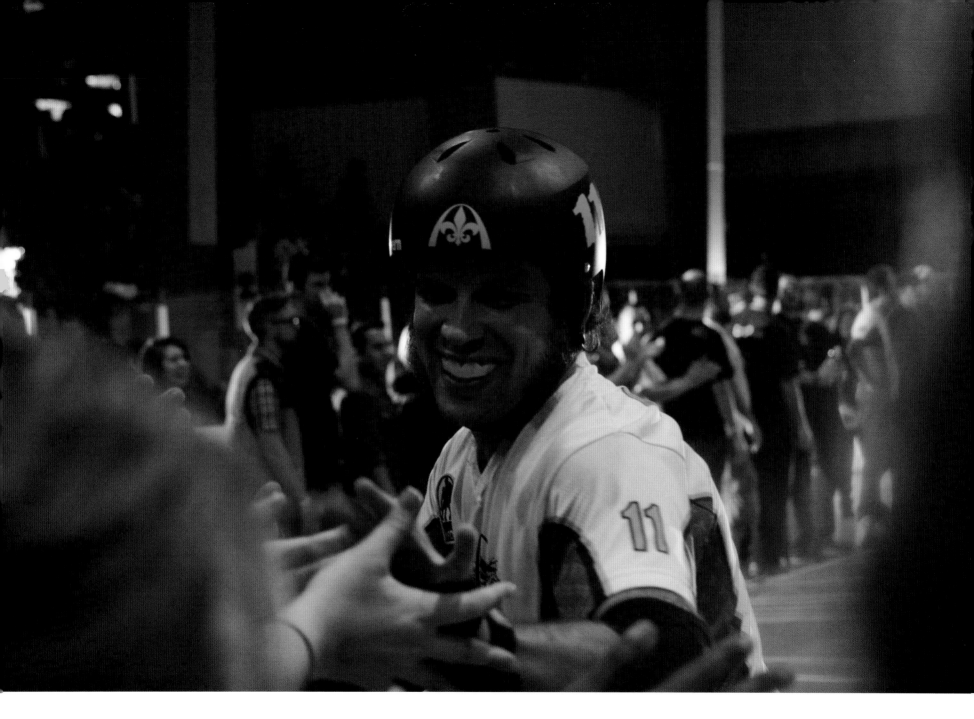

Debaucherous Prime,
St. Louis Gatekeepers, 2012

"We couldn't do this without the support of viewers like you."
—*Debaucherous Prime*

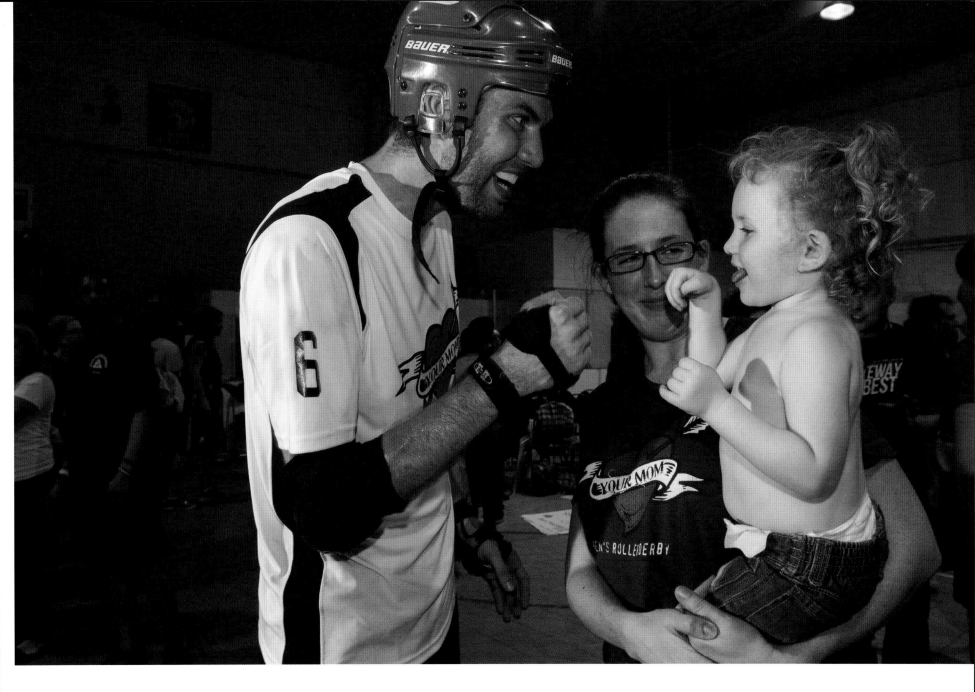

"Sugar Boots has the rare combination of being physically imposing while employing absurd agility. He can deliver devastating hip checks from seemingly benign positions. Skaters rue the play in which they lost track of him and lowered their guard. Plain and simple: He is a game changer."

—*Magnum, p.i.m.p., St. Louis GateKeepers*

Sugar Boots,
Your Mom Men's Derby,
2012

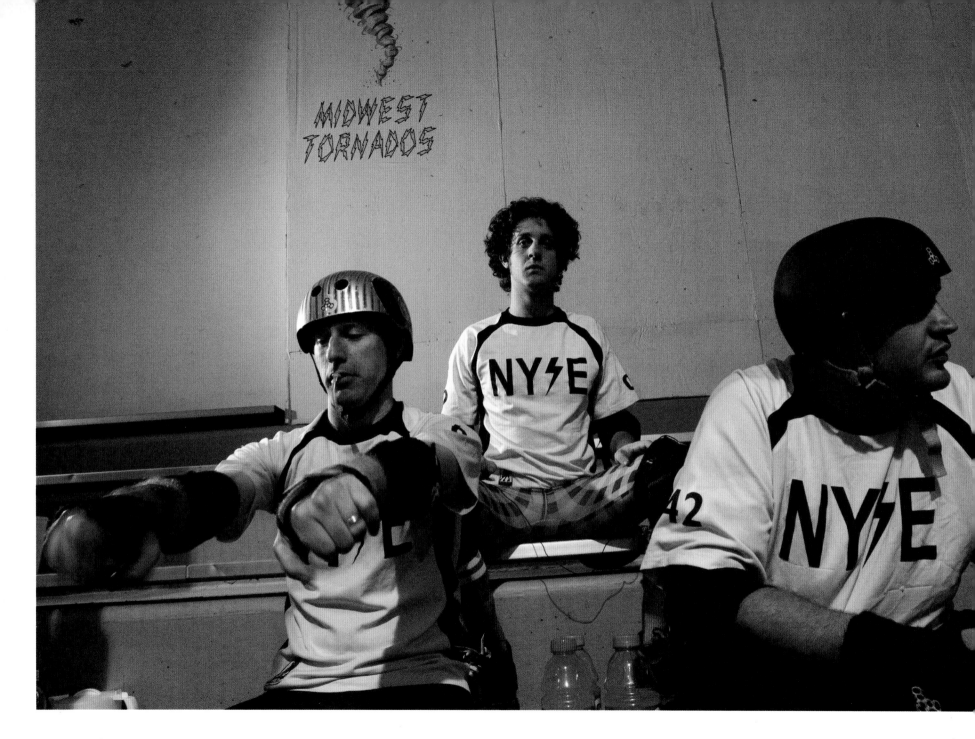

New York Stock Exchange, MRDA
Championships, 2012

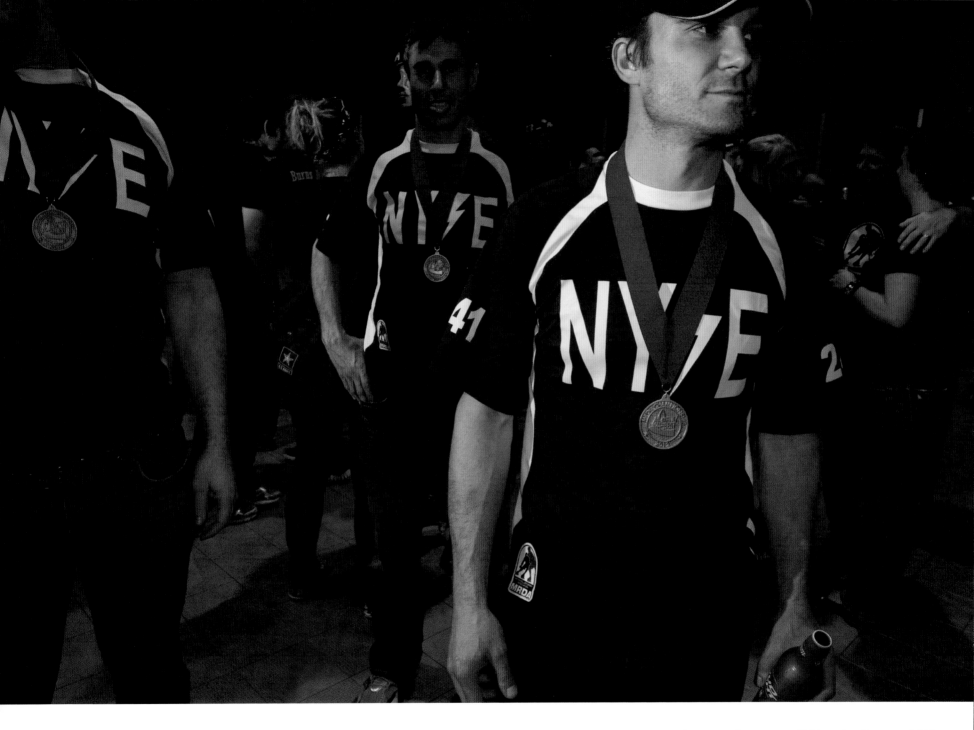

"Medal ceremonies can be super awkward. Though the medals St. Louis made for the tournament were super boss and custom."
—*Filthy McNasty, New York Shock Exchange*

Taking the Bronze, 2012

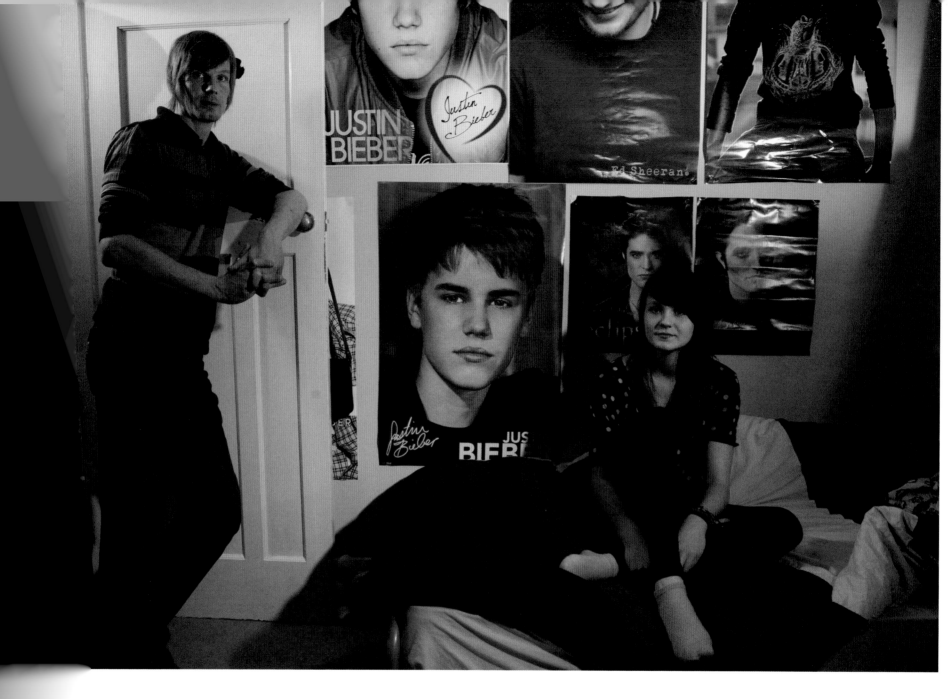

rd and his
ya Millen-
ffield, England,

"I was excited to have a team from New York staying with me and thrilled that they were so excited that I was playing Junior Derby. It was also great fun to be a model for the morning, and I got a day off school."

—*Minnie Me*

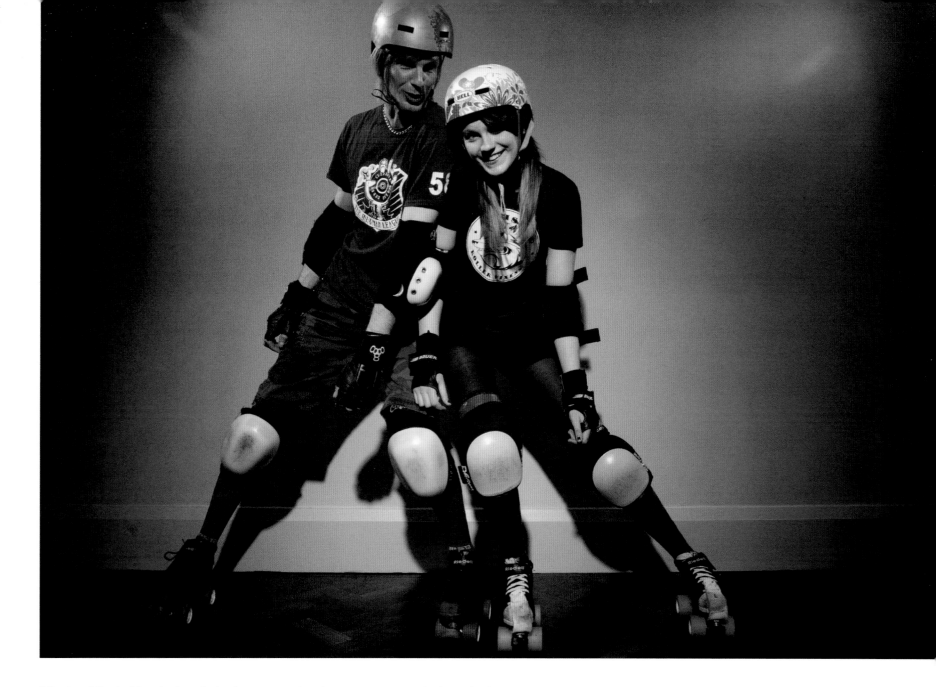

"Having Minnie Me playing derby is great and makes me very proud of her. It gives her the opportunity to meet loads of great people and allows her to see that growing up as a teen girl does not need to be all about stereotypes. I also like that derby is so inclusive and that for my daughter it is full of strong female role models. Having the shared interest in derby also allows us to spend loads of time together and has helped us be closer as father and daughter."

—*Daddy Longlegs*

Daddy Long Legs,
The Inhuman League,
and Minnie Me,
Chesterfield Twisted Vixens,
2012

Please DO NOT Urinate Onto
the Floor Thank You, 2012

"NYSE was on our Shock the UK tour—the first men's intercontinental roller derby tour in history!

I had a lot on my mind. I had just met my self-proclaimed 'biggest fan,' this awesome girl Julia, whose mom plays for the Northampton Shoetown Slayers. I had no idea anyone even knew I existed! Julia was around 14 at the time. Suddenly, I realized that I had a responsibility to her—in this odd way. Like, I would have to watch my language, and think before I spoke or did anything, lest I disillusion her. It forced me to grow up rather quickly! Although I'm not totally there yet, meeting her made a *huge* impact on my life, and how I comport myself during bouts. I felt like any outburst or unsportsmanlike behavior (not that that's my MO or anything) would turn her off to derby. I'll be damned if I was going to do that!

It certainly testifies to the growth of our sport! It was interesting to see that the concept of *derbylove* exists overseas as well. It cut across the pond and across cultures. Derbylove is the wind we all sail on, whether our team wins the bout or not.

—*Bane-ana on Skates, New York Shock Exchange*"

Shock the UK tour, 2012

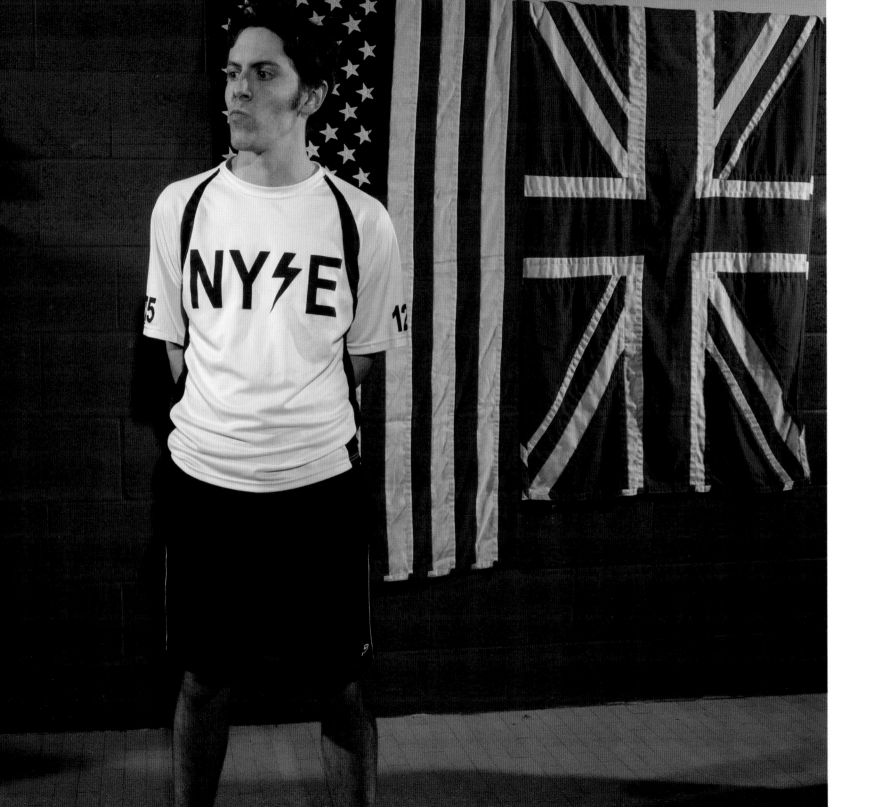

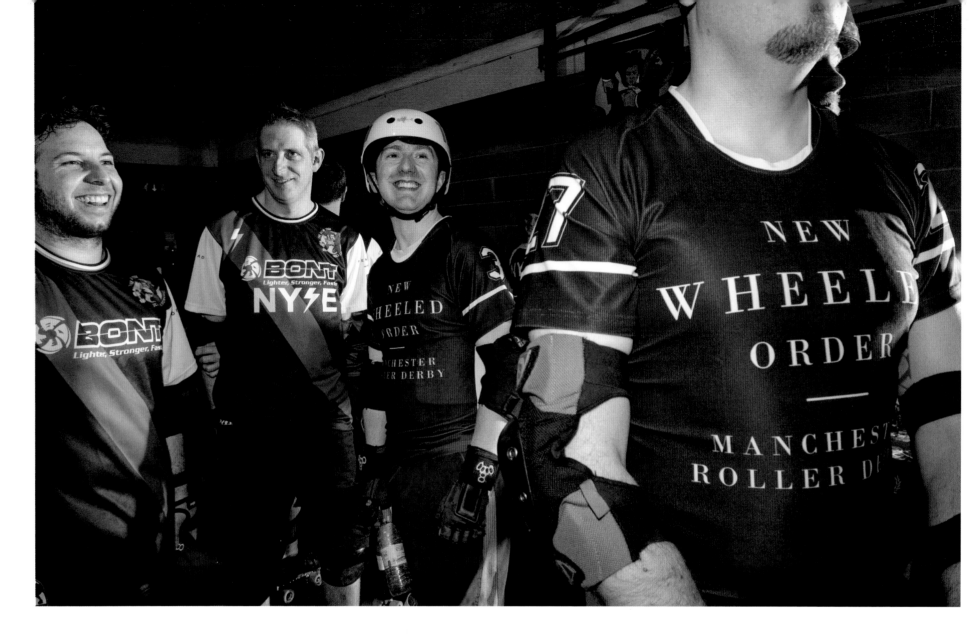

New York Shock Exchange
vs. New Wheeled Order
(Manchester, England), 2012

"There is a great comaraderie each skater feels within the roller derby community. We're doing something very few people in the world are doing, and are all thrilled ot be a part of it, and thrilled to be playing such a fun and exciting sport.

"Each day of NYSE's UK tour, we felt more and more proud of our accomplishments, actually making the tour work, and more and more surprised at the level of love and support we felt in every new town with every new league. I was completely overwhelmed by the enthusiasm and generosity from the fans and skaters. This would be the only time in my life I truly felt like a rock star."

—T-Stop Tornado, New York Shock Exchange

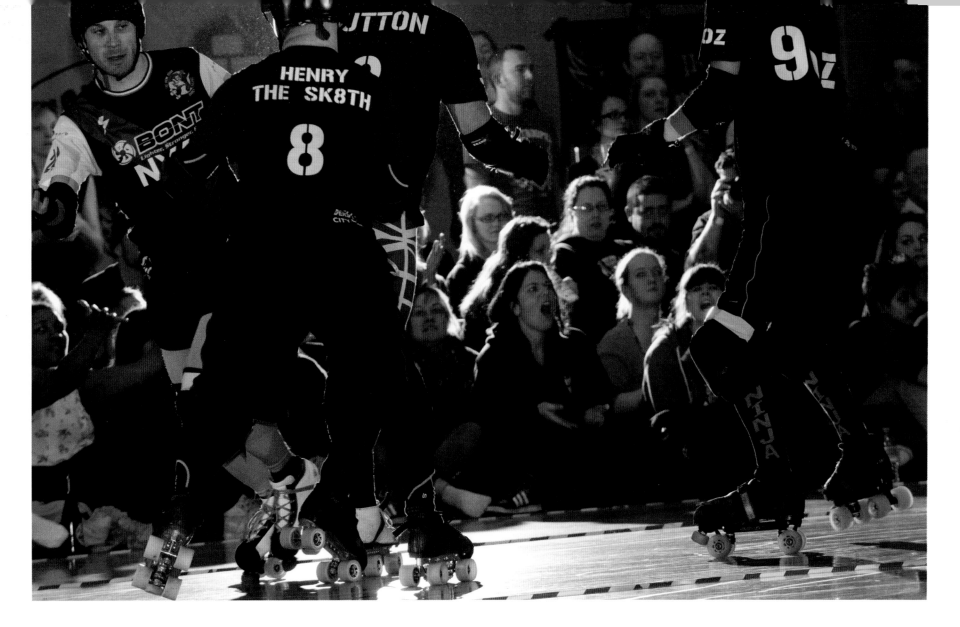

"This was our hardest game of our amazing Shock the UK tour. See the sweat flying and feel the chests thumping. See the love and dedication of derby players and fans the world over, although I am inclined to believe that the majority of London's derby fans there were cheering against me.

"We had kicked off our travels with a fantastic game of derby against Manchester's formidable New Wheeled Order and continued on down to London via various scrimmages against the great men's derby teams of England. Southern Discomfort were formidable opponents laying on the big hits. After playing almost nightly for a week straight, and with a short roster, I know I was tired. I was excited to beat London and get to the after-party and on to bed later. I had mixed emotions because the trip was coming to an end, but I couldn't wait to rest my aching bones."

—*Ladies Knight, New York Shock Exchange*

New York Shock Exchange
vs. Southern Discomfort
(High Wycombe, England),
2012

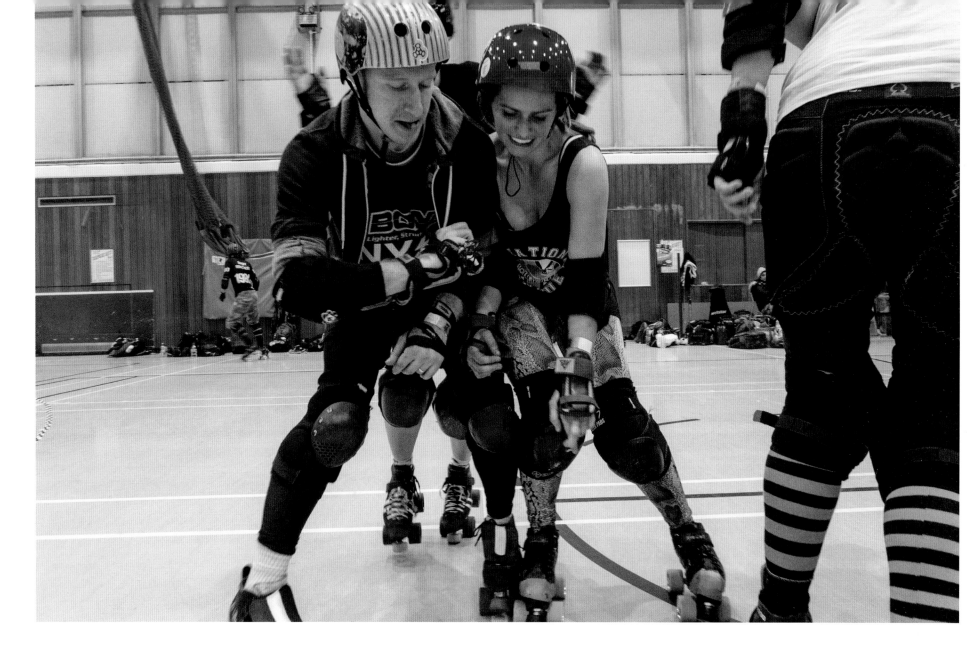

Bootcamp, 2012

"I enjoy teaching roller derby a lot. It is a real delight to see skaters improve. Seeing someone complete a new skating skill for the first time is like seeing a baby take her first step. Since I have so much experience skating myself, no problem seems insurmountable.

"The demand for roller derby knowledge is high. The sport is spreading fast but the number of experienced coaches available, as compared to most any other sport, is incredibly low. Although nowadays a nearly infinite number of ideas can be disseminated instantaneously online, in-person coaching trumps all."

— *Jonathan R, New York Shock Exchange*

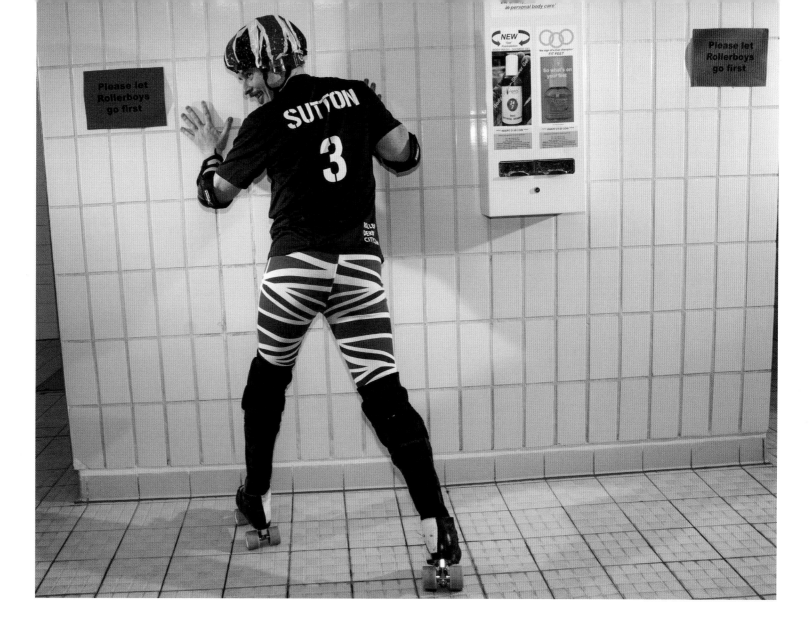

"Southern Discomfort Roller Derby had just lost to the New York Shock Exchange. Although we did not come out victorious, we did hold the Shockers to the closest game of their U.K. tour. The completion of this bout was the final element we required to enable SDRD's Men's Roller Derby Association application, which was the next step in our mission to help promote European Men's Roller Derby. It was the culmination of months of planning on both sides of the Atlantic, and I was massively relieved that it had gone to plan (apart from us losing). I'm wearing the shower cap that Jonathan R had been utilising during NYSE's tour, as we all thought it went great with my subtle union flag leggings. Just off camera are lots of semi-naked men."
—*Sutton Impact*

Sutton Impact,
Southern Discomfort Roller
Derby, 2012

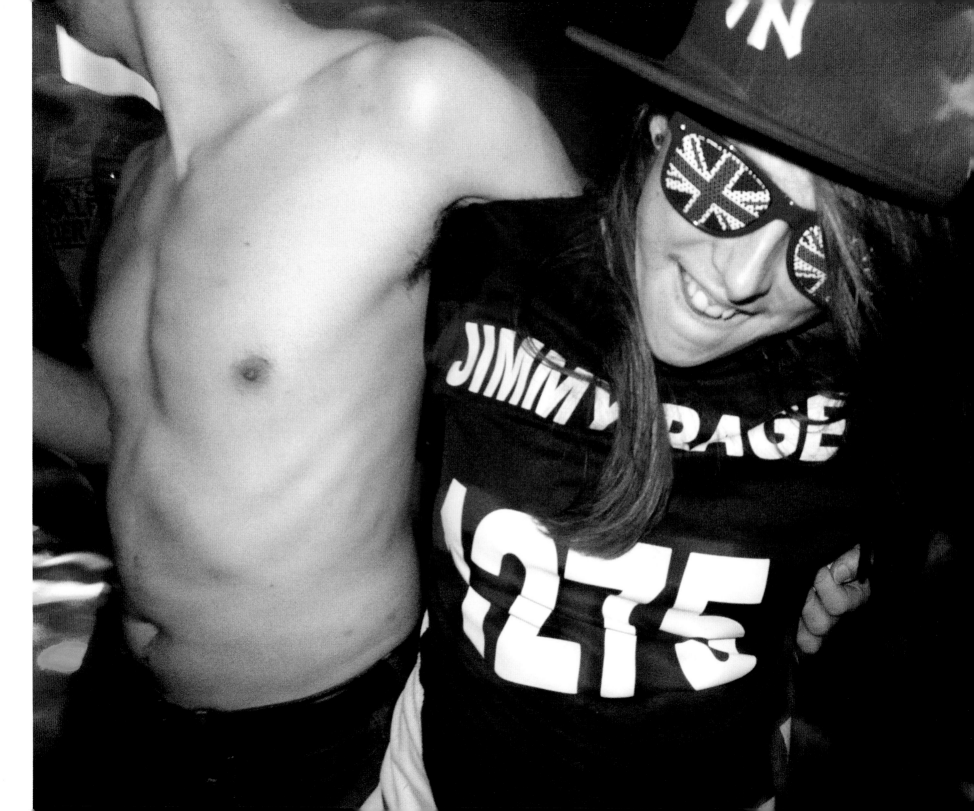

> " Afterward I banged my head on the women's restroom sink. I got two awards for that in the NYSE holiday party that year. "
>
> —*Jimmy Rage, New York Shock Exchange*

> " It's not me at my best exactly. "
>
> —*Rogue Runner, London Rollergirls*

Jimmy Rage, High Wycombe, England, 2012

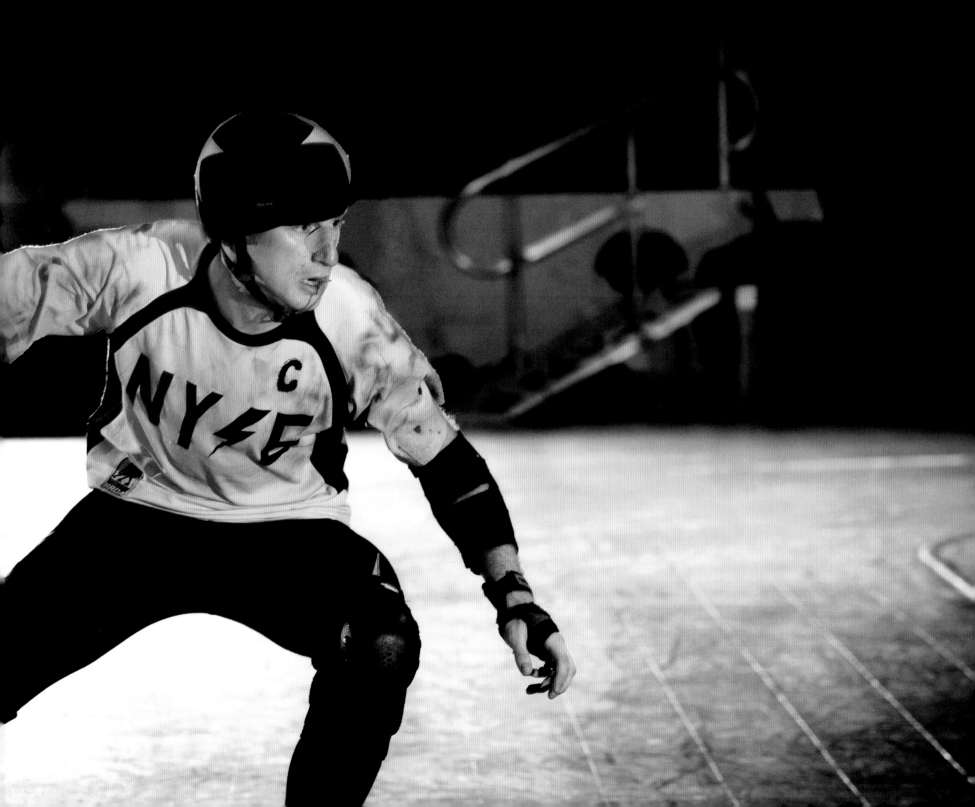

"Roller Derby is a challenging, violent sport. You need a warrior's spirit to succeed.
—*Jonathan R, New York Shock Exchange*

Jonathan R, 2012

"One does not simply sample derby or 'visit.' If you're there, you're family, more so because it is powerful and all-consuming.

—Eclipse, Kansas City Roller Warriors

The brutality of the sport seems incongruous with my personal demeanor, and I do get comments about that. Since I am middle-aged, I came in (to it) a completely formed person. Had I started 20-plus years earlier, then it would certainly have changed my outlook and development.

—Roly Ramone, New York Shock Exchange

Derby did give me the confidence to finally come out to my family, and that has made a huge difference. They have all been extremely supportive of me!

—PAC-JAM, Long Island Roller Rebels

Roller derby isn't for everyone. It's a huge time commitment, and you might have a career where your limbs are very important—or for whatever reason it might not be right for you. But for me, derby is the best thing that has happened, and I'll be skating until there's no cartilage left in my knee.

—Crashtastic Cate, Long Island Roller Rebels

I have received mixed reactions from coworkers when they hear that I play roller derby. Some people tease me because if you were just to look at me at work you wouldn't think I'd be the type of person to play such an aggressive and full contact sport. I have had some very big supporters who have come out to games and others who had watched games that were streamed online, but I've noticed that most aren't sure how to take me after they hear I'm a derby girl.

—Angry Penguin, Long Island Roller Rebels

When I was a kid I used to watch RollerGames for that one year it aired, right after Saturday morning cartoons. A friend from high school, Kristin, sent me an e-mail in December 2005, letting me know that she had recently made the decision to call herself "Trixie Timebomb" and had forsaken all sense of personal safety by joining a roller derby league that was starting up (later to be known as the Long Island Roller Rebels). She asked if I'd be interested in being an announcer for the league and, with the nostalgic, hyperbolic images of RollerGames flooding back from childhood in my head, I said yes. That very evening, the short-lived A&E reality show Rollergirls started and gave me an idea of what to expect. I've been announcing ever since!

—Jake Steel (aka CAPS LOCK), announcer

My family supports me and is also terrified. At the first bout my sister saw me skate in I broke my collarbone so...that wasn't so great.

—Atticus Flinch, New York Shock Exchange

Derby has strong women athletes who young girls can look up to. Young girls see derby players and they want to be like them, and I feel that's positive for the future. I've been trying to get my niece to play junior derby, because I feel like it could bring some really positive things to her life. I love it. And I am going to play it for as long as my body allows.

—Filthy McNasty, New York Shock Exchange

Ughhhhhhhhh, I am 'the girl who plays roller derby' at work, never mind that I have a name, or a Ph.D., or do a lot of important and useful things within the company that have nothing to do with derby. I've worked places where I never told them about derby at all because I saw how I got pigeonholed in my first job. It's been a double-edged sword. I think at a certain point when I first was involved it helped me grow as a person. I'd never worked with people on a team before, and it forced me to get used to that dynamic.

— Dainty Inferno, New Jersey Dirty Dames, Gotham Girls Roller Derby

Derby is an open door as long as you follow rule number 1: Don't be a douche. Love it!

—TestosteRon Jeremy, New Hampshire Roller Derby, Helsinki Roller Derby, Boston Derby Dames

When I was in college I was browsing through Myspace one day, and came across a profile that belonged to a skater for the Gotham Girls Roller Derby. It was 2004, and the roller derby revolution had been started but was still fresh. I was blown away that it existed and had to check it out. I would drive down to the Skate Key in the Bronx every month to watch the only league in NYC play. At the time there were only two teams, Manhattan Mayhem and the Brooklyn Bombshells. My favorite skaters were Suzy Hotrod on Brooklyn, and Rolletta Lynn for Manhattan. I instantly fell in love.

—Hardcory, Long Island Roller Rebels

On July 27, 2005, eleven girls showed up at Suffolk County Community College to a meeting. Roller derby was explained with a pack of cigarettes. I proclaimed, 'But is there a ball?! How does a team score points?!'

—Captain Morgan, Long Island Roller Rebels

Roller derby is like a second job, but one that you really don't mind going to. You can have practice up to four times a week. There are also attendance requirements as well. Sure, it was easier staying home, but there was something that drew me in. I wanted to practice, learn different strategies, work with other skaters and help them out. It was addicting. I remember getting up for work after a night of practice barely able to walk, sore muscles, bruises, and scrapes. But I wore those black and blues like a badge of honor. When it was show time, you knew it was all worth it. One of my biggest fans is my Pops. He always had front-row seats and would purchase Greasy DeeCee merchandise every game. I loved seeing that man smile when I skated past him.

—Greasy DeeCee, Long Island Roller Rebels

All in, baby! I relocated back home to play derby, and for the most part my social scene has been derby-driven ever since. Derby is super easy to be involved with, and I can't tear myself away yet.

—Jurasskick Park, Pioneer Valley Roller Derby, Mass Maelstrom Roller Derby

There are a lot of positive impacts. If I had to pick one thing, though, I think it is our great influence on children. We can be huge role models to the younger generation. I love junior roller derby and what it is doing for the youth. It is a great alternative option for a sport for kids, coed especially. It is a great way to build confidence, physique, mental strength, and leadership skills.

—Tracy Disco Akers, Rocky Mountain, Denver Roller Dolls

Roller derby became my life. Long hours four to five times a week. I probably spend more time at derby than I do at work. I've lost friends because I have spent so much time doing derby, but also gained quite a bit more friends. It's a sacrifice I will make year after year until I can't skate anymore. Then I'll probably NSO.

—Celtic Thunder, Long Island Roller Rebels, Gotham Girls Roller Derby

My husband is extremely supportive. He insists on going to all my bouts. In my derby career, he has missed one bout. I've actually refused jobs because they interfere with my practice schedule. Because of the business aspect of roller derby, I have learned to be more diplomatic and democratic in my dealings with individuals.

—Sonic Euthanizer, Hellions of Troy, Green Mountain Derby Dames

I started playing the summer after I graduated high school, so I pretty much grew into an adult in the derby world. I wanted out of my hometown of Fort Smith, Arkansas, and thanks to my good friend Bat Wing, whom I met through derby, I was able to make that a reality much quicker than I thought. I've had so many wonderful things happen for me since I moved to STL, and none of it would have happened if I hadn't know derby people here.

—Killer Painguin, River Valley Roller Girls, Arch Rival Roller Girls

I watched the film *Whip It* and afterward did a Google search as I didn't believe it was a real sport. I found it was and that I could even start playing it in the city I was living in, Leicester, England.

—Rogue Runner, Dolly Rockit Rollers, London Brawling

Everyone I tell about my daughter being in roller derby is surprised and impressed. Some are a little concerned about her safety.

—Lynne Sucher, mother of Papierschnitt, Gotham Girls Roller Derby

The most significant moment in my roller derby experience was actually deciding to leave it. Roller derby takes over your life. It is just the nature of the ride, but deciding to stop playing and move on with my life was a huge moment for me. It was very difficult but walking away from roller derby allowed my to see that everything in life comes to an end, and there is nothing sad or bad about that. It just illustrates how precious the time is that we have and reinforces that we should never stop moving forward.

—Comet Atcha, Rat City Rollergirls

Bridging the gap between off-skates derby supporter and on-skates derby player would not have been possible if it wasn't for the generosity and coaxing of Terminal City's Rollergirl. I DJ'd her *Barbarella* space-themed birthday party in 2010, and as I was walking out at the end of the night, she said, 'Hey LaRock—if you rip up that check, I will more than double it in retail at my store.' As a result of this incredible gift, I was able to afford a complete package of protective gear, and my very first pair of roller skates. I will always humbly acknowledge this great debt and inspiration. It changed my life in a profound way.

—LaRock Steady, Vancouver Murder

Skater-owned-and-operated businesses are at the core of roller derby culture.

—Bonnie Thunders, co-owner, Five Strides Skate Shop

My family is both intrigued and confused by my passion and seeming obsession with roller derby. I joined derby after my mom passed away in an accident in 2006, and my father was rightfully scared for my physical health. I've missed a few events because of derby, but my family is also 3,000 miles away. I've never missed a Christmas, wedding, or funeral for derby so I feel pretty good about my balance of priorities. I know my family respects my commitment to the game, and sees me as a fierce, strong, and motivated woman because I play roller derby.

—Black Star Heroine, Suburbia Roller Derby, Angel City Derby Girls (and Drive-By City Rollers)

Back in the day, when Myspace was still big, I used to see these bulletins about the Long Island Roller Rebels all the time. So, in September of 2007, I attended my first bout. It was an interleague bout, and I loved it. From there on in, I was hooked.

—Doctor Muerbe, NSO, Long Island Roller Rebels

Crazy ex-nun at my rollerfit class said she was starting a league and that I should be involved with roller derby.

—Perky Nah Nah, Richter City Roller Derby, Victorian Roller Derby League

I always wanted to play roller derby as a kid. It was my dream. I speed skated as a child and then played rugby in college. Roller derby was a perfect combination of the two.

—Frida Beater, Rocky Mountain Rollergirls

I saw a post about men's roller derby on a blog called Boing Boing. So I wrote a letter to the New York Shock Exchange that said 'I WANT TO JOIN ROLLER DERBY! What do I need to do and what do I need to buy?'

—Frozen Chozen, New York Shock Exchange

I think I was an athlete pretty much at birth. I've played any and every sport in little league and all through my school years, continuing after with more extreme sports. I race jet skiis, made Blade Warriors, a roller version of American Gladiators, surf, snowboard, mountain bike, ride motorcycles and horses. All that led to my career as a professional stunt woman, and through the stunt work, I became a professional wrestler with the WWE. I think it was just a matter of time till this sport found its way into my lap.

—Trinity, Long Island Roller Rebels, Strong Island Derby Revolution

We achieved far, far greater heights than we ever thought imaginable, as women, as businesses, as athletes, and as humans. There are so few women-only sports. Derby might be the only one that has legitimized actual competition at the levels we've achieved. I never felt like there were enough options for my sports aspirations, and I am so happy that women and girls of the future will have this option.

—Beatrix Slaughter, Gotham Girls Roller Derby

When I joined the Shock Exchange I was reluctant to take a derby name. I'd played team sports for a long time and liked having my own name on my jersey. I was also 39 and I knew myself as a person and an adult. The idea of having a persona turned me off. I wanted to skate as myself. The same guy that sits in the studio and works all day is the same guy who goes out on the track and gives it his all. I've since embraced the name 'Willverine,' and I like it. It helps that I go by Will and that's how my teammates refer to me. Willverine has just become a nickname used by announcers, etc.

—Willverine, New York Shock Exchange

My original derby name, Jake Steel, is just a slight modification of my real name. Entertainingly, there emerged another Jake Steel who works in quite a different industry than mine and a few overzealous fans of his were beginning to get the two of us mixed up, so I changed my name to CAPS LOCK, because it symbolizes being loud on the Internet. When you want to unleash the fury, you tap CAPS LOCK.

—Jake Steel (aka CAPS LOCK), announcer

Roller Derby opens the door for cultural exchange. It brings people together and allows us to celebrate what makes us unique whether these differences are from the next town over or across oceanic, international borders.

Jonathan R, New York Shock Exchange

It seemed crazy to me that someone wanted to document this moment and try to capture who and what roller derby was at that time. I remember thinking, *This is it, I'm in a photo shoot for a professional photographer, I could be famous*. Ha, I was so young.

Vicious van GoGo, Texas Rollergirls, Gotham Girls Roller Derby

ACKNOWLEDGMENTS

This project could never have happened without the support and encouragement of far too many people than I could ever remember, much less name. However, I will give it my best shot.

There were many stages to this project: First and foremost, Papierschnitt for the very first introduction to roller derby; Ginger Snap and Bluebonnet Plague (Meghan Rockey) for the access to start photographing Gotham; Michael Giaculli for my name, Point N Shoot; my two derby wives Sonic Euthanizer and Breakneck Brie; Mathundra Storm, my support when the world fell apart; Ladies Knight and Maulin Brando for their introduction to men's derby and their tremendous support; the New York Shock Exchange for allowing me to travel with them to the U.K. (WHITE VAN!); Buster Cheatin and Endless Justin for selecting me to be official photographer for Team USA; all the leagues that gave me access and endless connections to amazing groups of women; Fisti Cuffs for filling out the most number of surveys; OMG WFT for all the leads and detective work, along with Ginger Snap, Sparkly Plenty, Jess LaRotonda, Bob Noxious, Pieces of Hate, Rat City Rollers, Bitches Bruze; Sara Rosen, whose honesty is well cherished; Brian Dilg, photography department chair, New York Film Academy, for helping with the final culling of images; my one true "focus group": Veronica Wasserman, Rob Valois, Willverine, Roly Ramon, and his brother Ivan and sister-in-law Christina (although I'm not sure I took any of your sound advice); my amazing assistants through the years—some being my students: Andrea Gentile-Shilling, Emily Beringer, Alison Milner, Harm's Way (before I ever noticed him noticing me), Janilla Ice, Aunt Pricilla; Violet Knockout and Tanya Yankova for their diligent clerical work without which we never would have pulled together the hundreds of moving parts to this book; my mother Dianna Gage, my father Andrew Seymore, my sister Courtney, and the coolest nephew Ethan; Lori Ackerson, the best art teacher anyone could ever have, because without her I would never have pursued my life's journey as a photographer; Talia Cliff and Lisa Vaccaro for their support, and everyone who ever came to watch me skate; all my students at BOCES who came to my bouts and photographed events—There were moments of frustration and moments of joy, but you left me with fond memories and revived my passion for photography; Joanna Milter from the *New York Times Magazine,* who published the first men's roller derby photograph in a national publication; my first league, the Hellions of Troy, and my last league, the Long Island Roller Rebels, both of whom made me feel like I was in a roller derby version of *The Bad News Bears*, but I wouldn't have it any other way; Suzy Hotrod for her wonderful Foreword; and last but not least the love of my life, the man behind the curtain, Timothy Travaglini, Harm's Way, as without his way with words, his skill with editing, and his constant encouragement, this project would have not come to life on these pages.

Thank you for everyone who submitted their stories, opinions, and insights. People wrote funny, heartbreaking, poignant, inspiring, amazing things, and I am sorry we could not use everything. Thank you to everyone featured in a photo and quoted in the book, and also to: Account DeeRacula, Alabama Whirley, Anna Tramp, Ashley Burkard, AugustNFury, Ballistic Whistle, Big Panda, Black Amberconda, Black Widow Biter, Bob Noxious, BadJelly the Bitch, Byte, carlovely, Celtic Storm, Chochness Monster, Claire D. Way, Crash Kalwa, Dani Rockets, Devoida Mercy, Dottie Damage, Dr. Spankenstein, Elle Qaeda, Emily Smykal, Endless Justin, Eve L. Taco, Fantasmic, Flo It All (formerly known as Florence Fighting Gal), Gazooka, Glittersaurus Rex, Hela Skelter, Helda Raise, Homer Jency, Hyper Lynx, Ida the Living Dead, Intended Anger, James Schwarzwalder, Jefferee, John Shankem Jingleheimer Strict, Jonny Longhare, Julia Childless, Just Plain Evil, Kelli Catana, LawlessMess, Little Loca, Malcolm Sex, Mayday Va*J*J, Meghan Rockey (Bluebonnet Plague), Merry Pain, Mick Swagger, Mirambo, Miso Vicious, Ms.Ree Bellion, Patch Darragh, Prof. Rumbledore, Quad Almighty, Rhino-Might, Rice Rocket, Ronnie Mako, Scooter McGoot, Shimmy Hendrix, Shockratease, Sin Diesel, Sissy Spankit, Skip Tease, Smarty Pants, Teflon Donna, Todd Bradley, U-Go-Boss, Vincent Madonia, Winnie the Pow.

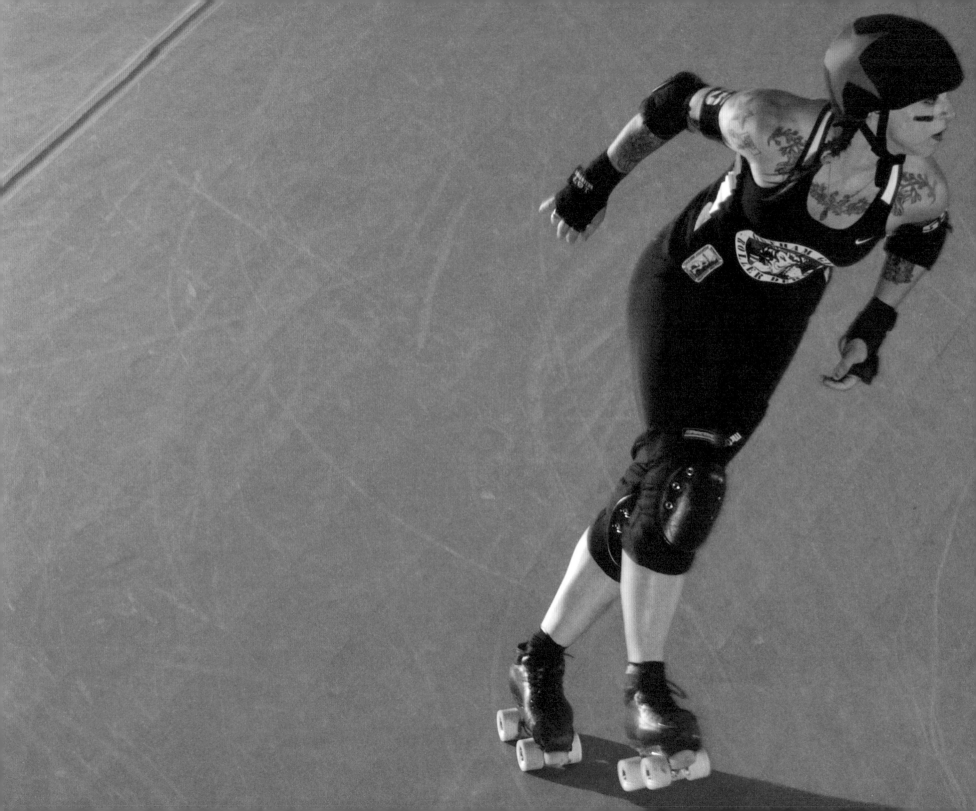